T0133005

Red

THE ART AND SCIENCE OF A COLOUR

Spike Bucklow

REAKTION BOOKS

Dedicated to Tara

Published by Reaktion Books Ltd
Unit 32, Waterside
44–48 Wharf Rd
London N1 7UX, UK
www.reaktionbooks.co.uk

First published 2016

Copyright © Spike Bucklow 2016

All rights reserved

No part of this publication may be reproduced, stored in a retrieval
system, or transmitted, in any form or by any means, electronic,
mechanical, photocopying, recording or otherwise, without the prior
permission of the publishers

Printed and bound in China by 1010 Printing International Ltd

A catalogue record for this book is available from the British Library

ISBN 978 1 78023 591 2

Contents

Introduction

THE EVERYDAY language we all share is generously sprinkled with references to 'red', and with good reason. We lay out the 'red carpet' to greet celebrities because for over a thousand years, red cloth was the most expensive that money could buy. A 'red letter day' is out of the ordinary for us but has its origins in the use of red, rather than black, ink for some letters and words in medieval illuminated manuscripts. Hitting 'red lights' is a way of saying we have met a series of obstacles, while being tied up in 'red tape' suggests we are struggling with the continuous obstruction of bureaucracy. Wrongdoers are caught 'red-handed' if they bear evidence of their crimes (in which case they may be embarrassed, blushing and 'red faced'). Such phrases allude to blood on (or close to) the surface of the skin. TV documentaries revel in Nature when she is – to use Tennyson's phrase – 'red in tooth and claw' and they tug at the heartstrings with the fate of individual animals, especially endangered ones on the 'red list'. 'Painting the town red' is a celebratory activity that might make a more sober and sedate townsperson 'see red' or even become helplessly engulfed in an angry 'red mist'. 'Seeing red' and the related 'red rag to a bull' are expressions of irritation, provoca-tion or threat and official responses to those posed by foreign powers or homegrown terrorists – or, if really unlucky, by the weather – include putting armed forces or the whole population on 'red alert'. A 'red sky at night, shepherd's delight' and 'red sky in the morning, shepherd's warning' is weather-lore that has some validity in Western Europe where clouds often come in from the Atlantic. When the sky is red in the morning 'the East is red', but

this phrase has more significant political connotations due to the adoption of red as the colour of socialism and communism. This association spawned the 'red menace', 'red peril' and 'red revolution' together with Western fears of 'reds under the beds' and the alternate responses of being either 'better dead than red' or 'better red than dead'. Then, no sooner had the threat or opportunity for change from without receded, but threats or opportunities for change arose within, with the likes of the Italian 'red brigade' and the feminist 'Redstockings'. Of course, these political colour codes have limited shelf lives but they reflect much older social distinctions, such as the difference between 'red-blooded' working men and others, like the effeminate and the aristocratic or blue-blooded.

Sometimes red is understood relative to another colour. In twenty-first-century economics, the debt-averse try to avoid being 'in the red' and prefer being in the black, but in nineteenth-century literature, Stendhal's *The Red and the Black* referred to the Church and State. Red was juxtaposed with white in revolutionary Russia (Bolshevik and Tsarist) and these two colours often seem to be in conflict. Before the Bolsheviks and Tsarists there were, for example, the Houses of Lancaster and York (red and white roses) and before them, the Britons and Saxons (red and white dragons, according to Merlin).[1] Red is paired with blue in class-war or two-party politics (left and right), and with green in traffic lights (stop and go) and on power tools (off and on). At other times, red's meaning is an absolute. Sometimes red phrases have very literal meanings – among other things, 'red eye' can refer to conjunctivitis, a badly timed long-haul flight or a consequence of flash-photography. Yet again they don't have literal meanings but can refer to things that are not red, like the Red Sea (unless it is suffering a bloodbath or an algal bloom). Some reds don't even exist, like the 'red line' that must not be crossed.

One cannot generalize about the red in red phrases. And just as the quality of redness seems hard to pin down in language, so red also resists psychological generalizations. Red triggers different things in us at different times, but wherever it is, red often has shock-value. Red is associated with anger, shame, fear,

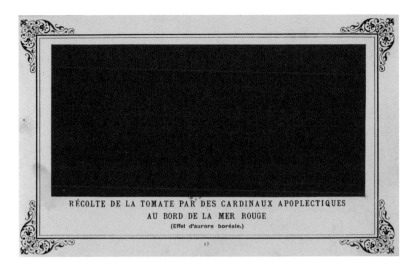

RÉCOLTE DE LA TOMATE PAR DES CARDINAUX APOPLECTIQUES
AU BORD DE LA MER ROUGE
(Effet d'aurore boréale.)

1 Alphonse Allais, *Apoplectic Cardinals Harvesting Tomatoes on the Shore of the Red Sea (Aurora borealis Effect)*, 1897, monochrome on paper. This contemporary parody of Impressionism significantly pre-dates the Abstract Expressionists' colour field paintings of the 1940s, '50s and '60s so it would seem churlish to insist that, usually, the Red Sea is not in fact red.

attraction and an extraordinary range of emotions. Given red's apparently mercurial character, can there be a common thread that runs through the colour? Is there, in fact, a 'red thread'?

Threads, herrings and lines

> The English Navy has a certain arrangement by which every rope in the Royal Fleet, from the stoutest to the finest, is spun in such a fashion that a red thread runs through it which cannot be extracted without unravelling the whole rope, so that even the smallest piece of this rope can be recognised as belonging to the Crown.[2]

Goethe made this observation, before the age of steel hawsers, in a novel he wrote around 1809 when in his late fifties. The book has an autobiographical element and unfolds the story of a relationship between a young girl and an older married man,

Eduard. The quoted passage appears when Goethe introduces his first extract from the young girl's diary, and he continues, 'similarly, there runs through Ottilie's journal a thread of affection and inclination that binds everything together and characterizes the whole.'[3] The story of Ottilie and Eduard has a faint echo of those other star-crossed lovers, Romeo and Juliet, since they are eventually united in death, sharing a vault made for two. Looking back through the diary, and indeed the whole novel, what initially seemed to be innocent comments and chance coincidences take on the appearance of prophetic, fateful premonitions.[4] Like the Royal Navy's red thread, the novel's theme of death was always present although it was often hidden.[5]

For two centuries, Goethe's 'red thread' has been a motif for recurrent themes, half-hidden harmless details and anecdotes that seem to pop up sporadically to ornament or decorate the whole, but which are actually inseparable from, and define, the bigger picture. This book hopes to find a unifying thread that runs through the story of red.

A much older 'red thread' can be found in the Eastern tradition and it refers to what drew Ottilie and Eduard, Romeo and Juliet, and indeed all lovers, together in the first place. This invisible elastic red thread joins soulmates and, depending on the individuals' life choices, it may stretch to breaking point or bind them inseparably.[6] The European tradition doesn't share this particular red thread, although it does recognize the effects on our relationships of the threads of fate spun by the Greek goddess Clotho, then measured and cut by her sisters Lachesis and Atropos. Apollodorus, Ovid and other classical authorities do not tell us the colour of these life-threads, yet the thread that first gives us life, the umbilical cord, is, or at least carries, red.

Today, the imaginary line-that-must-not-be-crossed could be any colour you like, so why is it a 'red line'? And the Royal Navy could have chosen any colour for the single thread identifying Crown property, so why did they choose red?

A survey of folklore suggests that red is by far the most favoured colour for protective charms. We could ask – do today's political and military strategists think that the redness of their

invisible lines might help protect their territories? And did the Navy chose a red thread to brand their rope and, at the same time, to protect their ships? In fact, the Navy's always-present, often-hidden red thread had much in common with the hidden red thread that the Irish wove into their horses' tails to protect them from the evil eye.[7] That particular practice has more or less passed away, but could the trendy red thread that briefly identified celebrity followers of the Kabala have been a more recent expression of the same desire for red's protection? Or are such practices merely 'red herrings' that throw us off the scent? (Red herrings are false leads or logical fallacies. The phrase probably originated in the use of a strongly cured fish to distract hunting dogs.[8])

Glimpses of the unifying red thread need to be sorted from possibly distracting red herrings, but the effort of sorting can bring its own rewards. In 1887 or 1888 (depending on whether you read it in magazine instalments or as a book), a fictitious 'consulting detective' claimed that 'There's the scarlet thread of murder running through the colourless skein of life, and our duty is to unravel it.'[9] The author, Sir Arthur Conan Doyle, evidently knew of Goethe's red thread. He had been a doctor before he created his hero, Sherlock Holmes, who relentlessly tracked down his quarry by applying medical methods to follow a trail of clues.[10] Conan Doyle sprinkled red herrings across his red thread and for over a century, readers and film and TV viewers have been entertained by Holmes's attempts to sort herrings from threads and unravel the evidence. This book tries to use Holmes's methods to pick up and follow a trail, crossing red lines where necessary along the way.

Sherlock Holmes used observation of facts (symptoms) and deduction from facts (diagnoses). This method sounds very rational and reliable but, as an ever-lengthening list of miscarriages of justice suggests, it is actually riddled with pitfalls.[11] Whether a fact is a clue – part of the red thread – or a meaningless detail – a red herring – depends to a very great extent on the hypothesis you are pursuing or the hunch you are following.

In the search for red's meaning, I will not be pursuing any hypotheses that depend on Isaac Newton's solitary activities in

a darkened room with triangular bits of glass. Those experiments eventually led to the colour being defined as a physical wavelength of light between 650 and 700 nanometres (nm). Nor will I be pursuing physiological definitions of red as a particular response of colour-sensitive 'cone' cells in the retina. Following those physiological definitions, what many scientific textbooks erroneously call the 'red' cone is most sensitive to light with a wavelength of around 570 nm. Now, 570 does not fall between 650 and 700 and, while these numbers may make sense when isolated in physics or physiology, the numerical mismatch between what is called 'red' when it comes out of a prism and what is called 'red' when it goes into the eye does nothing to help us understand our everyday experience of the colour. Under modern science's quantitative influence, colour becomes more and more confusing and, as the philosopher Wittgenstein noted, we 'stand there like the ox in front of the newly-painted stall door'.[12] Thinking of red as a limited range of wavelengths does absolutely nothing to help us understand the fact that (yellow) gold, (orange) flames, (brown) dogs, (ginger to auburn) hair, and more, can all be called 'red'. Also, historically, red and purple were often synonymous. For example, Shakespeare's Richard ii described the blood spilt in battle as 'purple testament' and 'scarlet indignation' in practically the same breath (iii, iii, 94, 99). The crucified Christ's loincloth was described by Matthew and Luke as red, yet according to Mark and John it was purple.[13] It seems that the term 'red' can cover more than half the Newtonian spectrum, excluding as it does only green and blue. Red's meaning is not to be found in individual things, whether glass prisms or living retinas.

The hunch I will be following assumes that meanings reside in the interactions between many things and many people. A 'red' that includes yellow, orange, brown, ginger, purple and even invisible things is evidently a very flexible and accommodating colour category, which – along with the litany of red phrases – suggests that considerable cultural significance is attached to the quality of 'redness'. I will therefore look for clues to red's meaning by focusing on the physical things that have provided, and still provide, people with red.

Very briefly, through chapters One to Five, I will review
the evidence and consider the biographies of reds extracted
from animals, vegetables and minerals as well as synthetic and
industrial reds. In Chapter Six I will look at the most recent
twist in industrial reds, the reds that come and go on electronic
screens. Chapter Seven very briefly acknowledges that, just as
red covers more than half the spectrum, the things that provide
it spread across the categories – like animal, vegetable or mineral
– with which we try to order our world. Chapter Eight considers
the meanings associated with red words and phrases. This
acknowledges the fact that the clues Sherlock Holmes sought
were not just physical, like weapons or footprints. They were
also psychological, like people's motives and their reactions to
unexpected revelations. In chapters Nine, Ten and Eleven I will
look at things that are traditionally described as red while actually
being a wide range of colours. They are, respectively, earth, blood
and fire. In the final chapter I will look to the sunset to try and
draw together the threads that run through these material and
psychological biographies.

However, before embarking on the biographies of some red
things, we need to establish that red can plausibly make some
claim to being a culturally important colour and that red things
have in fact been known and valued by many people. This can
easily be established by a quick survey of red make-up. The
survey also introduces many of the reds that will form the focus
of later chapters.

A brief history of rouge

The first use of rouge is lost in the mists of time but we can pick
up the story a few thousand years before Christ in either what
is now Iraq or Egypt. In both cultures, it was customary to
equip the dead with accessories for life in the afterworld and
these grave goods commonly included cosmetics. Red make-up
powders of the natural mineral haematite, otherwise known
as red ochre or simply 'earth', were often stored in convenient

cockleshells, which were found in the Royal Cemetery of Ur and in Egyptian tombs.[14]

In ancient Rome, women applied their rouge over a white foundation of lead white, clays or chalks. Modern authorities say that Roman rouge was made of cinnabar, vermilion or minium which, together with the foundation materials, were also used as pigments by Roman painters. Actually, none of the materials used in cosmetics were exclusive to cosmetics and many also had medicinal value. Ovid mentioned that fashionable women's cheeks were covered with 'poisonous compounds', which may have been the cinnabar, vermilion and minium listed by Pliny.[15] Yet they also used other, less toxic reds, including plant dyes like fucus and alkanet, rose and poppy petals and red chalks, as well as the red ochres found in Ur and Egypt's tombs.[16]

More exotic ingredients for red cosmetics included *crocodilea*, supposedly the contents of a crocodile's intestines. Galen mentions its use as a cosmetic and Pliny suggests that applying crocodile dung to the cheeks may not have been as unpleasant as one might imagine. This is because the contents of a crocodile's intestines were said to be fragrant, due to their habit of grazing on sweet-smelling flowers.[17] (Today, some cosmetics contain ingredients from similarly unappetizing sources, such as reds from algae.) However, recipes for cosmetics, like artists' recipes, were related to alchemists' recipes and in them things are not always as they seem. It has been suggested, for example, that *crocodilea* is an Egyptian code word for 'Ethiopian soil'.[18] Other earths and soils were highly prized for skin preparations and, according to Herodotus, Libya's was particularly red,[19] so perhaps *crocodilea* was actually the same haematite, red ochre or earth used by Assyrian and Egyptian women thousands of years earlier.

Pre-Roman Britain was renowned for bodily embellishment, and the tribal name Pict means 'painted', but the natives became Romanized and body painting only returned under the influence of German tribes. Then it was blue. By the Middle Ages, Britain's main cosmetic focus was on long hair and particularly on long red (natural or dyed) hair. When grooming of any kind was

censured it was usually for excessive hair-combing and plucking, although there were some attacks on the use of 'unnatural colours'. Rouge doesn't feature much in the earliest records of English cosmetics. It made its comeback after the Crusades when it was used to enhance the aesthetic of an English 'lily-and-rose' complexion.[20]

Shakespeare's Perdita in *The Winter's Tale* referred to 'streak'd gillyvors' (cross-fertilized white flowers with a splash of red) as 'nature's bastards'. She implied that, like rouged faces, they were an insult to Nature (IV, iv, 83–4). Perdita's anti-cosmetic, anti-rouge sentiment owed much to the different ways in which female and male artistic creativity were seen at the end of the sixteenth century. The rhetoric suggested that male artists acted in the image of God, the divine creator, while women's artistry – which included painting their faces – was condemned (by men) as a blasphemous counterfeit that challenged the natural order.[21] Men painted 'from life', depicting Nature, while women painted 'upon life', literally defacing Nature.[22] But of course, such rhetoric has to be seen as part of an ongoing war of words that is not necessarily to be taken at face value.

Elizabeth I's natural red hair reflected and reinforced the ancient British aesthetic. However, she may have interpreted her quintessentially English 'lily-and-rose' complexion in more politically charged terms. As a Tudor monarch, she could have seen her cosmetic combination in terms of the Tudor rose, in which the white rose of York was subsumed into the red rose of Lancaster. As her hair lost its youthful fiery glow, she dyed it red and then wore a succession of red wigs. She also rouged her cheeks and dyed her lips and her example was widely copied. In a letter that accompanied a portrait of herself that Elizabeth sent her brother, Edward VI, she warned that the picture's 'colours may fade by time'.[23] Many of them have indeed faded, or at least the transparent reds have, and today paintings of Elizabeth give a misleading impression of a stark, ghostly white figure, with little blood, let alone rouge.[24] Some of the reds that faded included dried cochineal beetles from Mexico, saffron from the Middle East and henna from India that, by the seventeenth century, were

being applied as make-up with crayons and pencils as well as with the powder brush.[25]

In eighteenth-century France, rouge was an invitation to love; for Casanova, and for Parisians in general, it was a marker of class – brighter reds were more aristocratic, like a badge that enabled access to Versailles. But while cosmetics defined the social cosmos (the words 'cosmetic' and 'cosmos' both come from the Greek 'to order'), they could also be used to 'make-up' a position in society. Well-established red signals could be subverted, so social positions no longer became just the mark of high birth, but could also be the result of highly skilled social performances. Such skilfully manipulated upward mobility has rarely bettered that of Madame de Pompadour, who became the official mistress of Louis XV. She was a great beauty and her portrait was painted many times, once by François Boucher at her toilette, in the tradition of artist's self-portraits. In the artist's self-portrait, the artist-sitter faces us as if looking in a mirror, with paintbrush in hand, and we see the back of the painting upon which they are apparently working. But in Boucher's portrait, Madame de Pompadour faces us, make-up brush in hand, and we see the back of her mirror. Her make-up brush is charged with a red powder that is the same as her rouged cheeks. It is also the pigment Boucher used in the painting to depict both.[26]

This painting of a self-made aristocrat applying make-up plays with ideas of social identity and representation. It also plays with the connection between paint and cosmetics. The materials that Madame de Pompadour used to paint her lips and cheeks were exactly the same materials that Boucher used to paint her painted lips and cheeks. In fact, around the time Madame de Pompadour was born, Jean-Antoine Watteau painted *Gersaint's Shop Sign*, which depicts aristocratic customers in an art-dealer's store full of paintings and mirrors as well as mirrored compacts and cosmetics.

As a direct response to the perceived artificiality of heavily rouged French cheeks, the English reinvented the idea of 'natural beauty'.[27] The eighteenth-century English reverted to a pre-Elizabethan aesthetic for the less-painted female face.[28] The

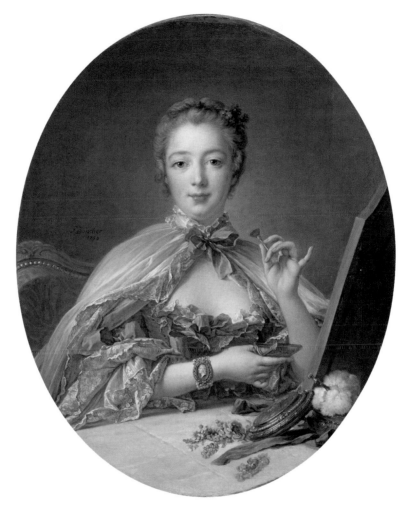

2 François Boucher, *Jeanne-Antoinette Poisson, Marquise de Pompadour*, 1750, with later additions, oil on canvas. A practically self-made aristocrat making herself up. The artist painted the image of her face with the same pigment that she used to paint her own face. This non-fugitive red had a millennia-old track record of use in cosmetics and in painting.

association of rouge with French fashion also accounts for why the English-speaking world still refers to red make-up with a French word. By 1850, the English manufactured precious few cosmetics, while in Paris alone over 700 people were employed making cosmetics (including an English chief chemist who made what was recognized as the finest carmine rouge).[29] Yet rouge was not absent from English make-up for long.

In the mid-nineteenth century, some rouges still used the poisonous compounds mentioned in the cosmetics of ancient Rome but, in industrial Victorian Britain, these heavy-metal

preparations had the added disadvantage of going black due to all the sulphur in the heavily polluted air.[30] This was a particular problem because make-up was a largely urban phenomenon, although even in clean country air fashionable women needed to know some chemistry in order to keep their complexions red. In the 1890s the *London Journal Fashions* felt it necessary to warn that 'a drop of ammonia will blacken any cosmetic containing mercury and many a face powder or rouge, harmless in itself, is rendered dangerous by the improper application of some new element, such as a perfume'.[31]

The Art of Being Beautiful, published in 1902, fought a rearguard action against rouge (along with other threats to feminine beauty, like the bicycle). By the 1920s, make-up was no longer restricted to cities and was no longer an indicator of class. And, to the long-serving dried beetles from Mexico and alkanet roots from Spain were added more novel synthetic reds from the chemist's laboratory, like the salts of Lithol red.[32]

During the Second World War, when international trade was disrupted and raw materials were diverted to the military, American cosmetics were still being manufactured. The *Science News Letters* of 1941 assured readers that there was

> no need to worry that American women will have to go back to nature, or rub beet juice on their lips and rose petals on their cheeks, à la Victorian grandmothers, the 1941 cosmetic prospects are for brighter and gayer faces. Shy colours of 1940 are giving way to patriotic reds.[33]

Industrial quantities of red make-up are used today, but since late twentieth- and early twenty-first-century fashions are so fragmented and fast moving, they no longer provide a manageable skein of threads upon which to try and hang a story of red. Some of the reds used in traditional make-up have been phased out; others went out of fashion and have now come back into fashion, and they have been joined by literally thousands of new reds. None of them is exclusive to cosmetics and the vast majority have multiple uses.

3 *Venereal Disease Covers the Earth: Learn to Protect Yourself Now*, 1940s lithograph after F. W. Williams. A warning to American servicemen about the dangers of sex with foreigners.

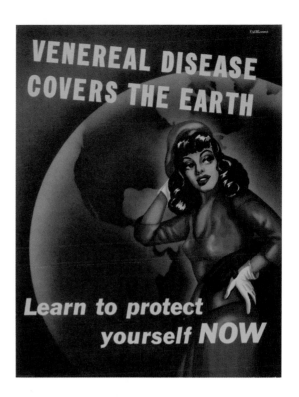

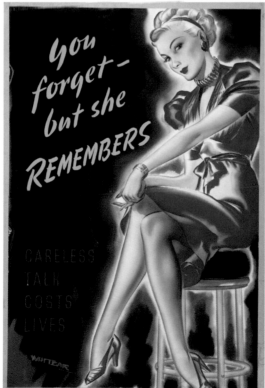

4 *You Forget – But She Remembers: Careless Talk Costs Lives*, gouache and watercolour by Whitear, artwork for a British Ministry of Information anti-rumour poster, 1940s.

Both these posters show wartime (scarlet) women wearing red lipstick that may be unpatriotic, a suggestion that there are two sides to red.

Yet why should Second World War America have considered red cosmetics patriotic? One possible answer – red is the colour of blood – comes from looking at the much older, slower-moving things that established the colour's cultural background. They include reds in the animal kingdom.

ONE

Animal Reds

\mathcal{A} NIMALS USE COLOUR to communicate. The female baboon, for example, uses her bright red rump to attract the interest of a potential mate. Yet nature is not simple, and in other animals red serves other purposes since, for example, both the male and the female robin have red breasts. The robin's red breast has also long attracted the attention of humans, for reasons best known to poets.[1] Red can also be seen in a fox's tail and in a cooked lobster. Animals may offer visible colours in their feathers, fur or shells, but they also have colours that are not on open display. Hidden animal colours include 'Indian yellow', which was extracted from the urine of a cow fed on mango leaves. 'Tyrian' purple and 'Tekhelet' blue were extracted from a gland in Mediterranean sea snails and, for millennia, similar colours were extracted worldwide from other molluscs. A rich, warm black was obtained from charred ivory or bones, while ground-up bones and shells provided soft whites. These sources hint at the great diversity of hidden animal colours. But most of them were red.

The most obvious red that animals offer is their spilled blood. The sacrifice of animals – providing a dramatic splash of colour at the appropriate point in the performance of a rite – has a very long history. In today's Eucharist, Christ's sacrificial blood has been transubstantiated into wine, although it is still usually red. These sacrificial reds are transitory since they are either drunk or cleaned away, just as real blood becomes rather unattractive if left lying around for too long. So, artists who have used blood in their work, whether historic or modern, probably did so for reasons other than its colour.

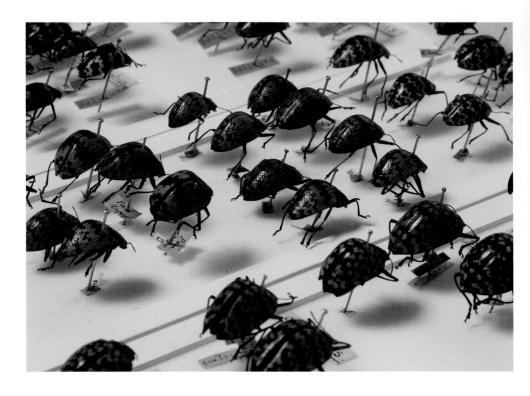

For example, at the time of writing, the British artist Marc Quinn is slowly producing a series of life casts of his head using nine pints of his own frozen blood. He made the first in 1991 and has since made five-yearly updates. The aesthetic effect is, not surprisingly, slightly chilling and the blood is seen through a thin cracked layer of ice so that its value is more conceptual than colouristic.[2] (Whatever that value may be, it changed significantly when the first head – bought by Charles Saatchi for an alleged £13,000 – melted after the freezer in which it was kept was unplugged by builders extending Nigella Lawson's kitchen.[3]) In European art, blood, from a variety of animals and humans, has usually played a symbolic or supporting role.[4] Blood was one of the many ingredients used to dye cloth red and while its use was outlawed in Venice in 1413, it still appeared in recipes for textile dyes well into the nineteenth century.[5]

However, the most culturally important animal-based reds were from rather unlikely sources. Perhaps surprisingly,

5 Some regimented red bugs whose lives were taken in order to delineate species' borders.

an extraordinarily significant red was extracted from rather insignificant-looking scale insects, shield lice or mealybugs. European culture is generally ill-disposed to insects, yet a range of spectacular reds is one of the three great gifts that insects provide, the others being honey and silk. Glorious red-bearing bugs have long been valued – the insects themselves and the cloth they dyed were booty in conflicts between East and West and between the New and Old Worlds. Yet more importantly, as diplomatic gifts and items in bridal dowries, they have also helped cement relations between diverse cultures. In the early thirteenth century, for example, Tsar Boril of Bulgaria gave his stepdaughter to the Latin emperor accompanied by sixty pack animals carrying gold, silver and jewels each covered in, and trailing, luxurious heavy red silk samites.[6] The most important red bugs were Indian lac (*Lakshadia spp.*), Armenian red (*Porphyrophora hameli*), kermes (*Kermococcus vermilis*), Polish cochineal (*Margarodes polonicus*) and American cochineal (*Dactylopius coccus*).

Indian lac

Lac insects are found across wide areas of southern and southeastern Asia where they live, both wild and domesticated, on a variety of host trees. After breeding with the males, the females congregate and exude a sticky resin that completely envelops them and their host plant. Twigs encrusted with a sticky mass of immobilized insects are broken off to sell as 'stickle', which is crushed and repeatedly sieved to remove wood splinters and insect body parts. A fourth-century BC Indian treatise on statecraft, economic and military strategy mentions the use of lac as a medicine as well as a dye. Mixed with honey, it apparently resuscitated those suffering from exhaustion.[7]

Cultivation of the insect probably started in Cambodia and it rapidly spread, along with the red it produced. Its use has been identified in Greco-Roman Egyptian paint and late Antique textiles from Egypt.[8] It is among the dyes and pigments

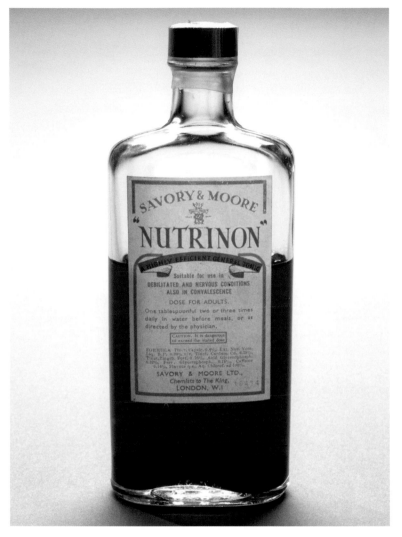

6 'Nutrinon', a 19th-century over-the-counter cordial tonic from Savory & Moore, London. The medicine's colour owed much to Arabic and medieval *confectio alchermes* (a heart tonic) and the ingrained cultural connection between red and health.

mentioned in northern European Anglo-Saxon paint recipes dating from the eleventh century.[9] In the Middle Ages, the red dyestuff was traditionally extracted directly from the sticky mass using alkalis, and artists' manuals recommend slowly cooking finely ground lac in one of the most widely used traditional alkalis – stale de-frothed urine.[10] Other materials, like the red resin varnish and adhesive shellac, can be extracted from the sticky mass by using alcohols.

In the mid-nineteenth century, England was importing more
than 300 tons of insect sticklac a year. At the end of that century,
William Morris described it as 'hot and not pleasant' but 600
years earlier, St Faith's chapel in London's Westminster Abbey
was painted generously with Indian lac.[11] The other pigments
used in this particular paint scheme – which include a blue worth
its weight in gold, ultramarine from Afghanistan – suggest that,
unlike William Morris, Henry III considered lac a very desirable,
high-status red.

Armenian red

Another scale insect, shield louse or mealybug that immobilizes
itself on a host plant when pregnant can be found on the roots of
grasses that grow in the flat valley floors around Mount Ararat,
which, at the time of writing, is in Turkey near the Armenian
and Iranian boarders. The oldest documentary evidence of the
use of this red as a dye is in the list of treasures plundered from
Muzazira by Sargon II of Assyria in 714 BC, which included
'scarlet textiles of Ararat and Kurkhi'.[12]

The Armenians were renowned traders and the area in
which the insect was harvested straddled the great east–west
trading routes – Azerbaijan, Armenia and Georgia formed an
overland corridor connecting the Caspian and the Black Seas.
The insect and its red dye were mentioned by Arabic historians
and philosophers, as well as by the Spanish traveller and diplomat
Ruy Gonzáles de Clavijo when on his way to Samarkand in 1404.[13]
Because Armenian red was harvested in a busy transglobal trade
corridor, its use was probably extremely widespread, but it is hard
to find unambiguous reference to it in the historical records. This
is in large part because of its name, which causes some confusion
with another red dye-producing insect.

The Armenian name for the insect was *garmir*, from the
Pahlavi *kalmir*. It is the origin of the Hebrew *karmil*, Polish *kirmis*
and eventually the English word kermes.[14] All have their root
in the Persian *kirmiz* and Sanskrit *kirmira*, meaning 'worm' or

'engendered by a worm' – in Latin, *vermis*. The source of red might superficially appear to be berries growing on trees or grasses, but it is clear from these names that the exact biological origins of the colour were known from a very early date. However, the name's generic nature means that written evidence of Armenian red's historical use has been swallowed up, in the European mind at least, by a red from a different but related insect.

Mediterranean kermes

Kermes insects lived on a type of evergreen oak that grew naturally around the shores of the Mediterranean. As the host of a red-producing insect, the small shrub-like oak was highly valued and Tiglath-Pileser I introduced it into Assyria by around 1100 BC.[15] Although the reason for transplanting the trees outside their natural range was not recorded, it was almost certainly to support a local population of kermes insects. Greek and Latin authorities appear slightly less confident about the exact nature of kermes. In the second century AD, Pausanius described it as a small creature that 'breeds in the fruit' of the kermes oak, rather than as a small creature that grows inside its immobilized mother on a kermes oak.[16] Uncertainty about this red's origins endures, in some quarters, right up to the present day.

The earliest reference to kermes is the record of it being taken by a Phoenician merchant to northern Iraq in the middle of the second millennium before Christ. The Phoenicians also took it to Egypt before 1000 BC. Around the time of Christ, Pliny said that kermes-dyed clothes 'rival the colour of flowers' and noted that they were reserved for the military. Pliny also reported that kermes was widely cultivated all over the Mediterranean and that half of all the tribute paid to the Roman Empire by Spain's population consisted of dried kermes beetles.[17]

Kermes was also used in food and drink. Caves in the south of France provide evidence of Neolithic red kermes-dyed textiles and meals of mixed meat, barley and kermes.[18] It was almost certainly not in the mix as a mere food colourant. Thousands

of years later, Sumerians, Phoenicians and Greeks also had kermes in their diets, and its role was mainly medicinal. Dioscorides and Pliny also record kermes' use as a poultice, ground up in vinegar and applied to wounds to speed healing.[19] Later still, the medical schools of Baghdad turned kermes into a heart tonic, *confectio alchermes*, which by the thirteenth century had become extremely popular throughout Europe through Montpellier's famous medical school.[20] Its recipe originally used all of the three insect gifts – the kermes was extracted from a length of dyed silk and the extract was sweetened and boiled down until it had the consistency of honey. In Europe, variants on the *confectio* recipe became known as 'cordials', literally, medicines for the heart. The cordial often included exotic additives; for example, the *alchermes* confection given to Elizabeth I's ambassador in France also contained musk, powdered amber, gold, pearl and unicorn horn.[21]

Kermes was not unusual in that it could be added to food for colour or flavour, and that it could be used as a medicine but also as a dye or pigment. Many things were at one and the same time spices, drugs and colours, and they could all come from the apothecary. In the international import and export centre of Venice, pigments only came from specialist artists' shops from the late fifteenth century.[22] Elsewhere, apothecaries stocked a mix of spices, drugs and colours, right up to the seventeenth century. The millennia-old tradition of using red insects in medicine had a strong influence on the perceived significance of the colour red. A connection with health is a glimpse of the red thread that runs through the colour.

In the mid-eighteenth century, the Dominicans of Santa Maria Novella, Florence, turned the kermes *confectio* into a red alcoholic liqueur called Alkermes. Its success probably prompted the development of another red alcoholic drink.[23] However, this drink, Campari, used a different scale insect, shield louse or mealybug, to provide its colour – cochineal. Two main types of this red-bearing insect were exploited, one from the Old World (Africa, Asia and Europe) and the other from the New World (the Americas).

Old World cochineal

Cochineal has probably been known in the Old World for as long as kermes and Armenian red, which it usurped as the most prestigious red in Western Europe around the late Middle Ages. This particular insect attached itself to the roots of a grass, like Armenian red, and was cultivated in a wide swathe from Sweden, Poland, Central and Eastern Europe to western Siberia and almost as far south as the Black Sea. Its host plant was a knotgrass widely known as *knawel*, a word which is probably of Swedish origin.

The pregnant insect released its young around the summer solstice, traditionally marked by the feast day of St John the Baptist, on 24 June. The harvest involved lifting the plants, which liked sandy soil, and gently picking most of the up to 50 insects off the roots. The knotgrass was then replanted with a few insects left to breed for next year. The picked insects were killed, by exposure to vinegar fumes, dried and traded as 'St John's blood'.[24]

Chemical analysis has identified the dye in Hellenistic-Roman textiles from Egypt and Syria, and St John's blood, or 'Polish cochineal', may even have made its way to China.[25] The oldest surviving mention of it in the West is in the ninth century, when the dried beetle was demanded as rent and tithe, a custom that continued for 500 years. The plant, insect and dye are mentioned by herbalists and medical botanists through to the seventeenth century and, by the eighteenth century, it was still important enough to be considered as a subject worthy of a place in the *Philosophical Transactions* of the Royal Society of London.[26] However, from the mid-sixteenth century onwards it was gradually being eclipsed by New World cochineal, which was much easier to harvest, was available in much greater quantities and was therefore significantly cheaper.

New World cochineal

That other cochineal lived in Mexico and Peru. When the Spanish landed in the New World, they found the insect being systematically harvested by the indigenous inhabitants who had already been using it for nearly 2,000 years.[27] Just as the Old World red-dye insects had medicinal value, so the Aztecs also used their cochineal as a medicine, some of which Francisco Hernández brought back to Europe, where he was physician to Philip II.[28] And, just as the Old World insects were used as tithes and tributes, so too were the New World insects. (Between them, the Tlaxiaco, Coixtlahuaca and Cuilapan provinces gave 4,420 kg of dried beetles to their rulers in 1511–12.) Again, just like the Europeans, New World women also used cochineal as a cosmetic. One of the earliest Spaniards in Mexico commented enthusiastically on the range of red-dyed fabrics available in local markets, comparing them to the silk markets of Granada, only bigger.[29]

The Spanish quickly recognized that this New World cochineal was superior to their own, now Old World, cochineal since each individual insect contained more colour. It is not known whether the insects were naturally well-endowed with red or whether centuries of selective breeding had made them so. But either way, New World cochineal beetles were domesticated and quite different from their wild relatives, which lived outside the plantations.

Conveniently, the New World cochineal lived above ground on a cactus. The main host, a prickly pear, also known as Indian fig, was first cultivated for its juicy fruit, but later its parasitic insect – which might, in other circumstances, have been viewed as a pest – became much more important. The prickly pear's size and sharp spines made it a natural plant for establishing defensive enclosures and it was also used as a source of food and medicine.[30] Everything was done to help the cacti support the insect. Plots were prepared with fertilizers (wood ash, guano, household waste), plantations were protected from wind and

rain, fires were lit when frost threatened, individual plants were
cleaned regularly, they were rested every two or three years,
old plants were propped up with poles and replaced after ten
or fifteen years. The insect's enemies – from spiders, rats and
lizards, through to turkeys, snakes and armadillos – were strictly
controlled.[31]

The domesticated insects were ready for harvesting after
90–120 days so the same host plant might support two or three
harvests a year. The fully grown insects, which were up to the size
of a kidney bean, were gently spooned off the cactus. Some were
killed and dried to be sold for dyestuff or to pay tribute to the
powers that be. Others were used to reseed the cacti, transferred
in man-made nests or picked up gently with a fox-hair brush and
painted back onto the host.[32] Initially, the Spanish government
did little to encourage exploitation of this ancient American
practice but the plantations were soon scaled up, some by
Dominicans seeking an income to support their missions.

When dried, the beetles looked like shrivelled berries or
peas and were called 'grains'. Cochineal-dyed red cloth, in which
the dye could cost more than the cloth, was called 'ingrained'. Our
word for firmly fixed or well-established beliefs or habits comes
from the permanent bright red that was an integral part of the
most expensive cloth that money could buy.

The first shipment of dried Mexican beetles arrived in Spain
in 1526. Imports quickly increased – 72 tons were shipped from
Peru in 1578 – but while the Spanish exploited the insect, they
did not initially recognize its potential and it had very little
impact on the dyeing of cloth across most of Europe for the first
25 years or so. However, by the 1550s the beetles were reaching
England, by 1564 an annual flotilla was established between
Mexico and Spain, and by 1600 the Spanish imported over 13
tons per annum of dried beetles from Mexico.[33] Anglo–Spanish
commerce was hampered by a relatively desultory war between
1588 and 1604, but by 1613, a survey of the English county of
Suffolk indicates that twenty ships were employed to supply the
local dyers who consumed one-seventh of the annual Spanish
shipments of cochineal. By the 1620s, Spanish New World

7 Cochineal
cactus (*Nopalea
cochinillifera*) and
insects, including
the source of red dye
(*Dactylopius coccus*).
Coloured etching by
J. Pass, after J-E. Ihle
(1801).

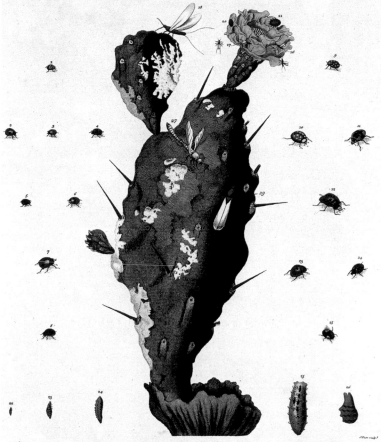

*Fig 1.to 15. different Species of Coccinella. Fig 16.to 21. male and female Coccus.
Fig 22.to 27. the Insect supposed to feed on the Coccus.*

cochineal was even traded (by the Dutch) up to the Baltic states, Western Europe's main source of Old World cochineal. Records of taxes imposed on ships passing through the sound between Copenhagen and Malmö suggest that individual cargos were worth in excess of £1,200.[34] New World cochineal was a very high-value item and traders from a variety of European nations took it to Turkey, India, the Philippines and China throughout the seventeenth century.

After a slow start, over the course of just a few decades New World cochineal changed traditional dyeing practices across

31

Europe and had a significant impact on red cloth in much of the rest of the world. But, much more importantly, it was one of a tiny handful of commodities – second only to New World silver – that determined the way in which the whole world now trades. New World cochineal slotted straight into the position that had been occupied for over a millennium by Old World cochineal, kermes, Armenian red and sticklac. The demand for red clothes and the appropriate craft and trade infrastructures were all well established, but the supply routes and the scale of trade suddenly changed. All European nations tried to control the flow of New World cochineal, to benefit from it and at the same time to protect themselves from the damage it inevitably caused to the ways of life it supplanted. The newly born mercantile economy had to cope with five similar red dyes, each of which had fluctuating supply and fickle, fashion-driven demand. New import and export controls were implemented, new monopolies and privileges granted, and new taxes were imposed on raw materials, on processed materials and on finished goods. For example, the Spanish banned production of luxury fabrics in the Americas and, for 250 years, there was an embargo on the export of live insects from the Americas.

Many of the fledgling trade policies were either ineffective or counterproductive. And people's responses to them were, as always, creative. One important aspect of early trade in New World cochineal, in which the English were particularly active, was piracy. Elizabeth I approved the harassment of Spanish ships, and pirates (according to the Spanish) or privateers (according to the English) paid regular customs duties when unloading their spoils in England. Records of these cochineal duties, as well as court cases about failure to pay them, mean that many sixteenth- and seventeenth-century English pirates or privateers are known by name – Richard Greenfield, Peter Begleman, John Hawkins, Robert Flicke and John Watts were but a few. Even the poet John Donne was involved in the crime or trade (depending on your allegiance) when he sailed to Cádiz with the Earl of Essex. He evidently drew upon personal experience when he featured 'pirates' and 'weak ships fraught with cochineal' in one of his *Satires*.[35]

The fate of one cargo in 1607 gives a flavour of the complexity of early New World cochineal trade. A group of Flemings loaded Mexican cochineal onto the *Pearl* in Seville and set sail, only to be captured by English pirates who were acting on behalf of the Dutch. The ship and its cargo were taken to the Barbary Coast (to avoid paying customs) and sold to Jewish merchants who were capitalized from Portugal. The cargo was loaded onto the *Jonathan* to be taken to England but was transferred en route to the *Peter*. When the *Peter* reached London, its cargo was officially declared and the English pirates, privateers or speculators paid a tax of £907. They then promptly sold the beetles for nearly £3,000. At this point the original shippers sued for recovery of their lost cargo.[36] European piracy was eventually controlled, not by military might, but by changing the rules of international commerce.

The prize of New World cochineal also motivated explorers. Richard Hakluyt instructed Martin Frobisher to look for cochineal, and finding it was one of the stated objectives of

8 Dried metallic-looking cochineal beetles or 'grains', with just a faint hint of the redness for which they were farmed and traded. Each of these beetles is about 3–5 mm across.

founding the colony of Virginia in 1609. Spain recognized the advantage of possessing Mexico and protected her advantage by cloaking the red dye's origins in mystery. According to a description from 1599, the cochineal insects grew like peas in a pod, and were harvested by cutting the stalks and threshing before replanting some. Such misinformation made New World cochineal production one of the best-kept trade secrets of all time, defying even the best efforts of scientists in London's newly formed Royal Society.[37]

The arrival of New World cochineal in Europe coincided with the disintegration of the guild systems and the mass migration of dyers from Flanders in the wake of religious wars. Refugees established new centres for dyeing and the movement of highly skilled peoples all around Europe helped disseminate new techniques. Cornelis Drebbel, for example, moved from Holland to East London and brought with him an improved way of dyeing which helped in England's early industrialization.[38]

The arrival of highly desirable New World cochineal in Europe at a time of social upheaval meant that this particular little red insect had a disproportionately large impact on world history. The lessons that Europeans learned in the sixteenth and seventeenth centuries, as the Old World grappled with the flood of dried New World 'grains', are now deeply 'ingrained' in the global market.

TWO

Eastern Trees

RED IS A DEEPLY MEANINGFUL natural signal. But since most of us no longer live in the natural world and we get our food in supermarkets, many of us have forgotten how to read nature's signals. Now, we need newspapers and magazines to tell us that red fruit, berries and vegetables are especially 'good for you' and that the deeper the colour, the better they are. Their redness comes from molecules called anthocyanins, carotenoids and lycopenes, which also happen to be potent antioxidants. When eaten, these reds mop up the free-radical oxygen floating around our bodies that, left to its own devices, would otherwise accelerate our ageing.

This might sound new, but 'an apple a day keeps the doctor away', so the saying goes, and the practice, if not the explanation, has evidently been around for generations. And recent research suggests that birds also know it. The more red anthocyanins there are in fruits, the darker their colour and the more attractive they are to birds. Lots of anthocyanins can make fruit look purple or even black, but when you squeeze it, it's usually a red that oozes out. Some plants rely on birds to disperse their seeds, which germinate after passing through them, and they appear to select fruit by colour. Seed-dispersing birds are more likely to select darker red fruits that display the presence of lots of antioxidants. So, by picking deep-red fruit, birds have a healthier diet, and by making deep-red fruit, plants improve their seed dispersal.[1]

Focused scientific research always encourages neat and tidy conclusions, but of course real life is always much more complicated. For example, broccoli is also 'good for you', but it's

not red. And deadly nightshade berries are red but, as their name suggests, they are not necessarily quite so good. Other research has shown, as if we didn't already know, that there are many factors at work in the selection of fruit by those who want to eat them, and that plants that want help distributing their seeds have many different strategies.[2] In the nineteenth century, Charles Darwin suggested that flowers were sex organs designed to lure insects to aid pollination, and this has led to the idea that flowers are like commercial 'brands' or 'logos', while bees behave like advertising-savvy shoppers in a busy marketplace. This model may resonate with contemporary ideology, but other research shows that the reasons for, and meanings of, flowers' colours are still a complete mystery.[3]

Plants are an obvious source of colour, and roses, for example, have always been enjoyed for their redness. Yet the fate of the rose's red is intimately tied to the fate of the rose itself. Individual rose petals can carry the colour and can be used as confetti (each pink petal in a dog-rose is a perfect heart shape) or to colour food and drink but, one way or another, the colour will be gone in a few days. Left on the rose, the petals will last a bit longer, but they still eventually wilt, fall and fade. Even when dried and pressed, most

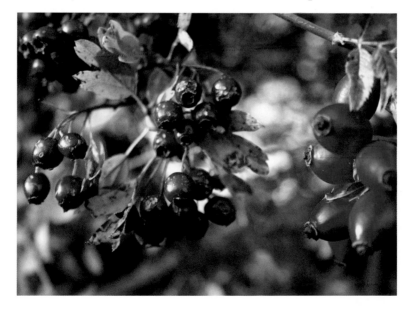

9 Reds and health: hawthorn and rosehip. Rosehips were traditionally collected and conserved as a winter source of vitamin C. Hawthorn berries were also a popular source of nutrients but have recently been called poisonous (their pips contain cyanide, like apple pips).

10 Reds and health: a lone belladonna. Deadly nightshade is a poison but has a long history of use in medicine.

of the colour goes. The spectacularly solid-looking reds of apples, strawberries or tomatoes are also only temporary as fruit too is bound to rot unless eaten, whether picked or left on the plant.

The obvious reds that nature provides in the vegetable kingdom have to be appreciated in their own terms – and those terms are strictly time-limited. Yet those limitations are part of their charm and the passing nature of beautiful fruit and flowers was explored in the seventeenth-century Dutch tradition of *vanitas* paintings, where transience was celebrated in works of art that were made, paradoxically, to be as enduring as possible. In such works of art, a red flower cannot be painted with material extracted from a red flower – the red cannot be transferred from petal to painting.

Those who wanted more permanent reds from the vegetable kingdom had to look for much less obvious sources. And even they were scarce, which added value to any usable source of red, as well as adding to the status and mystery associated with the colour itself.

The first few of the traditional plant reds we will consider here are not permanent – they slowly fade when exposed to the light. Nonetheless, due to the dearth of permanent, or 'fast', reds,

even these slowly 'fugitive' reds have very long histories of use. Quite how long they have been used cannot be known because the evidence has literally faded away. They may have been used alongside dried beetles (which, being more durable, have survived in the archaeological record) by Palaeolithic painters, but we can only go back with confidence as far as the oldest written records.

In humankind's quest for reds, which seems to have left no stone unturned, the first vegetable source that we will consider – a lichen – may actually have been on a stone that was overturned. In a modern urban environment, lichens are probably most familiar as the delicate, dry, overlapping rosettes that encrust old tombstones in graveyards and grow on undisturbed walls or trees. They generally do not look like very promising sources of colour.

Lichens

Lichens are not simple plants. They are cooperative partnerships between two organisms (fungi and algae) that grow together very slowly but can live in the coldest tundra or the hottest desert. Arctic lichens have long been grazed by reindeer, and in times of need in Scandinavia and North America, 'bread moss' and 'rock tripe' lichens have been part of recent human diets.[4] Lichens tend not to have particularly spectacular colours, and their hidden colours only become obvious when they are dried, crushed and treated with acids like vinegar, or alkalis like urine. These colour-making vexations can occur naturally and anyone who relieved themselves on a sunny, well-trodden, lichen-covered rock could discover these colours. The fact that vegetable colours could change – in urine or vinegar – was a source of fascination for seventeenth-century scientists, but it was already known to medieval illuminators who used a range of turnsole dyes.[5]

One of the earliest records of a lichen as a source of red is a Roman-Egyptian papyrus that describes 'archil' and its use in dyeing wool scarlet-red or red-purple around the fourth century AD.[6] There, archil-dyed wool was described as 'snail coloured', which suggests that it was used as a substitute for the

extraordinarily precious Tyrian red-purples extracted from the
Murex snail. Tyrian purple was extremely expensive and all aspects
of its use were strictly regulated – illegal possession could be a
capital offence, and mixing other dyes with it could be punishable
by amputation – so the Byzantine craftspeople who used these
archil recipes may have done so at some considerable personal risk.
(A millennium after these recipes were written, true Tyrian purple
became completely unobtainable when Constantinople fell and
cardinals' robes turned from purple to red.)[7]

In northern Europe, numerous lichen dyes were used in
Anglo-Saxon textiles,[8] and by the early fourteenth century, another
red lichen dye, 'lacmus', was exported from Norway to Germany
and England. Around the same time 'orchil', which may be the
same as the ancient Egyptian archil, was processed in Florence
under such secrecy that a near monopoly was maintained for
almost 300 years. The eighteenth century saw more varieties of
lichens used for dyeing, including 'parelle' in France and 'cudbear'
in Scotland.[9] Specimens of the red-dye lichen from Sri Lanka
were displayed at the Crystal Palace Great Exhibition of 1851, at
which time it was worth the princely sum of £380 per ton.
England was still importing over 180 tons per annum in 1935.[10]

In the 1940s, local lichens were still being scraped off coastal
rocks in Scotland to dye wool for Harris tweeds. However, it was
reported in the *National Geographic Magazine* that 'fishermen
do not use this colour while in their boats believing that what
was taken from the rocks will return to the rocks'.[11] Presumably,
dyestuffs appropriate for sailing clothes would include reds
and purples extracted from whelks, the local equivalent of the
Mediterranean's more famous Tyrian dyes.

On the Scottish islands, early twentieth-century womenfolk
wore bright red petticoats and woollen shawls dyed with madder,
sourced from plant roots.[12] But their menfolk had an aversion
to wearing a land-sourced colour when out on the waters. Their
choice indicates that, only a few generations ago, a person's
awareness of a colour's origins – together with their belief in the
interconnectedness of nature and its influence upon one's own
fate – determined the way in which they used colour.

Sometimes, beliefs about the source of colour could even mean that it was never used at all. In Scandinavia, for example, where practically everything from the forest was harvested, from lichen upwards, a perfectly good source of red was completely ignored. The source in question was the mushroom *Cortinarius sanguineus*, known in Swedish as 'blodspindling' and in English as the 'blood-red webcap' mushroom. The name suggests that even though they didn't use it, people knew about the colour that could be extracted since, in passing, the mushroom doesn't

11 Blood-red webcap mushrooms (*Cortinarius* spp.) in the wild.

blood red web cap

12 'Blood red web cap' calligraphy on reindeer parchment, in gum arabic, by Penny Price. Mushroom extract provided by Sigrid Holmwood.

look particularly red. Traditional Swedish reluctance to use the colour came from the folk belief that mushrooms – which appear overnight as if by magic – were associated with trolls, and no sensible Nordic forest-dweller would want to risk upsetting a troll.[13]

Dragonsblood

Another plant-based red also had a strange mythical origin, although this particular myth actually encouraged the use of a red that was rather disparaged – on practical grounds – by at least one fourteenth-century artist. Cennino Cennini said, 'leave it alone and do not have too much respect for it, for it is not of a constitution to do you much credit.'[14] Dragonsblood did the artist little credit because it faded; nonetheless, it was used for millennia. It appeared in the same Egyptian papyrus that featured archil, where it was recommended in a recipe for treating crystals to imitate ruby.[15] It was also used into the nineteenth century, mainly as a lacquer on gold, as a paint glaze and in reverse glass painting.

According to Albertus Magnus in the mid-thirteenth century, 'medical men' said that dragonsblood was the 'juice of a certain plant'.[16] However, the origins of dragonsblood were not recorded in herbals, where one would expect to find stories about plants and plant products. Its origins were recorded in bestiaries, which transmitted animal lore. There, the red stuff was said to be the mixed, coagulated blood of a dragon and an elephant.

Dragonsblood was allegedly found by a tree where a dragon had ambushed a passing elephant. The dragon hid in the tree and dropped down onto the elephant's back, coiled around its prey and tightened its grip until the elephant suffocated. In its death throes, the elephant inevitably fell and crushed the dragon. This was always a fight in which both beasts died.

We may not find the story of this particular red very plausible, but that would be because the modern world is inclined to take things literally while the story is meant to be taken allegorically. The tale was often found in technical contexts – like making dyes, pigments or imitation rubies – so it was actually like a modern 'thought experiment'. In the twentieth century, when Einstein talked about riding on a beam of light looking at his reflection in a mirror he held in front of him, nobody took him literally. Einstein's *Gedankenexperiment* was merely intended to illustrate his idea about the speed of light being relative to the observer. Likewise, dragonsblood's origins were a 'thought experiment' and the story it described was the creation of everything. It was a mythological elaboration of the biblical 'In the beginning, God created the heaven and the earth' (Genesis 1:1).

The protagonists' attributes – the elephant's long memory and the dragon's hot blood, for example – identified them as

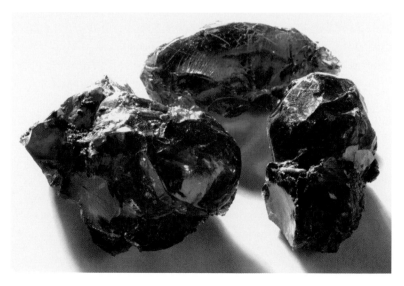

13 Dragonsblood resin, looking not unlike the fictitious version of the Philosopher's Stone featured in the first of the *Harry Potter* films, 2001.

the two principles that underlie all reality. They are mythical personifications of Aristotle's 'form' and 'matter', and their mutual destruction and transformation illustrate how all things that exist have some 'shape' and are embodied in some 'substance'. The legendary tale is an exploration of the ancient Greek concept of hylomorphism.[17] It was entirely appropriate that such a fundamental cosmic story should be associated with a red material. Dragonsblood's story may be strange but, in the search for a red thread, it is no red herring.

The story was told by Pliny in the first century, was illustrated in numerous bestiaries through the Middle Ages, and featured in seventeenth-century treatises on alchemy. The story endured because of its graphic power and philosophical elegance, even though everyone knew where the red stuff actually came from. The Roman-Egyptian papyrus recipe for imitation ruby, for example, described dragonsblood as the 'sap of balsam tree, resin of Palestine'. Dragonsblood could actually come from four species of tree and was originally imported from Southeast Asia. It came from the Orient – like the insect red lac – and was an early sign of the riches of the East that, centuries later, encouraged intrepid European explorers to 'look further to the East, whence the Light of the Sun, and Arts, have seemed first to arise to our World.'[18]

Later European explorers looked for a passage to the East by sailing west, and they consequently discovered trees that yielded dragonsblood in the New World.[19] And dragonsblood, it turns out, was not the only plant-based red to come into Europe, first from the East and then from the West.

Brazil

Although we now think of Brazil as the name of a country, it was originally the name of a red dye extracted from the Sappan trees of Southeast Asia. The red dye 'brazil' is recorded in the list of goods imported into London as early as 1233.[20] According to the *Oxford English Dictionary*, the red dye's name is thought to have come from the French for break (*briser*), crumble (*brésiller*) or

glowing coal (*braise*, as in brazier). The name's possible origins are all consistent with the nature of the raw material, which had to be broken and crumbled to release a red that was the colour of a glowing coal. While dragonsblood was a resin that oozed freely from a wounded tree, brazil had to be extracted from the unyielding timber itself.

Red woods were imported from the East for centuries and, when the New World was colonized, other red-bearing trees were discovered and quickly exploited. The area in South America where they were first found, Brazil, was named after the red dye, just as neighbouring Argentina was named after its greatest natural resource – silver, or 'argent'. (An enigmatic island west of Ireland, which disappeared from maps in the nineteenth century, was also called Brazil, but it probably did not owe its name to the red dye. If its name came from the Old Irish, it would mean beauty or strength, but its red connotations were entirely appropriate for an island in the west, like the sun-set red isle 'Erytheia', from which Heracles stole Geryon's 'red cattle'.[21]) As late as 1724, the lure of profit from brazilwood was still used to entice investment in the state of Pennsylvania (literally, Penn's forest).[22]

All aspects of using brazilwood were highly labour-intensive. Chopping down trees and chipping up wood was much harder work than picking insects and drying them. When the New World redwoods were exploited, most of the work was done by slaves but, because it faded, rasping the wood to make wood chips and powder was best done immediately before using the red as a dye, rather than before shipping it across the world. So, in the seventeenth century, the Dutch – who were at the time the greatest trading nation and also had Europe's best textile-dyeing industry – started processing brazilwood in Amsterdam.

Amsterdam had several prisons or *tuchthuizen*. In an all-female prison, the Spinhuis, inmates spun and wove and, in 1602, the all-male Rasphuis was granted a monopoly to rasp brazilwood. The task was undertaken by the stronger inmates and most serious offenders, and the system of hard labour was meant to make the prison self-supporting. The prison authorities had contracts with all the city's major dyers to supply this exclusive

Brazil, extr Alum / K_2CO_3

14 The brilliant (but fugitive) red of freshly ground and filtered brazilwood extract.

and expensive red. However, the Rasphuis had to compete with windmills where brazilwood was broken down and ground up illegally. The windmills' colour undercut the prison's colour and despite regulation and the prosecution of dyers, eventually the Dutch processing of brazilwood with forced labour proved unsustainable. It ended in 1766.[23]

Even after all the hard work of extracting the red, everybody knew it would soon fade. In the sixteenth century it used to be called 'false' and 'deceitful',[24] and before that, 'Paris red' was banned in the Munich painter's guild of 1448 because it was believed to be made of fugitive brazilwood. In fact, recipes

suggest that Paris red could be made from brazilwood, madder, kermes and lac, so the permanence of that particular commercial brand would vary from batch to batch.[25] Only one traditional plant-based red did not fade. It has always stood out from all the rest. While the various insect reds constantly jockeyed for position in the marketplace, madder always was, and still is, the pre-eminent plant-based red.

Madder

Madder red comes from a family of plants that is found, both wild and cultivated, all over the world. The most important is *Rubia tinctorum*, but many others have been used for their reds. The plant, which can grow to nearly 2 m in height, is native to western Asia. It spread into southern Europe very early and was introduced to Spain by the Moors. It became an important crop in the Netherlands in the sixteenth century, then in the south of France in the seventeenth and in Alsace by the eighteenth century. Above ground, there is absolutely nothing about the plant to suggest the colour red – its stalk and leaves are green, its flowers are yellow and its berries are black. Below ground, its roots are a dull brown. Yet in many regions, the name of the plant is closely connected to the word for red – *erythrodanon* in Greek and *rubidus* in Latin, for example, where *erythros* and *rubia*, respectively, mean red.[26]

Like all the other animal and vegetable reds, madder was used as a red cosmetic, a food colouring and in medicine, mainly for the treatment of wounds.[27] Its main use was in dyeing cloth, but it requires considerable skill to get a good red – in less skilled hands, it gives a red with a dull yellow or brown tinge. In the late sixteenth century the best madder-dyeing skills lay in the Near East and an English dyer was sent to Persia on an undercover mission to discover their secrets. In Europe, the first to acquire the skill of making 'Turkey red' were the French and in 1790, a Frenchman sold the secret to the Scots, who were then able to supplement their red wool with red cotton. (Madder will 'fix'

onto cotton, whereas the other reds were mainly 'fixed' onto wool.) The method, which took several weeks, involved soaking in various solutions made of, among other ingredients, sheep's dung and stale human urine. The recipe was published in *The Philosophical Magazine* in 1804.[28]

Madder was by far the most commonly used dye. It could be nearly 30 times cheaper than kermes or cochineal but just as permanent and, in skilled hands, it could be just as bright.[29] In England, it was home-grown and the crop was sufficient for local dyers' needs – no madder was imported until the fourteenth century although its export was forbidden.[30] It was not like, for example, the Byzantine purples, the use of which was restricted by law. Nor was it like cochineal, which was restricted by logistics (it took 70,000 insects to make a pound of dye).[31] Madder dyeing was not exclusive; in Britain, the vast bulk of all dyeing was an unregulated, domestic and rural affair because the country's main economic focus was on raising sheep.

In the twelfth century, however, dyeing in Britain started to become a more regulated, mercantile and urban activity. The textile town of Norwich, for example, had a district called Maddermarket, centred around a church dedicated to St John. Over time, madder dyeing expanded, but the local cultivation of madder did not keep pace. By the early eighteenth century, the British were mostly importing madder for their own domestic use, but commercially, British linen was exported to be dyed with madder in Holland, while British woven cotton was dyed with madder in Turkey. Thanks largely to the Flemish craftsmen who settled in England to escape religious turmoil in the previous century, the English eventually learned how to process red dyes better than their competitors.[32] Through the eighteenth century, the Ottoman Empire produced two-thirds of the world's madder. It was their third most important export and by the end of the century the biggest importer was England.[33] After centuries of being first-rate at raising sheep, but second- or third-rate at dyeing wool, England had managed to graft new technologies onto its small-scale but long-established cottage tradition of madder dyeing.

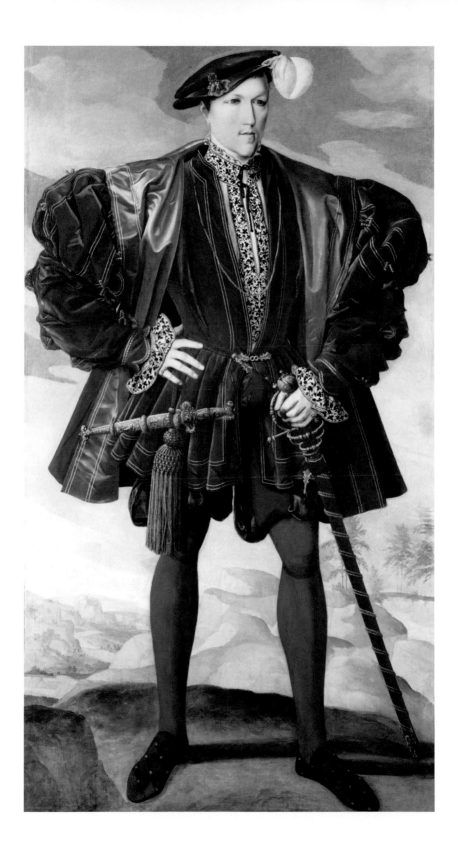

16 Detail from
Man in Red.

15 Anon., *Man in Red*, c. 1530, oil on panel. Image of an unknown man by an unknown painter, bought by Charles II in 1660 as a portrait of Henry VIII by Holbein. The garments are depicted in kermes and madder, which were themselves extracted from dyed red silk and wool.

Medieval England always had an excellent range of home-grown wools upon which to base its varied textile industries and one particular internationally sought-after woollen cloth gave its name to a red. 'Scarlet' was originally a type of cloth, not a colour. It was a luxurious sheared wool that was as expensive as, or even more expensive than, silk and to reinforce its status it was usually dyed red, hence the modern association of scarlet with a colour, not a cloth.[34] Nonetheless, red cloth is still associated with status, hence the celebrity 'red carpet'.

Today, walking on a red carpet makes an instant statement about a person's social, economic or political position. Until the nineteenth century, wearing red clothes also made an instant statement about a person's position (just as wearing rouge made a statement about arrival or belonging in eighteenth-century Versailles). Crimson red, together with purple and cloth of gold, were royal colours and every king was required to wear them. Edward IV ordered 25 garments in the summer of 1480, including

six red doublets, eight red gowns and two red jackets.[35] Henry VII
seemed less interested in clothes and in the whole year of 1502–3
he ordered only 22 garments. Yet he too had a penchant for red,
although his scarlet-lined stomachers were chosen for health
reasons rather than primarily for adornment, since red was
considered good for health.[36] (Red kermes was a key ingredient
of medicines taken by mouth, and red colour, when taken in by
the eye, was also apparently beneficial.) The power of clothes was
considerable, and sumptuary laws – which date from ancient
Greece, which restricted personal items and are still enforced to
varying extents – often proscribed particular types and colours
of clothes.[37]

Simply working with red also said a lot about the worker's
position because the social and economic status of craftspeople
was traditionally tied to the cosmological status of their materials.
(Goldsmiths and silversmiths were amply remunerated, high-
status workers, for example, while tinkers and plumbers were
poorly paid, low-status workers, simply because gold and silver
were 'noble' metals while tin and lead were 'base'.[38])

The cost of dyeing cloth red could rival the combined costs
of growing flax and hemp or tending sheep, plus threshing or
shearing, carding and spinning, weaving, fulling, napping and
finishing cloth. Over many centuries of fluctuating wool and
dye costs, red could more than double the cloth's value.[39] And
just as goldsmiths basked in the glory of the solar metal with
which they worked, so dyers basked in the glory of the reds they
imported from the furthest corners of the earth. Records show
that English clothworkers were organized into guilds in the
twelfth and thirteenth centuries, but the dyers did not have their
own guild – as merchants they did not need them. Dyers were
among the entrepreneurial and ruling classes. For example, as
his name suggests, Philip Tinctor was a dyer and was also the
mayor of Exeter in 1259. Dyers generally dictated the activities of
all the other crafts associated with making clothes.[40] Those who
controlled the red also controlled the things that carried red, like
red cloth, red clothes and the people rich enough to wear them.

THREE

Fruits of the Earth

*T*HESE FIRST CHAPTERS contain biographies of some historically significant red things. They are more than just records of the way people used red things – that would merely be their social lives – because, of course, animals and vegetables have lives of their own.[1] New World captive cochineal's breeding cycle could be between 90 and 120 days and madder plants matured for two years, so the lifespans of red-bearing animals and vegetables determined the working lives of the people who grew, traded and used them. People's fates were intimately entangled with the fates of red insects and plants. A red tree lured thousands of Europeans to Brazil; a red insect dictated the terms of international trade law.

Now, it is true that some red minerals were tied to the same agricultural cycles that determined the lives of rural workers. Red earth, for example, was dug out in the autumn after the harvests were in; rocks were left out over winter to freeze, thaw and crack, and then they were washed in the plentiful rains of spring. However, we generally think of minerals as being lifeless, so how can they have biographies?

Reds from animals and vegetables – obviously animate sources – were mainly liquids and they were used to dye cloth. Cloth, of course, was also made from animate sources – like flocks of sheep or fields of flax – and the textile's drape and the red's shimmer were then reanimated in the final product by being worn as clothing, following and flowing from the body.

On the other hand, the reds that the apparently inanimate earth provided were solid, and the way they were used and

17 Carbuncles (ruby, spinel and garnet) from the collection of the antiquarian, naturalist and geologist John Woodward (1665–1728).

appreciated was also very different. Most of them had to be ground up and then mixed with liquids that dried or cooled to form solid films of colour. If these films were thin they acted as coatings, like paint, but if they were thicker, they could be cut like glass or enamel. Unlike the dynamic animal and vegetable reds, the things that were made using mineral reds were largely static, like the sources themselves. Most of the apparently inanimate mineral reds were appreciated after they had been mixed with lime, gum, egg or oil and painted onto walls, wooden panels, vellum, paper or canvas. Enough survives for us to appreciate the skill and beauty of historic mineral colours, yet their extent is hard to appreciate. For example, the great Gothic cathedrals were painted, inside and out, with fantastically bright colours. Waves of iconoclasm, followed by neglect, have turned Europe's cathedrals into stark bare stone structures. Their long-lost, original visual

impact would have been similar to today's regularly repainted vibrant Buddhist and Hindu temples.

Yet one spectacular type of mineral red was technically ill-suited for use as a pigment and its red colour was never appreciated in paint on any surface. It was also so rare that, once found, nobody would want to grind it up.[2] But these particular red rocks were small enough to be set in gold and worn as jewellery. The definitive example of such rocks is the ruby, although it is not the only red gemstone. For example, the 'Black Prince's ruby' – given to Edward III by Pedro the Cruel in 1367 and now in the British Crown Jewels – is actually a red spinel. Some types of red garnets were also called rubies. Collectively, these minerals were sometimes called carbuncles, after *carbunculus*, Latin for 'glowing coal'.[3] They can all have a good red, they can all take a good polish (with considerable effort) and they can all be transparent.[4] All three were recognized by Albertus Magnus in his lapidary of about AD 1260.[5]

18 Red garnet crystals (grossular type) from Piedmont, Italy, from the collection of founding member of the Geological Society Abraham Hume (1749–1838).

There are other red gems, but rubies, spinels and garnets have all been appreciated for millennia for the combination of their colour and transparency. Both qualities were shown to full advantage by the way they were displayed – in gold, cut flat, into domes or, later, into facets. As minerals, they may appear static and inanimate but with the play of light they become animated, flashing and sparkling, especially so when worn on the body or seen under an animated light source such as a candle.

19 Garnet-like pomegranate seeds. The fruit was a symbol of multiplicity-in-unity and of perennial fertility in Greco-Roman, Hebrew, Christian, Islamic and other traditions. Its significance is reinforced by its spectacular colour.

Rubies

Light's liveliness within the ruby, spinel or garnet hints at a life that is potentially contained within apparently passive minerals. Traditionally, minerals had biographies too. After all, minerals constantly and inconspicuously support and nourish all life on earth, and the fiery light within rubies dovetailed with the tradition of believing that everything is alive, even the apparently inanimate.[6] The ruby's animation of light was completely in

accord with the stone's rather strange legendary origins, which were widely known until quite recently. Oscar Wilde, for example, mentioned its genesis in *The Picture of Dorian Gray*, his novel about a famously animated painting.[7]

In a widespread and enduring tradition that echoes the legendary origins of dragonsblood, rubies or carbuncles were said to be found in the heads of dragons or snakes. According to Pliny, dragons (along with basilisks and ordinary snakes) all had 'noble stones' in their brains, which, throughout the Middle Ages, were supposed to 'shine clearly' and have 'marvellous properties' but only if 'drawn out while the dragon is still alive and quivering'.[8]

Those who wanted a ruby had first to subdue a dragon or snake. Traditionally, snakes might succumb to rune-covered scarlet cloaks or, like babies, be lulled to sleep with song.[9] But the wily ones could resist the snake charmer by pressing one ear against the ground and sticking their tail in the other ear, thus becoming, as Psalm 58 noted, 'as deaf as an adder'.[10] If seduction failed, fumigation with laurel smoke could be attempted.[11] This tradition is related to the fabulous stones found in toads' heads.[12] It occurs in poetry, for example in Chaucer's *The Legend of Good Women* and Gower's *Confessio amantis*. Poetry also mentions properties like glowing in the dark, for example in *Sir Gawayne and the Green Knight* and *Sir Orpheo*.[13]

While dragonsblood was the mythical fruit of elemental antagonism, rubies were widely known as the mythical fruit of snakes unfortunate enough to meet with human cunning.

Translucent reds

Rubies were by far the most precious of all red stones, mainly due to the fact they were red as well as willing and able to let light pass through them unhindered. Yet not all rubies are crystal-clear, since some split the light into six-pointed stars and others simply glow like pomegranate seeds (hence the name 'garnet'). The whole of creation, both heaven and earth, resulted from the command 'Let there be light' (Genesis 1:3), but the greatest of all

light sources are in the heavens – whether the sun or moon, the planets or stars – and earth tends to be the end of the road for light. It follows that light was heavenly and that earthly things only very rarely allowed free passage to light. Any stone from under the earth that offered no resistance to light must have had some heavenly properties.

Albertus Magnus said that 'the powers of all things below originate in the stars' above. Those heavenly powers were expressed in a 'noble' manner when the earthly thing had 'brightness and transparency', and they were manifest as 'ignoble' when the materials were 'confused and foul, so that the heavenly power is, as it were, oppressed'. Gemstones were powerful because they were 'stars composed of elements' (made of terrestrial earth, water, air and fire, as opposed to celestial ether).[14] Red rubies had the power of the sun (which is sometimes red) and Mars (which is always red), and these connections made the ruby the 'lord and king of stones'.[15] (According to a seventeenth-century Spanish text, rubies also drew their power from the star Aldebaran, the glinting red eye of Taurus the bull.[16]) Albertus Magnus said that the most powerful stones came from the East because 'the power of the planets is most effective in those places'.[17] Their power was connected to their inherently 'noble' transparency, and gemstones of all types were said to be washed from the rivers of Paradise,[18] where, before the Fall, we once walked 'in the midst of fiery stones' (Ezekiel 28:14). Since Paradise was traditionally located in the East, rubies were mineral wonders of the East, along with vegetable wonders like dragonsblood resin and animal wonders like lac insects, both of which were also Eastern and gave transparent reds.

Yet the world is wide and not all stones can have been washed from Paradise. It follows that few rocks are transparent and most impede light's journey. However, there is not a strict dividing line between those things that are 'bright and transparent' and those that are 'confused and foul'. Transparency is a matter of degree. In fact, if rocks were not at least partly transparent, then they could have no colour at all, as all light would simply bounce straight off their surfaces. Since rocks have colours, there must be some

20 Scottish carnelian and red agate transported south by centuries of longshore drift down the North Sea to a beach in Norfolk, United Kingdom.

interaction between the light and the rock. (According to modern theories, any stone that looks red must absorb into itself all the other colours, otherwise it would look white, not red.) Between the complete clarity of crystal and the total obscurity of coal, there lies a range of rocks that are neither transparent nor opaque, but 'translucent'.

Sardinus, also known as sardius or sard, was red and Albertus Magnus described it as 'somewhat translucent, as if red earth were imagined to have some transparency'.[19] As well as being the colour of the earth it was also the colour of martyrdom and faith, through its similarity to Christ's spilled blood.[20] It was the first of the twelve biblical stones mentioned in the high priest's 'breastplate of judgment' – sard, followed by topaz, emerald, turquoise, sapphire, diamond, jacinth, agate and amethyst (Exodus 28:15–21). It also held the sixth place in the foundations of the Heavenly Jerusalem (Revelation 21:19–20), which was appropriate since Christ was born in the sixth age of the world and was crucified on the sixth day of the week on the sixth hour of the day.[21] Also, Adam was created on the sixth day (Adam's

relationship with red earth will be explored in a later chapter.) Sard was also called carnelian, a name that has obvious links with the Latin *caro*, or flesh, and which, according to the enormously influential sixth-century encyclopaedist Isidore of Seville, was related to the concept of 'creation'.[22] It had carnal associations and was used in averting miscarriages.[23] Carnelian, 'the colour of flesh', was generally believed to reduce bleeding and calm anger.[24]

Sard, or carnelian, had pride of place in symbolic religious structures and was used in medicine because of the 'heavenly powers' embodied in its red colour and because of the warm, soft glow of light that emerged from the heart of the stone. A number of other red stones were also highly valued but these were more opaque and did not obviously allow the passage of light. They included porphyry and jasper, although these stones also come

21 Two protective red jasper Egyptian amulets, one in the form of a trussed bull, the other a tyet-knot, associated with the goddess Isis. The tyet-knot's apparently anthropomorphic shape was unintended and may not have been recognized.

in other colours.[25] Yet even if red porphyry and red jasper appear opaque, they still have the potential to interact with light. They can be polished, thus animating the light that skims off their surfaces. The last red stone we shall consider was also found in more than one colour and also appears to be opaque. It had enormous cultural significance, although it was not revered like ruby, sard or porphyry, but was instead the focus of decidedly mixed feelings.

Haematite

Haematite occurs in two forms – one black and one red – and the black variety accepts a very high polish. Black haematite gemstones can therefore swallow up all the light that falls on them, and, with the slightest of shifts, they can also return all the light in a dazzling blaze of glare. Whether haematite gives or takes light depends on the relationship between your eye, the stone's surface and the source of light. The gemstones were valued for their extreme flashing lustre, rivalling diamonds in their black-backed jewellery settings that were popular before the development of the now more familiar brilliant cut.

The second, red, variety was much more common and was used very differently. In fact, the black gem variety could turn red if treated roughly and it showed its hidden inner redness by the colour of the blood-red streak it left when scraped across a hard surface. The red variety provides the colour for common or garden red earth so is, in Albertus Magnus' terms, 'like sard without the transparency'.[26] The most widespread form was 'red ochre', which was not appreciated the same way as decorative ruby, sard, porphyry or black haematite. Its value was more utilitarian – it was the stone from which iron was extracted. However, its usefulness as a source of metal only added to its already established symbolic significance.

Haematite's name is literally 'blood stone', which suggests it had medicinal uses associated with blood. Haematite and rust were not connected with Christ's blood, as was carnelian, but

with human blood, and their relationship with blood was much more complicated than carnelian's medicinal use in childbirth and healing. For example, in the Greek epics, Achilles healed a wound with rust taken from the spear which caused the wound.[27] The story of Achilles' spear's rust lived on, and the medicinal use of rust and haematite to staunch the flow of blood continued through and beyond the Middle Ages.[28] But this red rock's relationship with mankind was not exclusively beneficial – indeed it was practically the definition of an ambivalent relationship.

Through its connection with the sun, transparent ruby was the most 'noble' of the transparent gemstones, and was to the other gems as 'gold is to the other metals'. Opaque haematite, on the other hand, was linked to Mars, the 'red planet', and to iron, which was the most 'ignoble' of the metals.[29] The ignoble nature of iron – made from red ochre or haematite – was reflected in the relatively lowly status of the ironworker, or 'black' smith, and in the blackness of cut and polished haematite gemstones. (This ignobility accounts for why it was said that herbs lost their medicinal properties when dug up with iron implements, and why, when the earliest use of iron ploughs was associated with poor harvests, farmers reverted to wooden ploughs.[30]) The plough wounds the earth just as a knife can wound the flesh, and 'ignoble' iron facilitated both woundings, as Pliny said:

> Iron serves as the best and the worst part of the apparatus of life, inasmuch as with it we plough the ground . . . but we likewise use it for wars and slaughter and brigandage . . . to enable death to reach human beings more quickly, we have taught iron how to fly and given wings to it![31]

But iron's ability to deliver death was mitigated by the fact that, of all the metals, iron corroded the fastest. Pliny said that the

> benevolence of nature has limited the power of iron . . . by inflicting on it the penalty of rust . . . making nothing in the world more mortal than that which is most hostile to mortality.[32]

22 Shattered piece of haematite showing the mineral's black metallic lustre, its martial sharp edges and its blood-coloured, weathered coating.

Corrosion destroys weapons of destruction. This natural justice is underlined by the colour of the corrosion product – iron's rust is blood-red.[33] Aware of the story of Achilles' spear and the long medical tradition, Pliny also observed the cosmic symmetry that meant 'the effect of [iron's] rust is to unite wounds . . . though it is with iron that wounds are chiefly made!' Red rust's healing power may be one reason why the Greeks went into battle smeared with red ochre or haematite. Europe's original 'rouge' was literally 'war-paint'.[34]

The circular relationship between a red rock, an ignoble metal and a red rust accounts for the ambivalence associated with this particular red rock. But that relationship only became apparent after the techniques of iron smelting had been developed, which happened tens of thousands of years after ochres began to be

collected and transformed. The first iron was probably smelted around 4,000 years ago, while the red ochres it was smelted from were collected from about 70,000 years ago.[35]

The dead were sometimes sprinkled with powdered red ochre and, although this burial custom was only practised by a minority, they were very widespread and enduring cultures.[36] Having collected red ochres for tens of thousands of years and then used them in burials, suddenly, around 13,000 years ago, those who lived in Western Europe started painting with them. (At more or less the same time, people did the same the world over.) Material evidence suggests that this Upper Palaeolithic explosion in painting coincided with increasing social differentiation and the creation of objects associated with religious practices. People's social, artistic and spiritual lives all seemed to bloom simultaneously and these artists hit the ground running. They produced complex ensembles of beautiful images and their favourite pigments were various shades of red. Sometimes the red was a local earth and sometimes the red had to have been traded. One prehistoric site in Poland, for example, used a red ochre that was mined about 700 km away.[37] This long-distance trade in mineral reds has continued through history.

Sinopia

The fourteenth-century painter Cennino Cennini used exactly the same red earths as the prehistoric cave painters and he referred to them as both 'haematite' and 'sinoper' (he used the name 'ochre' mainly for the yellow earths).[38] The name sinoper came from the place through which these rocks had been traded around 2,000 years earlier.[39]

The town of Sinopia or Sinope is in the north of present-day Turkey, at the very centre of the Black Sea's southern coast. Writing around the time of Christ, Strabo followed other more ancient authorities in identifying it as the region's most important city.[40] Sinope happened to be the only good, all-weather harbour on the south coast of the Black Sea and behind it lay an

inhospitable and densely forested mountain range. It was the
biggest in a string of Greek coastal settlements along the
edge of Persian-controlled land. It provided a safe haven on
the sea passage east from the Armenian land corridor towards
Constantinople, the Mediterranean and the West. The forests
and mountains protected Sinope from the Persians and it was
effectively an island, accessible only by sea. It became an ancient
Greek trading centre, much like the Mediterranean's mountain-
hemmed port of Genoa and the island of Venice, which both
became international trade centres for Renaissance Europe. The
major trade routes between East and West converged in Sinope,
making it the ancient world's equivalent of today's island trading
hubs, Singapore or Hong Kong. For Europeans in the Middle
Ages, the name of this red rock would have conjured up historic
associations equivalent to today's international jet-setting and
high finance.

Strabo described a thriving trade in 'Sinopic *miltos*', which
is 'the best of all'.[41] Exactly what was meant by the term *miltos* has
been argued about by historians, but one suggestion is that it was
a generic name for widely traded red mineral pigments.[42] Most of
these reds were the iron-based earths – haematites and ochres –
that had already been traded for millennia. But there are two hints
that *miltos* might also have included another red mineral. First,
Theophrastus reported that the mines from which Sinopic *miltos*
was extracted had deadly suffocating air. Now, poisonous vapours
are not associated with iron-based red minerals, so this feature of
the mines suggests that one of these *miltos* might not be the usual
red earth. Second, Strabo compared this Sinopic *miltos* to that
found in Spain and Spanish *miltos* was, without a doubt, not
a haematite or an ochre but a completely different mineral.[43]

The red mineral from Spain was cinnabar and the strange
thing about cinnabar is that this naturally occurring and widely
traded red mineral was very rarely used as a red pigment. In the
first century AD, Pliny recorded that statues of Jupiter, as well as
people celebrating his feasts, were covered with cinnabar, but this
was a very unusual practice and Pliny admitted that he was 'at a
loss to explain the origin of this custom'.[44] The general failure to

use cinnabar for its bright red colour initially seems rather odd; after all, modern science would describe it as chemically identical to the extremely commonly used red pigment vermilion. So, what's the difference between red vermilion and red cinnabar, and why use one but not the other?

Mysterious Reds

WITH INGENUITY AND EFFORT, hidden reds can be brought out into the open – mined from the earth or extracted from plants or animals. Yet other red things can be made from things that are not themselves red. These reds are born in fire and are known as 'synthetic' or 'artificial', terms which today carry with them a certain suspicion. Here I try to look at them in a more positive light, exploring the fact that 'synthesis' involves bringing things together and is the polar opposite of analysis, which involves pulling things apart. I also aim to acknowledge the art in 'artifice', recognizing that while the word has recently come to mean 'shallow, contrived and almost worthless', for over 2,000 years, it meant 'full of deep skill and art'.[1]

We generally assume that artificial reds are modern, but they are as old as humankind. In fact, the valuing and making of these reds is one of the key features that archaeologists and anthropologists have used to define human beings, since the decorative use and making of colour provides physical evidence of shared symbolic activity.[2] Red earths were collected in prehistory and they were valued for their colour thousands of years before they became valued as sources of iron. However, yellow ochres were also collected because – almost magically – they could be turned red. The very first artificial red to attain widespread cultural value was an earth that changed colour beneath the campfire.

The initial transformation of a yellow into a red may have been fortuitous but it took observation and skill to turn it into a repeatable operation. Pioneering cavemen and women had to recognize which particular rocks would change colour, since

most did not, and then the once-yellow-now-red rock was
buried under ash and cinders so it had to be separated from the
remains of the fire. This is because the best colours and the most
dramatic colour changes happened with very soft and crumbly
rocks that broke easily. Red fragments and powder could have
been retrieved from cinders and ash using breath or the wind,
like 'separating the wheat from the chaff', or by using water, with
cinders floating, ash dissolving and red rock settling. All this was
reliably worked out tens of thousands of years ago and technical
details were recorded nearly 4,000 years ago.[3]

Hints about the significance of changing yellow into red can
be found in the Greek name for yellow, *ochros*, which meant,
among other things, 'lifeless'.[4] Red, on the other hand, has always
been associated with life. Burning ochre appeared to awaken
or revive a mineral life force. Making reds from earths has
continued ever since, with blocks of yellow ochre burned in kilns
custom-built for the purpose. Today, analysis of changes in crystal
structure can show whether prehistoric red stones are natural or
artificial in origin.[5]

23 Yellow ochre
together with a
piece of the same
rock transformed
after an hour or so
in a campfire. The
once-yellow-now-
red piece split once
pulled from the fire
and shows a rich
red through the
whole stone.

We can easily imagine that the ability to take yellow earth and, at will, turn it red may have been discovered accidentally in the course of everyday life. However, unwavering exploration was required to discover the other synthetic or artificial reds. They were the result of enormously complicated activities which purposefully transformed raw matter, and they were not at all related to anything required for subsistence living. These activities were not the preserve of full-time specialists, nor were they necessarily the preserve of males – they were a magical form of play. Until quite recently, all the synthetic reds that people managed to make came from a rather special type of material – an ore, or a stone that could be processed to make metal.[6]

Iron ores

The origin of iron smelting is lost in the mists of time and the standard story is that it was discovered accidentally while firing pottery. This is highly unlikely. The first pottery was decorative and ornamental, not utilitarian, which suggests that firing started as part of ritual or symbolic play with a culturally significant material – sculpted clay. Clay utensils came later. The utility of fired clay was a happy side effect of experiments in decoration and ornamentation. It is therefore possible that iron smelting arose because the metal's raw materials – yellow ochre, haematite or red earth – were already valued rocks and were therefore the focus of cultural attentions. These attentions must have included, at some point, the explorations that eventually produced iron. In other words, the later utility of haematite or red earth – as the source of iron – is most probably due to their earlier significance as stones prized for their redness. Nearly 500 years ago, the author of a German textbook on mineralogy said that colour was the single most important quality when it came to judging stones. Yet the significance of colour is only just beginning to be appreciated in modern archaeology.[7]

Palaeolithic playing with mineral reds could be compared with mankind's engagement with another type of stone. It has

24 Fragment of the Krasnojarsk pallasite meterorite that fell on Mount Bolshoi, Russia, in 1749. This particular type of stone-and-iron meteorite is rare but, since the 18th century, several metric tonnes of iron meteorites have been collected.

been suggested that, at the same time that people shaped stones, stones shaped people's ways of thinking. Flints 'told' people where to hit them in order to make sharp flakes and the modified shapes 'told' people about the possibility of tools that could cut. Similarly, the colour change in burnt ochres 'told' people that they contained something active and worth pursuing. Human intelligence is not located inside the skull, or even only within the skin – it is distributed across the mind, the body and the environment, and it emerges through our conscious interaction with matter.[8] It is most probable that the ultimately world-changing technology of iron smelting emerged from symbolic play with, and valuing of, redness. If flint stones were co-creators of the Stone Age, then red stones were co-creators of the Iron Age.[9]

The oldest red stones to be valued culturally – as well as the yellow ones that were converted into reds – were ores of iron. These natural and synthetic reds had magical associations, and similarly magical powers were associated with the extraction of their iron.[10] The prehistoric discovery of how to make iron revolutionized agriculture and warfare and brought with it

powers which had to be controlled, socially and politically. The powers derived from a red rock conferred special significance upon the smith in many cultures and, throughout the world, smelting ores and forging metals became surrounded by webs of taboo, ritual and myth.[11]

In the British tradition, faint echoes of the ancient powers associated with the smith's ability to extract metal from stone can be found in Arthurian legend. There, the 'true king' was identified as the one who was able to 'draw the sword from the stone'.[12] Now, extracting a steel weapon from a rock was a skill that only a smith possessed because – although gold, silver and copper can occur as metals – iron is never found as a metal on earth.

Actually, to be strictly accurate, iron did not occur as a metal *in* the earth but was, very occasionally, found *on* the earth's surface in the form of meteorites. Metallic iron meteorites fell to earth and the places where they fell were often turned into cult centres, while the metal was usually turned into tools with ritual uses. When Cortés asked the Aztecs where they got their iron, they pointed to the sky. The Sumerian for 'iron' is a combination of the pictograms for 'sky' and 'fire' while the ancient Egyptians called it 'metal from heaven'. Meteorites, or 'thunder stones', were generally seen as weapons of the gods.[13]

Yet meteorites fall much too rarely to feed an iron industry. Heavenly iron originally had spiritual value and iron attained its now familiar military value only after people learned how to deliver the metal from red earth. The fact that smiths usurped the heavenly source and exploited an earthly source – together with the value of their output – added to the mystery of their craft. Their extraction of iron from ores involved ochres, plus chalk, limestone or ground-up shells and breath blown through pipes or, later, air forced by bellows.[14] In the thirteenth century, Albertus Magnus said that iron was 'purified by many strong fires, which force it to distil out of the substance of the earth or stone, with the very bowels of which it seems to be united'.[15]

The power to manipulate nature – to sidestep heaven, to identify the appropriate earthly stone, roast and smelt the ore then forge the metal – was embodied in the craftsperson, in their

raw materials and processes, and in the objects they crafted.[16] In Arthurian legend, that power was reflected in Excalibur (drawn from the stone by fire and breath) and in the king as well as in his kingdom, which he 'forged' by harnessing his people's true 'mettle'. In wider culture, that power was embodied in red.

In prehistory, something like Excalibur's powers resided in synthetic or artificial red ochres that were made and collected by Palaeolithic cave dwellers. In more recent history, similar powers resided in the other sinopia or *miltos*, and cinnabar, as well as in the artists, apothecaries and alchemists who knew its secrets. Those powers might also be transferred to things painted with cinnabar, like the statue of Jupiter and his celebrants that Pliny was 'at a loss to explain'. They were certainly associated with the mercury that was extracted from cinnabar and the vermilion that could be made from that mercury.

Vermilion

The reds that the ancient Greeks traded through Sinope included cinnabar (the similarity of the words 'cinnabar' or *cinabro* and 'sinopia' hints at the distant historic connection). Although cinnabar was not valued as a red pigment it was highly valued as an ore. Just as red ochres were smelted for their iron, cinnabar was smelted for its mercury. Cinnabar was full of mercury and getting it out of the stone was much easier than getting iron out of red earths. Even buried underground, the red cinnabar could actually 'sweat' little silvery beads of the liquid metal. The fact that cinnabar was constantly releasing mercury explains Theophrastus' reports of deadly suffocating air in the 'Sinopic *miltos*' mines.[17]

The earliest evidence of cinnabar mining is late Neolithic, around 4,000 years ago,[18] but, by the time of recorded history, it is clear from Theophrastus that everyone knew the risks of playing with cinnabar and mercury. Around the time of Christ, bladder-skin masks were recommended to prevent inhaling dust when working with cinnabar. At the Spanish Almadén cinnabar mines, where security was 'second to none', local processing was

25 Piece of cinnabar from Hungary acquired by Sir Isaac Newton in 1669, probably intended as raw material for his numerous alchemical experiments. The grey colour is due to the red rock's surface coating of mercury droplets.

forbidden and 900 kg of the ore were sent annually to Rome. A thousand years later, artists and scholars warned of the threats to health that vermilion posed to those who worked with it.[19]

Stones were usually described in lapidaries, a type of book that was for minerals what herbals were for vegetables and bestiaries were for animals. Albertus Magnus wrote such a lapidary – *Book of Stones* – but it doesn't mention cinnabar. Nor, except in passing, does he mention it in his *Book of Intermediates*, or ores. Yet in his *Book of Metals* he calls it 'the stone in which [quicksilver or mercury] is produced'.[20] Albertus Magnus was not alone in writing about cinnabar in the context of metals. Pliny wrote about it in his *Book of Silver and Gold*, saying that it was 'found in silver mines'.[21] The main interest in cinnabar seemed to be its connection with metals since it was the ore for mercury, which was used in the purification of silver and gold.

When cinnabar was heated to extract its liquid mercury, vast clouds of noxious sulphur fumes were released, so it was crystal clear to the ancients that cinnabar was a natural mixture of mercury and sulphur. Since all the metals were related – they were seen as various stages of perfection, from lead, the basest, to gold, the most noble – mercury and sulphur were thought to coexist within each of the metals, and differences between them were due to the purities and ratios of mercury and sulphur. In the words of Albertus Magnus, 'in the constitution of metals, Sulphur is like the substance of the male semen and Quicksilver [also known as Mercury] like the menstrual fluid that is coagulated into the substance of the embryo.' This idea was enduring, and a seventeenth-century alchemical treatise claimed that both Nature and Art made metal from Sulphur and Mercury.[22]

Red earths and red cinnabar were early stages in Nature's slow subterranean ripening of metals. It was widely believed that the smith's arts of smelting were simply speeded-up versions of natural processes. In addition to the art of making metals from ores, the related alchemist's arts could also help the metals on their way to perfection, from lead through to gold. (So, by the Middle Ages, burning yellow ochre to make a red ochre would be seen as helping Nature on her first step towards iron and, ultimately, gold.) The alchemist's art was colour-coded and, in that code, red was very significant indeed.

Albertus Magnus said that 'alchemists wishing to make gold seek for the red elixir', which was also called 'the red of the Sun' and 'the medicine of the Sun'. Albertus also described the synthesis of 'a shining red powder'. That red powder was the 'red elixir' or the Philosopher's Stone, which the alchemist Roger Bacon claimed was made of sulphur and mercury.[23] So, alchemists sought the red powder made of sulphur and mercury in their quest to make gold. And while ordinary painters used the red powder made of sulphur and mercury as a pigment, they also used it in an elixir-like way to make a range of synthetic gold-coloured pigments.[24]

In his painting manual, Cennino Cennini said that his best red pigment, vermilion, was 'made by alchemy'. He also knew

how to make it, but did not include details, simply saying 'you will find plenty of [recipes] for it, and especially by asking of the friars'.[25] He implied that making vermilion was common knowledge and suggested that you bought it from the apothecary instead of making it. However, in another painting manual written a few centuries earlier, details of red vermilion's synthesis were included. Theophilus said,

> take sulphur . . . break it up on a dry stone, and add to it two equal parts of mercury, weighed out on the scales. When you have mixed them carefully, put them into a glass jar. Cover it all over with clay, block up the mouth so that no fumes can escape, and put it near the fire to dry. Then bury it in blazing coals and as soon as it begins to get hot, you will hear a crashing inside, as the mercury unites with the blazing sulphur. When the noise stops, immediately remove the jar, open it and take out the pigment.[26]

In practice, the process is more difficult than Theophilus' recipe suggests and many aspects of it were extremely dangerous. In brief, it involved finding a red vein of crystalline mercury sulphide and mining it at great risk, then burning it to drive off the choking sulphur and leave pure toxic mercury. That mercury was recombined with more sulphur – collected from a volcano – then placed in a fire to make red crystals. A modern chemist (as opposed to a medieval alchemist) would ask, why bother? As far as modern science is concerned, the red thing you ended up with was exactly the same as the red thing you started out with – you broke something down then stuck it back together again. But to the alchemist and to the painter, the initial red, cinnabar, and the final red, vermilion, were very different. The added value embodied in crystals of vermilion was an immeasurably greater level of personal engagement with the colour. The experience could offer insights into the nature of red, into their own nature and into the nature of all things. The alchemist respectfully took the opportunity to choreograph an elemental dance in which the leading couple parted, each taking the limelight for a solo

performance, before eventually rejoining with a fuller appreciation of their other half's individual qualities. The alchemist was a participant in, and witness to, an inorganic love story.

The synthesis of vermilion from cinnabar gave artists, apothecaries and alchemists the opportunity to engage profoundly with the basic structure of the material world. The process involved taking a solid and simultaneously creating from it a liquid and a vapour, then taking the liquid and mixing it with a solid to make another solid. The process went through various colours, from a red (cinnabar), into a silver (mercury), mixed with a golden red-yellow (sulphur), going through black (meta-cinnabar, a stage that Theophilus discreetly missed out of his recipe) and finally back to a red (vermilion).

This was a colour-coded journey through different states of being upon which the intrepid experimenter could meditate. The key stages in that journey were white, black and red, which artists recognized as being the same sequence of colours that charted the alchemical quest.[27] The final red physically embodied the mysteries alluded to in the mythical creation of dragonsblood from hylomorphic 'form' and 'matter' in the guise of elephants and dragons.

Nobody had to make this particular red but, at considerable risk to their health, many did and making vermilion was the most commonly repeated recipe in all medieval manuscripts.[28] Alchemists, apothecaries and artists all made it, but its synthesis is also found in collections of household recipes, along with how to make soap and even soup. The desire to make red vermilion spanned the whole of the Old World. For example, on his journey east, Marco Polo reported 200-year-old yogis in India who made and regularly took a potion – reminiscent of the kermes cordial – which was made from (presumably homeopathic quantities of) mercury and sulphur.[29] On his journey to the west, the Monkey King met Taoists who refined cinnabar, called *dan*, a key component in *waidan* and *neidan*, respectively outer, or material, and inner, or spiritual, alchemy. It is therefore no surprise that red cinnabar was an ingredient in 21 of the 27 elixir recipes in Ko Hung's fourth-century *Pao Phu Tzu*.[30]

26 Jar of synthetic vermilion made in the 19th century. Natural cinnabar's mercury and sulphur, split and reunited.

Alchemical elixirs were red the world over and in the European tradition many other reds, in addition to vermilion, were explored as possible sources for the elusive elixir, life force or Philosopher's Stone. One example is recorded in a painting that Joseph Wright of Derby worked on for over twenty years. It was inspired by an event that took place a century earlier, it was out of tune with his Enlightenment times and it was only sold after his death. The painting's full title is *The Alchymist, in Search of the Philosophers' Stone, Discovers Phosphorous, and Prays for the Successful Conclusion of his Operation, as was the Custom of the Ancient Chymical Astrologers*. It shows the alchemist and his workshop illuminated by a powerful light emanating from the reaction vessel. The glowing phosphorus – sign of a mineral life force – was made from an oil distilled out of concentrated human urine, which was, of course, red.

European alchemists, apothecaries and artists all knew and used that other red, dragonsblood, yet they could only imagine its dramatic genesis somewhere in the legendary East. By contrast, they could see, smell, hear and feel vermilion's genesis first-hand, and this is what made it so intriguing. If you were to make vermilion from cinnabar, you could see the whole world reflected in mercury's shifting silvery surface. If unlucky, an invisible cloud of sulphur could grab you by the throat and choke you. If successful, you could hear crashing as sulphur united with mercury under blazing coals. Finally, you could smash the vessel into which you put a coagulated black mass and be greeted by the glittering facets of countless red crystals. Vermilion's mercury and sulphur were the real mineral counterparts of dragonsblood's mythical dragon and elephant.

The philosophically inclined artist, apothecary or alchemist could experience Aristotle's hylomorphism in action in vermilion's synthesis. In Lao-Tzu's terms, this red displayed the *yin* and *yang* of *wanwu*, the 'ten thousand things'.[31] It was appropriate that the cosmic battle of dragons and elephants resulted in a red, and it is equally appropriate that the union of mercury and sulphur is red. Red is the centre of the Aristotelian

colour scale, midway between black (the colour of *yin* or matter) and white (the colour of *yang* or form).[32]

Great power was available to the person who understood the nature of the two principles, mercury and sulphur, and of their role in all transformations – of synthesis and analysis, of gathering and scattering or of marriage and divorce. Such power was harnessed by the smith and underlay the story of Arthur and his sword in the stone. The same power was explored by the alchemist and was evident in their apparent ability to make gold. However, power – whether derived from the sword or from gold – is open to abuse, so the artists who wrote about the synthesis of this particular red either simply referred their readers to 'the friars' or left out vital details. They also used obscure names for their materials and processes in order to hide the truth from the unqualified and to protect Nature from those who might exploit her powers.

The multitude of names for these culturally charged reds also served to reinforce connections between them – just as 'cinnabar' related to sinopia, so also 'vermilion' was related to *vermis*, the 'little worm', a generic name for the extraordinarily expensive insect reds. To further confuse the unwary, vermilion could also be called 'minium', the name of yet another artificial red.

Minium

The non-vermilion version of minium was made from another metal, produced from a different ore. (Vitruvius and Pliny called it *minium secundum* in order to distinguish it from minium-as-vermilion.) In traditional metallurgy, each of the metals was connected to a planet or a god. The metal mercury was associated with the planet and god Mercury, also known as Hermes. Iron was associated with Mars, or Ares, and the metal that gave this third synthetic red was lead, which was associated with Saturn or Kronos, the father of all the gods.

In the first century AD, Britain was described as an island where Kronos was imprisoned by sleep, surrounded by 'many

demigods as attendants and servants'.[33] The god Kronos (manifest in the heavens as the planet Saturn and on earth as the metal lead) slumbered in Britain with a retinue of 'demigods' that included the goddess Diana (associated with the moon and silver). Legends of these imprisoned gods and goddesses encouraged Britain's colonization – the Roman Empire wanted to awaken Kronos (Saturn) and Diana, who slept together in a mineral that we now call galena. Upon invading the British Isles, they mined and roasted the hard shiny stone, driving off the noxious sulphur to leave *calx*, the source of metals.

There were several ways of getting the red powder minium from the metal and one of them was directly related to the reason why the Romans wanted Britain's lead in the first place. The small amount of silver dissolved in the molten lead was extracted by a long process that finished with cupellation. This involved blowing air across silver-enriched molten lead to make a fine powder of litharge. The name of this powder – from 'lith' for stone and 'arge' for silver – hints at its significance because, when all of the molten lead had been consumed into the litharge, droplets of pure molten silver nestled in a bed of dry powder.

Litharge is a dull yellow and is not particularly stable. It can be turned into the more stable minium, or red lead, and there is evidence that this red by-product of silver mining was traded as a pigment across the Roman Empire. Chemical trace element analysis and lead isotope analysis of the red pigment in a group of second-century AD Roman-Egyptian red-shroud mummies determined that it was made from litharge, which was in turn made from lead mined for its silver content in Rio Tinto (literally, red river), Spain.[34] Minium's production was as toxic as vermilion's, but rather than being the central focus of a small-scale contemplative exercise for a few friars, painters, alchemists, yogis or Taoists, minium was the tiny, almost insignificant by-product of a massive empire-wide precious metals industry.

Once all the silver had been extracted from lead, the metal had a wide variety of uses such as providing pipe work, securing stained-glass windows and keeping the roof watertight. When it was exposed to acid fumes – usually by being sprinkled with

27 Roman-Egyptian red-shroud mummy, c. AD 100–150, human remains, polychromed cartonnage and wood. The casing was painted with minium manufactured from lead mined in the Sierra Morena mountains of Andalusia and exported to the opposite end of the Mediterranean.

vinegar and urine and buried under horse manure for a month – it slowly grew a white surface coating of rust. This white powder was collected as an artists' pigment and a medicine, but it could also be placed in a fire, whereupon it turned into minium.[35] This red powder also had medicinal uses, along with vermilion, and – as was evident in the brief history of rouge – both reds also had extremely long careers as cosmetics.

The synthetic reds were either ores for metals or they were made from metals. They might even be both. Iron, for example, which came from powdery red ochre and eventually turned into a pile of powdery red rust, was usually obtained from those natural ores that themselves looked most like rust.[36] In the cases we have considered so far, the metals themselves were not red – mercury is a silver colour, iron can be various shades of grey and lead is black. But according to the mercury-sulphur theory of metals, the metal itself might also be red if the metal's inner balance was particularly tipped towards sulphur. Gold was often described as a red metal and so was copper, and both were used to spectacular effect to make yet more synthetic reds.

Red glass

Copper metal will rust just like iron and lead, and copper was purposefully rusted – sprinkled with vinegar and urine and buried under horse manure for a month – just like lead. But its rust is green.[37] The red colour that came from copper was made when staining glass, and it was very different from the red that dragonsblood resin created in recipes for imitation ruby. Dragonsblood reds fade, but copper reds can be as lustrous today as they were when newly made, nearly a thousand years ago.

Glass could be made with sand and plant ash; Theophilus recommended the ash of beech trees in particular. If you wanted red glass, you would add copper filings to molten glass, which was warmed gently before being worked up into goblets or windowpanes. The process sounds simple; the recipe is once again deceptive. Great skill was required to make stained glass

28 Gold Anglo-Saxon bracteate from the 6th century with red glass inlay emulating garnet.

and if it was heated too strongly the copper could turn the glass green, instead of red. Red glass was the second most expensive colour (after blue) and it was the second most popular colour (again, after blue) in many Gothic cathedrals.[38]

The great panes of medieval red stained glass that survive today owe their existence to much older artificial rubies since the techniques of window making developed out of the ancient techniques for imitating gems. In the first century AD, Pliny observed that rubies were counterfeited with 'great exactness' in red glass but, with care, he could distinguish between the real gem and the glass by differences in colour, hardness and weight and by the presence of bubbles.[39] In the twelfth century, Theophilus wrote of 'setting gems in painted [window] glass', but he was fully aware that the 'gems' and the 'glass' on to which they were fixed were one and the same material.[40]

Medieval imitation rubies were cut with a dome-shaped top, just like real ruby cabochons, and they are found decorating the most extraordinarily prestigious works of art, such as the fabulous thirteenth-century altarpiece that stood on the high altar of London's Westminster Abbey. For centuries, Britain's monarchs were crowned in front of an altar decorated with over 2,000 imitation gems, including many hundreds of red-glass rubies.[41] The presence of imitation rubies on such an important object could not possibly indicate corner-cutting as the money ran out. Instead, the imitation gems were valued because of the skill, time and effort dedicated to making them. According to a twelfth-century inscription on an enamel plaque, 'Art is above gold and gems; the Creator is above all things.'[42]

For the craftspeople in medieval Westminster, the transformation of dry sand, plant ash and copper filings into something that looked just like a ruby was an opportunity for meditation, in exactly the same way that vermilion's synthesis was an opportunity for meditation. The meditative potential of red glass was reinforced by the fact that gold in glass also gave a ruby red, which became known as the Purple of Cassius or Kunkel after two seventeenth-century alchemists who experimented with and developed ruby-red glass. In the nineteenth century, Prince Albert and other worthies were treated to spectacular projections of ruby-red light from glass microscope slides of nanometre-sized gold particles in Michael Faraday's public scientific lectures.[43]

Whether stained with copper or with gold, red glass and imitation rubies participated fully in the quality of redness. They

29 Michael Faraday's ruby-red glass microscope slide with a deposit of nano-scale colloidal gold that he referred to as a 'sol'. It was prepared for a Royal Institution lecture of 1858 and is inscribed 'Faradays Gold given to Me himself after his Lecture at the RI'.

had an aspect of real ruby and, as the products of labour, they also had an honourable aspect of artifice (in the original sense of 'full of deep skill and art'). The artifice of these traditional synthetic reds was quite unlike that of modern synthetic reds, the subject of the next chapter. Today, artificial reds are made behind high razor-wire fences in vast industrial complexes where very few really know what goes on. The mystery of medieval glass-making, on the other hand, was, paradoxically, common knowledge. As Chaucer's squire said in 'The Squire's Tale', in the enduringly popular *Canterbury Tales*:

> . . . others said how strange it was to learn
> That glass is made out of the ash of fern,
> Though bearing no resemblances to glass;
> But being used to this, they let it pass.[44]

People accepted that, with cunning, a ruby could come from a serpent's head and they knew that something very much like ruby could be made, with a different kind of cunning, from ash, sand and a pinch of copper or gold. Such beliefs and knowledge informed the ways in which people engaged with the world, with each other and with the colour red. As St Bruno, the eleventh-century bishop of Segni, said, red stained glass and imitation rubies 'preach not by speaking out loud but by signifying'.[45] These synthetic reds provide tantalizing glimpses of an ever-present but often-hidden red thread.

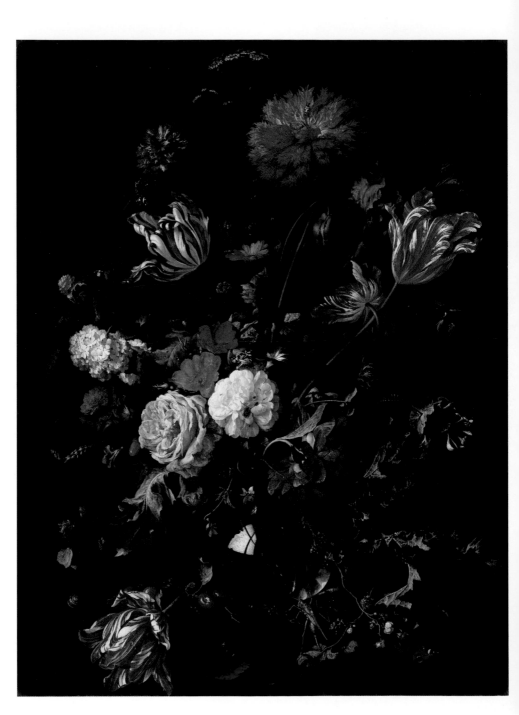

FIVE

Reds for a Better Life

A WEALTH OF NEW REDS appeared in the nineteenth century. They emerged from factories and, while each has its own story, those stories are strictly speaking not biographies because even their creators saw no life in them. (In fact, their lifelessness was explicitly acknowledged in the name given to one group of industrial reds.) Nonetheless, new industrial reds contributed to Europe's economic life since they were the single most important driving force behind the Chemical Revolution. As a result, synthetic colours are generally thought to be modern and the fact that the ancients also made synthetic colours, like vermilion and minium, is usually overlooked. It is also generally assumed that modern synthetic colours resulted from a sudden shift from old craft-based techniques to scientific exploration and new factory-based technologies. In fact, it's not that simple.

For example, at the beginning of the nineteenth century, madder was by far the most popular natural red dye and Holland had become Europe's biggest supplier. The Dutch way of making madder was small-scale and craft-based with many regional variations. Towns and regions built coveted reputations based on their madder's colour and durability, while communal 'stove houses' provided shared spaces for farmers to dry, purify and crush the madder roots they harvested every two or three years. The system had remained largely the same for centuries. However, in France, new ways of processing madder roots were being developed – processing was centralized and control was taken out of farmers' hands. Drying, purifying and crushing the madder roots was undertaken in factories on an industrial scale

30 Jan Davidsz. de Heem (1606–1683/4), *Flowers in a Glass Vase*, oil on panel. A mix of animal, vegetable, mineral and synthetic reds in an early modern painting.

85

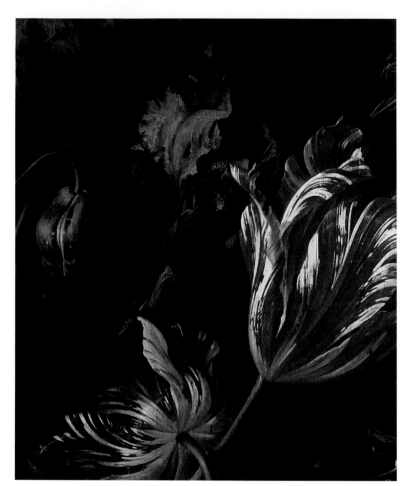

31 Detail from Jan Davidsz. de Heem, *Flowers in a Glass Vase*.

and the resulting powder was blended into homogeneous batches that were delivered directly to dye- and printworks. By 1840, the Dutch started to feel competition for their madder markets from the French. To try and win back some of their markets, the Dutch repealed legislation that prohibited mixing different grades of madder and rationalized their methods, but they stayed small-scale.[1] Then, in the 1860s another player entered the game – synthetic reds made from coal tar, a cheap, dirty and rapidly accumulating industrial waste product.

Colour from coal

The acknowledged father of synthetic coal-tar dyes was August Wilhelm von Hofmann, who extracted aniline from coal tar in the early 1840s, then managed to synthesize it from benzene and ammonia. He came to London in 1845 and carried on working with aniline because he saw it had similarities with a number of drugs, including the anti-malaria drug quinine. By the 1850s he had a large number of students.

In 1856, Professor Hofmann's teenage laboratory assistant, William Henry Perkin, discovered that one particular failed quinine experiment yielded an intense purple colour. Perkin promptly resigned from the Royal College of Chemistry and, with his father's backing, set up a commercial operation. He went on to generate a considerable personal fortune from mauve (his story has been told elsewhere).[2] Meanwhile, another less well-known student of Hofmann's, Edward Chambers Nicholson, also went on to manufacture dyes industrially. Nicholson continued to cooperate with his mentor, Hofmann, and their collaboration spawned a whole range of other aniline colours – including an extremely important red.

By the late 1850s, aniline purple was the colour to die for in fashion and it was manufactured by Perkins in England, as well as by others in France and Germany. Its popularity encouraged further research, and in Alsace, the traditional French textile-producing area near the German border, a new red – aniline red – was discovered. It was called 'fuchsine' in France and 'magenta' in England and it became a spectacular success in 1859. Hofmann's analysis showed that the salt of aniline red, called 'roseine' then 'roseaniline', had the formula $C_{20}H_{19}N_3, HC_2H_3O$. Such detailed chemical characterization was extremely useful because it enabled litigation in cases of patent infringement, since the potential profits from red dyes created great rivalry in the nascent industry. Thanks to Nicholson's precise manufacturing skills, it could be proved that French fuchsine was none other than the red colour Hofmann had made in England the previous year.

Professional rivalry between academic chemists – Hofmann in England and a fellow German, Hugo Schiff, in Switzerland – prompted more work on the exact composition of aniline red, and by 1864 Hofmann's hypotheses were widely accepted. This theoretical knowledge helped create powerful industrial monopolies, as competitors who wanted to make colours had to try and find different chemicals. Major lawsuits, combined with burgeoning pollution problems, encouraged the search for different approaches to red.

By 1865 Hofmann had become an international chemical superstar and, the same year, he left England to take up a prestigious post at the University of Berlin.[3] (In the second half of the nineteenth century, colour chemists' status was comparable to today's Internet entrepreneurs.) Also in 1865, a German theoretical chemist, Friedrich August Kekulé, proposed a structure for the six carbon and six hydrogen atoms in benzene. This structure – a ring – came to him as a dream in which he saw a snake biting its tail.[4] This image was known as the 'ouroboros' and it had been used for over 1,000 years by alchemists to depict the unity of nature. Kekulé's dream of the ouroboros was relevant to the development of synthetic dyes because academic chemists like Hofmann aimed for 'elegance and simplicity' in their understanding of matter.[5] After 1865, aniline could be thought of in terms of elegant, simple, hexagonal rings of carbon atoms, and this new way of thinking helped colour chemists to develop thousands of new dyes.

Traditional reds were not exclusively farm-based and modern reds are not exclusively factory-based. The real difference between traditional and modern synthetics is encapsulated in the tail-biting-snake-turned-six-membered-ring. The main difference lies in the way their complexity is expressed. The complexity of the old synthetic reds was internalized and was only glimpsed through poetic imagery, such as the elemental dance of mercury, sulphur and vermilion. As impenetrable alchemical treatises attest, it was just too complex to put into words alone, no matter how poetic they might be. The complexity of the new synthetic reds, on the other hand, became externalized and was documented

in an ever-more voluminous flood of chemical publications that featured explicit numerical formulae, molecular structures, chemical routines, factory equipment and more. In the process, the human being was usurped from the centre of the operation and banished to its periphery. The medieval alchemist had an intimate 'social' relationship with his or her mercury and sulphur and got as close as possible to them. On the other hand, the modern chemist has a distant 'technical' relationship with aniline and aims to make it as impersonal as possible.[6]

From laboratory bench to factory floor

Back in the 1850s, Hofmann had difficulty understanding certain aspects of aniline, and in the absence of Kekulé's theoretical structure, he had to wait for 'industry to fill up this blank' with its 'instinctive mode of experimenting'.[7] As an academic chemist, he knew that industrial chemists like Perkin were driven by different motives, faced different challenges and found different solutions to problems. The journey from a process that worked in a speculative laboratory test tube to one that worked in a profitable factory vat was not an easy one.

In the 1860s, the industrial production of synthetic colours used scaled-up laboratory equipment and was very labour-intensive. By the 1890s, however, colours were made in custom-built industrial equipment that was very capital-intensive. As the search for chemical pathways for making dyes stabilized, more and more specialized equipment evolved. The range of machines used for making aniline red using arsenic acid, for example, was described in nine publications between 1863 and 1889. Variations in the industrial preparation of alizarin show that it took about seven years to develop the patented process into a full-scale industrial process. The chemistry of red dyes stretched the ingenuity of engineers and the pursuit of new reds was the major impetus for industrialization. Equipment rapidly increased in size so that within a few decades, laboratory experiments which involved hand-held glassware had turned into processes that were

undertaken in thousand-litre iron vessels. These were fitted with manholes that allowed an unfortunate person access to the internal machinery, which was constantly being eroded by toxic, corrosive ingredients.

The industrial reds were the co-creation of chemists in laboratories and engineers in factories who, between them, pushed the frontiers of technology. And the importance of both sets of skills was recognized by financiers and lawyers. Some chemical advances were publicized and others were kept secret; likewise some process machinery was advertised and some was discreetly glossed over. Financiers and lawyers were also in completely new territory and they had to negotiate the competing demands of protecting investments through secrecy and promoting investments through advertising.

Dyeing processes and dyed textiles featured in the Great International Exhibitions of 1862 (in London), 1867 (Paris), 1873 (Vienna) and 1878 (Paris). Quite quickly, the colour makers had worked out that secrets were hard to keep. Patents were intensely scrutinized and if no patents were applied for, then the actual dyed materials were pulled apart by a mushrooming army of analytic chemists. It became apparent that secrecy about chemical processes only gave manufacturers a head start of a few months, and secrecy about industrial equipment could not be retained for more than a year or so. This was in large part due to the mobility of labour within the chemical industry.[8]

The men, women and children who made reds . . .

Historically, the people who made red dyes lived in towns with connections to crop-growing regions (for local madder) or to ports (for imported cochineal and so on) and to centres of textile processing. For centuries, Norwich had been England's second city based on its dyes and textiles, but by the eighteenth century the textile centres had moved north as mechanized looms revolutionized textile production. An even more radical disruption to dye production took place a century later after the

SPECIMEN TINTS OF WATER COLOURS

JAMES NEWMAN, LTD.
24 SOHO SQUARE, W.

| MADDER ARMINE. | MADDER LAKE. | MADDER PERMANENT CRIMSON | MADDER RED. | MADDER "ROSE DORE." | MARS ORANGE. | MARS RED | ORANGE VERMILION No. 2 (as Field's) | PINK MADDER. | PINK MADDER, DEEP. | REMBRANDT MADDER. | ROSE MADDER. | ROSE MADDER "FONCE." | ROSE ANTIQUE. |

32 Madder's last gasp. After alizarin decimated the large-scale trade in madder, specialists still provided the colour. This 1930s swatch shows 10 of 17 madders available from a London artists' supplier. Other swatch sheets show 7 more madders (Scarlet, Purple, Rubens and Yellow Madders – both pale and deep – plus Madder Orange and Madder Green).

discovery of aniline colours. The new synthetic reds were produced in massive amounts with capital-intensive equipment and – despite optimistic predictions of coexistence as late as 1880 – the small scale producers of natural reds simply could not compete. In France, a quintal (just under 50 kg) of dried madder roots cost 200 francs in 1865. Ten years later, the same amount cost one-eighth as much – just 25 francs. Around the same time, Britain imported madder from Turkey, but by the 1870s the value of the imports had plummeted to one-tenth of their 1850s value. All natural colours were affected so, for example, Sri Lankan red lichen fell from £380 per ton in 1851 to between £20 and £30 by 1867.[9] Whole ways of life were destroyed by the development of the coal-tar reds.

Madder's demise came about because of a company founded by a German colour maker and a colour merchant. In 1868 the company, Bayer, characterized the structure of one of the red compounds found in madder roots, and the following year they managed to synthesize 'alizarin', the artificial version of that natural red compound. (They filed a patent for the process in London, one day before Perkin filed an almost identical patent.[10]) By 1870 Bayer had improved the profitability of the process, starting from coal tar, and began production. In 1871 they built a dedicated alizarin factory. By 1874 the factory employed 64 workers and by 1877 it employed 136 and produced 6,000 kg of

alizarin per day. Bayer was not alone in growing an enormous business by extracting colour from coal tar. Another German giant, BASF, was founded in 1865 and the 'A' in its acronym stands for aniline, the first source of colour from coal.

While British factories (aided by German chemists) had led the world in the production of synthetic colours in 1865, a decade later German factories had taken the lead. Their rapid expansion was due to systematic research and an international marketing effort that was the first of its kind.[11] The proliferation of chemical factories across Germany also coincided with the political unification of 25 German states into the German Reich in 1871. That same year, the Treaty of Frankfurt allowed the French to buy German synthetic alizarin that undercut their own home-grown natural madder-sourced red dye.[12]

By 1913 Bayer employed 10,000 people, and by 1914 Germany produced 85 per cent of the world's synthetic colours. In 1925 the chemical cartel IG Farbenindustrie AG (*Farben* means 'colour' in German) was formed from Bayer, BASF, AGFA and others, many of which had also started as colour manufacturers (the last 'A' in AGFA also stands for 'aniline'). As a result of the First World War, the German share of the world market in synthetic colours had fallen to 44 per cent in 1926, but after the formation of the cartel it rose again to 65 per cent by 1932. In 1933, Hitler was named chancellor and, by 1937, IG Farben, by this time purged of Jewish scientists, was actively involved in the Nazi preparations for war. Between 1939 and 1943, IG Farben's profits more than doubled as it converted its colour factories to produce chemically related nerve gases and explosives. The cartel participated in the construction of Nazi concentration camps, and the prisoners who worked in their camp factory had a life expectancy of three or four months, while those who worked in their coal mine lasted about a month.[13] At the end of the Second World War, in 1945, IG Farben's cartel of 2,000 firms was dissolved. Patents were seized; technicians and scientists were interrogated and then promptly re-employed by the Allies or in the companies that had originally made up the cartel and which continued as separate entities.[14] At the time of writing, Bayer's motto is 'science for a better life'.[15]

IG Farben's use of forced labour in concentration camps took to an extreme the chemical industry's already bad reputation for labour relations. English colour works were exempted from the 1850 Factories Act until, under pressure, workers' conditions gradually improved. By 1862, the working week was reduced in stages to 60 hours (ten and a half hours on weekdays and seven and a half on Saturday).[16] Not only were hours in the colour factories long, they were also extremely unhealthy. In the 1940s a trades unionist documented the hazards faced by colour workers, including fatal conditions associated with the most common raw ingredient, coal tar, and the final products, including the entire aniline family of dyes.[17] Fifty years later, research in America has demonstrated that the risk of cancers among those who manufacture aniline dyestuffs is still significantly higher than in the population as a whole.[18] And the manufacture of solid pigments was not necessarily much safer. For example, those who worked with chromium (the element named after its many colours that was isolated at the end of the eighteenth century) risked riddling their bodies with painful ulcerated 'chrome holes'. As the name suggests, these ulcers completely ate away the flesh and were first recognized as a major industrial hazard less than 30 years after the metal's discovery.[19]

Of course, making natural colours was not always easy either, as was clear from the rasping of brazilwood in Dutch prisons, although this was a rather unusual, ideologically motivated and ultimately unsustainable local practice. Making most natural colours had usually been an integral part of the seasons, with the rhythm of work determined by the sun and moon rather than by the prison or factory clock. The changes that occurred with the modern industrialization of synthetic reds came at a considerable cost for those who made them.

. . . and their neighbours

The manufacture of synthetic colours was not just a cause of nuisance for those who worked in factories. Pollution caused

by the manufacture of synthetic reds became a public issue practically the instant the factories were set up. The favoured way of making aniline red used arsenic acid and lots of highly toxic waste was produced. In the 1850s, concern was expressed in many parts of Europe and by the 1860s the dye manufacturers were lobbying hard for the right to 'sacrifice' stretches of river downstream from their factories. Just one example gives a hint of the scale of the problem.

In Basel, the firm of J. G. Geigy had been extracting reds from dye woods (including brazilwood) since 1758, and in 1859 they converted their factory to make aniline red. The factory was leased to Müller-Pack, who started making the red chemical marketed as fuchsine or magenta. Three years later, in 1862, Geigy built a second factory nearby, which Müller-Pack also leased. That same year, Müller-Pack won a prize for colours extracted from dye woods at the International Exhibition in London where Hofmann also described his new arsenic-based recipe for aniline red. Müller-Pack adopted the new process and, almost immediately, more concerns about workers' health arose.

Basel's public chemist visited the factories in April 1863 and noted that arsenic waste was being discharged into unlined pits. In May they visited again and saw that factories released arsenic-rich wastewater into the neighbouring canal twice daily. In October, the Basel authorities received complaints about escaped aniline gases. In November, they forbade further manufacture of dyes in one of the factories. A visit in January 1864 revealed that the injunction had been ignored and the city council again ordered Müller-Pack to stop producing aniline red. Instead, they carried on, simply converting the red into a blue and a violet.

In July 1864, the public chemist published details of water samples taken from nearby wells and demonstrated that arsenic from the factory waste pits was seeping through the soil and into the local drinking supply. The court action went on for eight months – Müller-Pack was struck off the registry of businesses and the Geigy family took over the factories again, building a pipeline to dispose of waste directly into the Rhine. In 1873

official reports noted that the Geigy operation was still a public nuisance and the Basel authorities banned further manufacture of aniline red with arsenic acid. Yet through the 1880s, Rhine fishermen still reported large numbers of dead fish. Although the issue was of wide public concern, the chemical companies were sufficiently powerful to dictate terms. German dye manufactures started to ship their waste off to the North Sea and the Baltic but the illegal dumping in rivers continued. No fatalities were recorded as a direct result of Müller-Pack's poisoned wells, but around the same time several people died in the vicinity of a French aniline-red factory.[20]

Now, it might be said that problems for workers and the wider environment are not peculiar to the manufacture of synthetic reds. And that would be true. Similar problems can be associated with nuclear power or fracking or any number of other current industrial processes. However, the conceptual structures and physical infrastructures that lie behind nuclear power, fracking and other current industrial processes owe much to the modern synthetic reds, just as current economic and trade structures owe much to New World cochineal.

Although much trumpeted in the Anglophone world, Perkin's mauve was not the first coal-tar colour (yellow picric acid was) and it was not the best coal-tar colour (it was rapidly superseded by the violet derived from aniline red). The most important coal-tar colours were the reds. Aniline red was manufactured in enormous quantities because it was used in its own right and also as the feedstock for other colours – in London alone, 47 patents for other colours derived from aniline red were issued before 1868.[21] Alizarin red demonstrated the power that could be harnessed by capital-intensive industries capable of consuming other industries' waste products.

Perkin's accidental discovery of mauve had little or no effect on the import of natural dyes into England. But after the German chemists' systematic discovery of alizarin, England's imports of madder fell from 250,000 to 38,000 hundredweight in the five years between 1872 and 1877.[22] Alizarin red's decimation of the millennia-old madder trade and aniline red's colourful

offspring inspired generations of industrial chemists and their financiers. Between them, aniline and alizarin reds created the manufacturing and trading patterns that underpin today's multinational chemical, pharmaceutical and energy giants.

Using the new reds

Most of the synthetic reds went into clothes. The new colours had novelty value in the fashion industry but their importance depended upon practicalities, like price, durability and ability to bind onto cloth. Dyers liked the synthetics because they were more predictable than natural dyes in mass production. But dissatisfaction among consumers quickly set in as some of the synthetics proved to wash out easily and fade rapidly. Aniline red (1858) and its derivatives were important because they were easy to apply, but they could only be used on wool and silk. Alizarin red (1868) was better in terms of being 'fast' to washing and to light and this was the dye that had most impact on fashion. Congo red (1884) was cheap and, unlike earlier synthetics, it could be used on cotton. Tastes were changed by the synthetics, but a backlash was inevitable and in 1890 a professor of dyeing technology had to plead for balance in the use of colours, acknowledging that anilines could be 'unworthy of our attention . . . crude and inartistic' but that, correctly used, they could also make the 'older colours [look] poor and lifeless'.[23] Although the new reds (and other colours) were marketed as being more durable than the old colours, in reality, the sheer variety of them was a problem for the consumer.

The quality and durability of the many new reds were also a particular issue for painters. Today, creating problems for painters would be seen as relatively unimportant – few would worry that science might create difficulties for artists, or indeed see a connection between the activities of scientists and artists. But the period in which the synthetic reds burst upon the scene also happened to be the period in which living artists, like members of the Pre-Raphaelite Brotherhood, enjoyed

their highest ever status in the modern world. As a result, the difficulties faced by artists motivated scientists to try and find solutions for them. For example, from around 1795, analytical chemists sought to discover the composition of one of artists' most expensive pigments, lapis lazuli, in order to make a cheaper alternative. Governmental bodies promoted the search with international competitions and a French chemist finally won a 6,000-franc prize in 1824.[24] (This is why synthetic lapis is now known as 'French ultramarine'.) So when the modern synthetic reds started to create problems for artists it was seen as a cultural issue of some significance.

In the October 1856 issue of an arts journal called *The Crayon*, advice was given about which reds could be trusted and which were to be avoided. Vermilion and all iron-based or earth reds, for example, were considered 'permanent', while minium or red lead had become 'objectionable', due mainly to the polluted Victorian environment, as it was 'liable to the injurious action of foul vapours'. Dragonsblood, which had long been known to fade, together with madder and cochineal, which can be permanent, were also 'rejected' along with some of the new unstable or toxic synthetic reds, like 'peroxide of mercury', 'iodide of mercury' and 'phosphate of cobalt'.[25]

The Pre-Raphaelite painter William Holman Hunt entered into a long correspondence with his specialist supplier of artists' materials, the colourman Charles Roberson, to complain that his reds 'turned liverish'.[26] He even included a painted-out sample to demonstrate the problem, which the colourman dutifully tried to rectify. In 1869, *Field's Chromatography* claimed that madder was often adulterated with 'brick-dust, red ochre, red sand, clay, mahogany sawdust', while finely powdered French madders contained 'half their weight of gum, sugar, salts' and more.[27] Modern analysis of paints revealed that artists' madder could be contaminated with, or even completely substituted by, aniline red.[28] Such adulterations, fraudulent exchanges and even the simple limitations of untested novel materials could have dramatic effects. For example, Vincent van Gogh's sunset-pink clouds have completely faded to a pure white on *The Oise at*

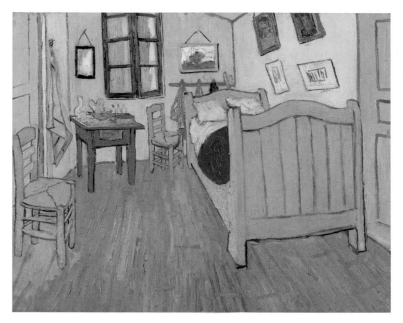

33 Vincent van Gogh, *The Bedroom*, 1888, oil on canvas. The image is a reproduction of the painting's appearance under normal lighting conditions in 2015. The colour balance has shifted from what he actually painted due to the fading of red Geranium Lake and cochineal, mainly in the walls, floor and door. In letters to his brother Theo and to his fellow painter and friend Gauguin, Vincent described his bedroom – with violet or lilac walls and red floor – and described the painting as 'suggestive of rest or of sleep'.

Auvers (1890). The original colour is just visible around the very edge of the painting under the frame, where the fugitive red has been protected from the light.[29]

Twentieth-century painters continued to be caught out by their reds. For example, Mark Rothko mixed lithol red (a fugitive colour, also used in rouge) with French ultramarine (a permanent colour) to create the crimson backgrounds of his *Harvard Murals*. These were hung in bright light in the early 1960s, so the red faded dramatically, prompting the paintings' removal.[30]

The problem of unpredictable colour was caused by a division of labour that accelerated through the eighteenth century. But it was greatly exacerbated by the collapsible paint tube, which was invented in 1841 and was adopted by painters almost instantly. The paint tube liberated artists by providing them with pre-prepared

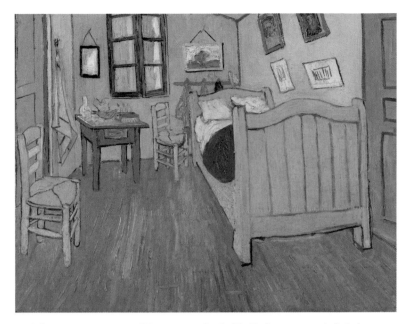

34 Colour reconstruction of Vincent van Gogh, *The Bedroom*, 1888. A digital colour reconstruction of the painting's probable original appearance, which is altogether warmer, softer and quite possibly more 'suggestive of rest or of sleep'. This image was made by Ella Hendriks (Van Gogh Museum) in an interdisciplinary collaboration with Roy S. Berns (Chester F. Carlson Center for Imaging Science, Munsell Colour Science Laboratory, RIT, Rochester, New York). The image was created by the application of Kubelka-Munk theory, using spectral data derived from the artificial ageing of historically informed physical paint reconstructions.

materials that, for the first time, could conveniently be taken outside to paint in the countryside. For centuries, painters had made their own colours and used them immediately or stored them in small bladders, to be punctured with a thorn before squeezing out paint. Very briefly, between the bladder and the tube, the paint syringe made an appearance in the studio. The paint syringe symbolized the artists' problem of novel, and possibly adulterated, colours. The painter had become like that other syringe user, the drug addict – both of them depended upon on their supplier and neither could know with complete confidence exactly what they were buying.

The ordinary consumer faced precisely the same problem. The ancient *confectio alchermes* and more recent Campari were – for remedial or recreational effect – coloured red with kermes

and cochineal, but cheaper, synthetic red food colourings replaced many natural reds in the nineteenth and twentieth centuries. Then it was discovered that some of these new reds caused cancer and others induced behavioural problems. Slowly, over a period of decades, the natural reds started to make a comeback. The trade in New World cochineal (the cultivation of which had been decimated, along with the cultivation of madder) started to recover, with Tenerife and Lanzarote in the Canary Islands and Ayacucho in Peru producing several hundred tons of dried insects each year.[31]

In the course of just a few generations, following the artists, the public had entered completely new territory in their relationship with colour. People no longer knew where colour came from. Their reds might be from a natural or a burned earth, from vermilion, minium, madder or cochineal. Or they might be from chromium, aniline, alizarin or literally hundreds of other sources. Red had been uprooted from established places, ways of life and trade routes. However, within a few generations, relationships with red were destined to become even more complicated.

Brave New Reds

T HE INDUSTRIAL REDS – like aniline and alizarin – may have been new in themselves but they did little to extend the range of available colours. Claims of major advances in the historic availability of colour are due to a combination of ideological bias and simple ignorance of the historical evidence.[1] In general, manufactured colours just got cheaper and the industrial reds simply enabled clothes designers and painters to play new variations on themes they had already been exploring for centuries. However, the cheapness of industrial colour did spawn some new visual vehicles – like billboards and packaging, for example – and these, in turn, fed back into fashion and artistic practice. Also, in the twentieth century a small number of brand-new colours did appear.

Fluorescent 'dayglo' colours, which include a range of reds, were developed in the 1930s; they were popular in the 1960s and are now enhanced by ultraviolet light or 'black light'. They were completely novel and are quintessentially modern. In addition to these reds, modern science has also produced some other reds that no historic artist seems to have predicted. (Art usually anticipates science but, to the best of my knowledge, these brave new colours are not to be found in science fiction, a genre that dates from the seventeenth century.) Yet even though these other reds are radically different from everything considered so far, they did not arrive completely out of the blue.

Anyone who went to church in the Middle Ages would have seen them on the floor, the walls and even on fellow members of the congregation. These reds are not obviously grounded in any

red material – they are projected from materials which themselves may or may not be red. The builders of great churches and cathedrals decorated their windows with a multitude of cut and coloured glasses. They were intended to tell stories from the Old and New Testaments. Yet as St Bruno said, the glass and colours themselves, irrespective of what they might depict, could also silently 'preach'. When the sun shone, the stained-glass windows projected gentle, slowly shifting patchworks of colours. For over a thousand years, traces of those colours have repeatedly moved down one wall, across the floor and up the opposite wall as the sun rises and sets.

Then, in the late Middle Ages, the magic lantern appeared, following in the footsteps of church stained-glass windows. Magic lanterns employed painted glass slides, starting as magicians' equipment before turning into an Elizabethan plaything and finally becoming a widespread phenomenon in the nineteenth century. The cinema, with its silver screen, quickly followed. All of these involve shining light through coloured materials – in the case of red, this could be copper in medieval stained glass, dragonsblood in Victorian painted glass, or organic dyes like aniline red on modern celluloid film, and so on.

What follows is a brief overview of science's accelerating development of the brave new reds that emerged along the twisting thread that continued beyond the stained-glass window, the magic lantern and the cinema.

35 Disembodied red about to disappear back into a south-facing stained-glass window at the end of the day after a circular journey across the floor of King's College Chapel, Cambridge, then returning to climb a west-facing wall.

The hunt for new reds

The past century has seen astonishingly frenetic activity in making brand new reds. There are two main ways of making them. All traditional, and the vast majority of modern, paints and dyes, as well as stained-glass windows, magic lanterns and cine film, selectively absorb light, whether it is from the sun, a paraffin lamp or the bulb in a projector. Yet colour can also be created by exciting something until it emits light.[2]

All sorts of apparently dull things can be persuaded to make colour when excited. The most obvious example is the ordinary iron poker which, when put in a fire, glows bright red. But the effect is passing and, as the red-hot poker cools, it goes back to black. Other relatively dull-coloured metals can also give off extraordinarily bright colours when burnt in a flame. For example,

36 The planet Jupiter and an almost full moon about to be temporarily eclipsed by the ephemeral drifting red smoke of a firework display.

calcium makes a brick-red, strontium makes an orange-scarlet and lithium makes a violet-crimson. Health and safety laws permitting, these colours are now demonstrated in rather dry high-school science lessons. More entertainingly, they can now also be choreographed with split-second timing around the globe in spectacular firework displays every New Year's Eve. They first appeared in China around the seventh century and their original name, *huo yao* or 'fire-drugs', suggests a connection between these colours and the use of metals in Chinese medicine.[3] Putting something in a fire is an obvious way to excite it, and another way to give energy to something is to expose it to light (just as we warm up when sunbathing). When light shines on something, if the energy that it absorbs corresponds to visible light, then it has colour – like dyes, pigments and apparently solid rocks. Things that absorb ultraviolet light do not necessarily have a colour, but the energy they absorb can still cause changes (just as we go red if we stay in the sun too long without protection from uv).

'Dayglo' colours absorb ultraviolet light and respond by emitting visible light. They were intended to do so permanently, although in practice they tend to fade quite quickly. However, before the physical phenomenon that underlies dayglo was used to create bright clothes, paint and make-up, it was used to create coloured light. 'Phosphors', materials which absorb ultraviolet light and emit coloured visible light, were first used in neon lights in the early 1900s and combinations of them are still used today in low-energy light bulbs.

Other materials could give off light when they were painted inside one end of a big, heavy, evacuated glass tube. These materials were then excited by being hit with a stream of electrons fired from a 'cathode' at other end of the tube. In 1927, it was proudly announced that such a vacuum tube could produce 'as many electrons per second as a ton of radium – and there is only a pound of that rare substance in the world'. It also noted that 'the [white] mineral calcite apparently becomes red-hot coals when exposed for a moment to these [cathode] rays'.[4]

Bulky 'cathode ray tubes' were mass-produced to make very small black-and-white screens for quite large television sets. The

37 Sue Shepherd, *Fire 1*, 2014, found object and neon. This sculpture uses fluorescent excitation (of low-pressure neon gas, with several tens of thousands of volts) to mimic incandescent excitation (of a 1-kilowatt filament), which in turn mimics the traditional combustion (of carbon) as a source of domestic heat.

38 Shepherd, *Fire 1*. Neon gas in the absence of several tens of thousands of volts.

screens quickly grew in size, but it took a relatively long time for colour television to appear – in the 1960s, after nearly 40 years of feverish research – mainly because of the difficulty in finding phosphors that would give off red light. White calcite may have glowed like 'red-hot coals' when bombarded with cathode rays but, in other respects, it was not suitable for colour TV.

The cathode ray tube brought the world into the living room and, for half a century, it could be shut away behind wooden-veneer doors, camouflaged as domestic furniture. This may have been in part because of an understandable reluctance to sit on the sofa looking down the barrel of a ray gun capable of turning white rock red. It is, after all, no coincidence that ray guns proliferated in science fiction around the same time that cathode ray tubes appeared in the living room. Another reason for shutting televisions away in cabinets could be because of a spooky association with surveillance. The cathode ray tube's best-known military application was in radar, where it visualized hidden threats. At home, people might have felt that when they were not watching the tube, it was watching them.

Flat reds

Behind the screen, the electronics in the box were getting smaller and cleverer. By the early 2000s, cathode-ray tubes had been almost completely replaced by flat screens, although they live on in the name of the video-sharing website YouTube.[5] (Similarly, the magic lantern lives on in the concept of digital PowerPoint 'slides'.) Computers had arrived, and after managing to create a much-vaunted eight colours on the screen, they then achieved 256 colours and now, with eight bits, they are said to offer nearly 17 million colours. Yet every single one of the 17 million theoretically different colours that software can specify has to be displayed on a screen that – exactly like the old-style colour TV – is capable of making just three colours – one red, plus one green and one blue.[6]

The old technology of coloured neon tubes was revived and miniaturized and a generation of 'plasma screen' televisions was

made that used ultraviolet light from xenon gas to excite red, green or blue phosphors. Another way of making flat screen displays used 'light emitting diodes', or LEDs, excited by an electric current. The first commercial LED displays used inorganic materials, including some that were related to artists' pigments. More recently, 'organic LEDs', or OLEDs, have been developed. These are ultimately derived from coal tars and some of them include anthracene, which was the nineteenth-century starting material for industrial synthetic alizarin. While things may seem to change, they also remain the same, like a red thread twisting along inside a rope.

At the same time as looking at different ways of emitting light, scientists were also working on new ways of absorbing light, following in the footsteps of stained-glass windows, magic lanterns and cine film. Most of these modern variations have now fallen by the wayside. One of them, 'dichroism', required light-absorbing crystals to be held in various orientations by electric fields. This sounds very hi-tech. However, the favoured medium in which these crystals were flipped around was first made by adding iodine to the urine of a dog that had been fed quinine.[7] Urine and quinine make it sound like a strange variation on the traditional method of making artists' Indian yellow from cow's urine, the alchemical discovery of phosphorus from human urine, or the failed nineteenth-century quinine-making routine that resulted in Perkin's lucrative mauve.

From the 1960s, one of the more successful methods used 'liquid crystal displays', or LCDs. These first appeared on very small screens too, on wristwatches and calculators, most of which were made in Japan. The liquid crystals themselves were all ultimately made from coal tars and the early ones again included some of the nineteenth-century synthetic reds. At the end of the 1970s, worldwide sales of liquid crystals were worth less than £5 million per annum, but at the time of writing, the figure is more like £1,000 million per annum.[8] Now, LCDs in phones and other electronic gadgets contain a cocktail of around 30 different chemicals.

Reds with sell-by dates

These late twentieth- and early twenty-first-century reds are radically different from any reds enjoyed by the whole of humanity from Palaeolithic times right up to the dawn of the Swinging Sixties. With all the other reds, whether natural or synthetic, durability was most highly valued and clothes or pictures in which the red faded would be considered to have failed. There were early hints that these brave new reds – the products of excitation – were different because the red-hot poker turned black as soon as it cooled and dayglo faded faster than other commercial colours.

The brave new reds created, and then fed, an appetite for colours that would change before your eyes. Magic lantern shows and the cinema made colours and images that changed (on the screen), but they also needed to endure (on the slide or reel), since film technologies recorded events that had to be viewed in retrospect. On the other hand, the cathode ray tube and its slimmed-down successors were capable of instantaneously projecting colours and images across space. These newer technologies could broadcast live events, which is why the cathode ray tube could invade the home so much more aggressively than any magic lantern.

In order to change instantaneously, colours had to be able to come and, crucially, also go. White calcite may not have been a suitable phosphor for colour TV because it may not have been able to switch its redness on and off quickly enough when bombarded with cathode rays. With the reds (and the greens and blues) created by phosphors, LEDs and LCDs, the age-old goal of durability became a fatal flaw. The fading that had devalued brazilwood and lichen reds now became a highly desirable feature. Durability caused ghost images that rendered TV, computer and phone screens unfit for purpose. Modern science's new goal was to produce completely ephemeral reds.

In themselves, ephemeral reds are nothing new. The red sky lasts only a few minutes at dawn or dusk and the nebulous

floating red patch in a sunlit church slowly climbs the wall and fades away. Modern science, on the other hand, has put an enormous effort into making reds that can disappear in a few thousandths of a second. Of course, the same colour should ideally continue to appear and disappear, and scientists aimed to make electronic components with working lives of hundreds of thousands of hours. But the reappearance of a disappeared red does not just depend on the lifetime of a sporadically excited light source. The return of these brave new reds depends on the correct functioning of every other component in the gadget, as well as, of course, on the desirability of the gadget itself as a fashion item.

There is no problem as such with immaterial reds, but the apparently arbitrary nature of the coming and going of reds with instant sell-by dates is brand new, and it takes the cultural significance of colour into uncharted territory. On their own, all of the most recently invented things that can look red only do so when excited. When the gadget is switched off, when the battery dies, or when a software fault arises, what was a riot of colour instantly becomes uniformly dull. Digital colours are the outward face of virtual realities that may or may not be real. As more and more of our experience of red is provided by electronic screens, our contact with real red things is weakening.

The brave new reds are very different from cochineal, madder, red earth, vermilion or alizarin, for example, because they are only potentially red. Sooner or later all digital devices show their 'true colour', which is a dead-grey screen. The brave new reds only actually become red when a literally unimaginable number of conditions are satisfied. Some of these conditions – like flat batteries – may be in the viewer's power to rectify. Charge the battery and the lost colours can be regained. But the provision of these new reds rests upon a very wide spectrum of necessary conditions, the vast majority of which are completely outside any individual's control.

The technological conditions necessary to maintain these reds – such as the operative lifetimes of the gadget's components – seem to be of geeky academic interest when the wider issues are recognized. The things that keep the brave new reds red

include licensing agreements, business models of Internet service providers and the geopolitics of power-supply security. (Even disregarding the international oil market's fraught vicissitudes, the domestic distribution of power is complicated enough. Jane Bennett used the example of an American blackout that affected 50 million people in 2003 to examine the factors that lie behind just this one aspect of power supply. She suggests that the grid – an assemblage of power plants, power lines, politicians, businessmen, consumers and, of course, electrons – has a life of its own.[9] Virtual reds exist at the mercy of such poorly understood life forms.) The reds also rely on the relationships that multinational corporations have with governments and environmentalists in the 'developed' world, and with warlords in the 'developing' world, for example, to ensure the supply of essential ingredients for digital devices, such as the rare metal tantalum.

The brave new reds – along with the brave new greens and blues, of course – have changed the rules of engagement across all aspects of culture. Their arrival in the modern world is like the arrival of New World cochineal beetles in the Old World 500 years ago. Those tiny dried insects – or more accurately, our desire for the colour they gave us – caused major cultural disruption, as ways of trading had to be radically revised. Similarly, the even smaller electronic components – or more accurately, our desire for the colours they give us – have just started to force another major cultural change. One obvious sign of the way they have helped disrupt the current rules of engagement is the fact that, in 2008, display screens in banks and financial exchanges across the whole world all went red, indicating a virtual lack of money. At the time of writing, there is little evidence that lessons have been learned, and new rules for working in the digital world have yet to emerge.[10] Another sign of disruption to the established culture is the fact that piracy has now made an extraordinarily profitable comeback; only now, piracy in the Caribbean looks like child's play next to piracy in cyberspace.[11]

Impact of the new reds

Previously, all colours in cultural contexts resided in
relationships between the viewer's eye and relatively
unambiguous objects like a piece of clothing, a painting
or a stained-glass window. The red colours in them usually
originated in something that was alive, like a pregnant beetle,
a dragonsblood tree (or a legendary dragon and elephant) or
a coal-tar dye (made from the fossil remains of countless living
creatures). But by the time those reds graced cultural items,
the living sources of red were all dead. Right from the very
beginnings of art, it was recognized that man-made images
needed to be brought back to life. So, from the earliest times
to the late Middle Ages, images were physically constructed
and then formally consecrated. Such ritual enlivening of images
included the ancient Egyptian 'opening of the mouth' ceremony
performed on newly created statues in a manner not dissimilar
to God's sculpting of Adam from clay, followed by his animation
by breath.[12] For the past few centuries in the West, images have
no longer been consecrated by ritual acts but they are still
animated by the people who pay them attention. The fact that
coloured things – like clothes, paintings and stained-glass
windows – all have slow, predictable trajectories towards the
scrapheap reinforces the fact that visual imagery needs our active
participation in order to come alive with meaning.

By contrast, digital colours seem to come and go at a whim
because the combined life cycles of LEDs, their supporting
gadgetry and infrastructures, are much more difficult to
understand than the life cycle of a favourite little red dress.
Being so inscrutable, digital colours appear to be there, ready-
made and requiring little or no participation. We are persuaded
that electronic screens bring great benefits, but at the same time,
we are sleepwalking into a new way of seeing colour. We should
remember the Egyptian king Thamus who declined the god
Thoth's gift of writing for his people, saying that it would implant
'the conceit of wisdom' and 'forgetfulness in their souls'.[13]

39 A mobile phone displaying part of Albrecht Dürer, *The Virgin and Child (The Madonna with the Iris)*, c. 1500–1510, oil on lime. The combination of ambient lighting, phone display screen, digital photography and four-colour printing means that the colour rendition of the painting is not necessarily accurate.

Most of us who use digital devices are now aware of 'identity theft', which highlights the inescapable fact that, simply by using a system, the user becomes part of it and is no longer separate from any part of that system. In the process of assimilation into the system, the user's identity is reduced to handfuls of digits and he or she is no longer seen as a living, breathing person.[14] Collectively, we have impoverished our social identities to the extent that they can now be misappropriated without our even

40 Magnified shots of the same digital file shown opposite displayed on a calibrated LCD digital screen. These are four-colour printer (CMYK) renditions of the red, green and blue levels in the LCDs which can each vary from 0 to 256. The RGB levels in the top section are approximately 180, 70, 50 (the combined effect corresponding to the orange-red of the Virgin's proper right arm). In the middle section, the levels are about 175, 110, 120 (together corresponding to the pale-red of the Virgin's lap). In the bottom section they are 100, 3, 20 (corresponding to the dark-red below the Virgin's proper left arm).

noticing. And at the same time, digital colours have also suffered a kind of 'identity theft'.

Red used only to shine from things like a ruby, a strawberry, a robin's breast, or from paint or ink made of vermilion, madder roots or cochineal beetles. But now red can shine from more or less anything, and whatever shows red one second may show any other colour the next, since digital reds rest on unstable foundations whose default colour is no colour. Even when they show red, those reds inevitably lose the nuances of the originals because they are created on screens with uniform surfaces. The comforting uniformity of the screen's physical surface may even account for people's desire to deal with virtual realities rather than with a threateningly diverse real world. The ubiquitous screen means that digital rubies, strawberries or robin breast feathers are all exactly the same red, plus or minus varying bits of green and blue. Moreover, they all have exactly the same texture. Our visual processing of colour is intimately tied up with our visual processing of texture, yet a digitized ruby red has no depth or sparkle, a digital strawberry red has no softness or moisture and the robin's red breast does not flutter and pulse on the screen.

Of course, technologically induced changes in our relationship with colours have happened before. The translation of 'things' into 'images', whether paintings or statues, has always been fraught with difficulties and, over millennia, different cultures found different solutions to the problems posed by paintings and statues. Regularly, waves of iconoclasm across the globe have demonstrated the depth of feeling stirred up by images and the accompanying possibilities of idolatry, the confusions between the depiction and what it depicts or the relationships between likeness and presence. Those issues have not been resolved – modern objectification by pornography is just one example – but the brave new colours have incomparably complicated them by facilitating the proliferation of imagery. As one commentator has put it, 'technological feast becomes unregulated gluttony'.[15]

Digital colours add to the ubiquity of ephemeral images and they also raise novel problems. They do not end up crumpled and faded, blown across the street like discarded magazines and

newspapers, and they cannot be burned or smashed like paintings
and statues.[16] They appear to defy the laws of nature. They appear
to reside simultaneously in no particular place and in almost
any place (network coverage permitting) and they seem not to
change over time. Ripping up photos of one's ex was so much
more satisfying than limiting one's access to their images by
'unfriending' them.

When looking at the traditional use of animal and vegetable
dyes, it was clear that red was in control of the things that carried
it. Insects' and madder's life cycles determined what farmers and
traders could do, dyers determined what weavers could do and, of
course, sumptuary laws (made and adjudicated by men who wore
red) determined who could wear what.[17] Today, colour is still one
of the factors that determines whether or not clothes sell. However,
increasingly, cultural things now control the colours they carry –
digital devices have started to determine what we see and how we
see it.

Digitized colours disconnect immaterial colours from their
material sources and cast our visual world into new territory. The
skills of thousands of graduates have honed the hardware and
software, selected the best camera angles, tweaked the contrast
and composed the soundtrack for digital images. Meanwhile, the
real thing is not edited for maximum effect and we have created
a situation in which the experience of spectacular realities can now
underwhelm. Whatever it is – whether it's on the highest mountain,
in the deepest ocean, or on the football pitch – we've seen it all
before, probably in close-up and, if lucky, in high-definition.

The brave new reds are among the latest products of
modernity, a historical period that has been characterized as
one of 'disenchantment'.[18] Certainly, the stories surrounding LEDs
or LCDs (not to mention aniline or alizarin) do not immediately
seem as 'enchanting' as those surrounding dragonsblood or
vermilion. Yet the political theorist who saw the U.S. power grid
as a poorly understood life form felt that these brave new reds did
have the potential to enchant. However, she also recognized their
sinister power to enthral and delude.[19]

63.

Naissance des larves.

nat.del.

Librairie J.B.Baillière et Fils Paris.

Annedouche sculp.

Imp. A. Salmon R. Vielle Estrapade, 15,

SEVEN

Crossing the Red Line

\mathcal{I}N AN ATTEMPT TO NAVIGATE a multitude of reds, we have looked at traditional and modern things, animal, vegetable and mineral things, plus artificial reds and colourless things that sometimes look red. But the divisions between these sources of red are far from clear-cut. This is especially relevant for red things, since it was noted that red was a particularly flexible colour category – one that could accommodate yellow gold, orange flames, brown dogs and purple cloth, as well as invisible lines.

Blurred lines were evident because the pregnant insects that were picked off plants were so well attached and immobile that there was sometimes doubt about whether they were actually part of the plant. The late sixteenth-century Spanish knew exactly what they were nurturing and harvesting, yet they purposefully exploited this ambiguity to obscure the origin of New World reds and help maintain their commercial advantage. Confusion about these reds is ongoing and it may be that ignorance is bliss because being told, for example, that the red in lipstick might come from scale insects, shield lice or mealybugs (as well as, today, from BASF's industrially farmed algae), is not particularly romantic or appetizing.[1]

Red coral also blurred the traditional animal-vegetable-mineral boundaries. According to Ovid's *Metamorphoses*, Perseus laid the Medusa's severed head on a bed of seaweed that promptly 'drew into itself the [petrifying] power of the monster' and hardened to the touch. Sea nymphs scattered the seeds of these transformed weeds so that 'even today, coral retains this same nature, hardening at the touch of air; that which was a plant

41 Neither a plant (in water) nor a stone (in air), coral is more properly considered a colony of animals (alive in water and dead in air). This mid-19th-century diagram shows the birth of an individual coral-building organism.

when under water becomes a rock when brought above the surface.'[2]

We might find it quaint that some ancients appeared to confuse a pregnant insect for a rotting berry riddled with worms, or that their understanding of coral seemed oblivious to its role as a self-build community for marine organisms.[3] Or even that they described a tree resin as the mixed blood of elephants and dragons, or said that rubies were extracted from snake's heads. Yet such blurring of boundaries is not confined to the ancients. Twentieth-century hunter-gatherer communities of Alaska and Yukon saw native copper, for example, as a red metal that was born underground, could walk around 'like a big porcupine' and was not discovered by people, but sometimes actively chose to reveal itself to them.[4] And, already, a number of highly significant twenty-first-century geopolitical and military 'red lines' seem to have evaporated into thin air. If we were feeling a little more charitable about the historic blurring of boundaries, we might interpret the apparent confusions of categories as a positive fusion of those categories. Red might not just be a particular type of colour, different from yellow, orange, brown and purple, and so on. Maybe red just *is* colour.[5]

The flexibility, or porosity, of traditional categories helped make reality into one vast continuum rather than a set of many separate entities. 'Nature abhors a vacuum', and blurring the boundaries allowed for hybrids and bridges, avoiding the

42 Flashes of red. Native copper metal from Lake Superior, Canada, revealing itself.

possibility of gaps between categories. Blurred boundaries between the animal, vegetable and mineral realms were seen as reflecting the unity of God's creation.[6] In the traditional world, things differed in degree much more than they differed in kind. There were aspects of humans that resonated with animals (we and they have senses), vegetables (we and they reproduce) and minerals (we and they exist). These links accounted for the way red things – from ochre and haematite, through lichens and upwards – could resonate with people as physical, psychological and spiritual beings.

Blurred boundaries also encouraged a dynamic view of reality. Fixed categories could encourage the view that reality was made of permanent, solid things, but blurring the boundaries allows the possibility that reality might reside in the fluid process of change. Ovid, who wrote an entire book about boundary crossing – *Metamorphoses* – and painters, who habitually engaged in material metamorphoses, knew of both possibilities. Ovid presented the matter of the universe as both chaotic (in Book I) and orderly (in Book xv). Painters could take their pick, and they could follow the tradition of Parmenides – stressing the permanent aspects of reality – and could also follow Heraclitus' tradition – emphasizing reality's changing aspects. Their stories about ruby, dragonsblood, coral and kermes were ways of accommodating both possible views.

While the modern world might like to have things in nice, neat compartments, reality resists being tightly categorized. For example, red-bearing lichen are not plants, they are not fungi and they are not algae, but, whatever they are, they thrive the world over. And anthocyanins are not in red berries to make birds healthy or to spread plants' seeds; they bridge the animal and vegetable kingdoms, and they just happen to do both. Modern geologists might know that chalk is made of the microscopic shells of sea creatures and climate chemists might know that those shells were made from the carbon dioxide breathed out by animals and dissolved in seawater. Yet everyday, most of us completely ignore the fluid relationships between chalk, the carbon dioxide we produce and the 'carbon sink' in the

sea that feeds marine microorganisms. On the other hand, today's traditional potter who adds limestone – a hardened form of chalk – to their glaze is consciously using an 'organic' rock, part of a global life cycle, as a vital life force that helps their materials flow in the furnace.[7] (This practice faithfully follows in the footsteps of those first iron-smelters who, some 4,000 years ago, added seashells to their red earths to help the iron bloom flow.)

Natural and artificial

If boundaries between animals, vegetables and minerals in the natural world are blurred, then the distinction between natural reds and artificial reds is also rather hazy. The very earliest red pigments used by cave painters were sometimes red earths and sometimes heat-treated yellow earths.[8] Around 300 years before Christ, Theophrastus said that yellow earth became 'like glowing charcoal' in the fire.[9] He seemed to suggest that the earth turned red 'in sympathy with' the nature of fire. Sympathy between burned earth and fire might be hinted at by their shared red, but as elements, earth and fire also share the property of 'dryness' and so are inclined to a sympathetic relationship in the Aristotelian

43 A massive fragment of botryoidal haematite from Lancashire. Its geological name comes from the Greek for 'bunch-of-grapes shaped blood-stone'. The name – involving animal and vegetable terms to describe a mineral – is an unacknowledged remnant of more flexible pre-modern ways of seeing the world.

scheme of things.[10] The yellow earth may have turned into a red earth underneath a campfire built by humans, but exactly the same transformation could have happened as the result of a natural forest fire or divine thunderbolt.

The traditional world understood all the arts – whether changing a yellow earth into a red earth, glazing a pot or synthesizing vermilion – as activities that merely assisted nature. As the thirteenth-century *Book of Hermes* said, 'the works of man can be both natural with regard to essence and artificial with regard to mode of production.'[11] Albertus Magnus claimed that 'all things whatsoever, whether made by nature or art, receive their impulse in the first place by the powers of heaven.'[12] Heaven could either make red earth supernaturally or naturally, with a thunderbolt or forest fire, or it could do it artificially, by inspiring a person to make a campfire.

The difference between natural and artificial things was also minimized by the traditional assumption that everything participated in life and that all things acted out of their own inherent desires. (This contrasts starkly with the modern assumption that physical matter is inert and that things happen under the influence of outside forces.) Yet, even if these theoretical issues are ignored, the boundary between natural and artificial was still very imprecise in practice. For example, the natural reds from insects or plants were, strictly speaking, not very natural by the time they dyed clothing or coloured paintings. The red dyestuffs had to be attached to fibres or to colourless pigment particles in order to make 'fast' colours that would not wash out. While the raw materials for making red dyes, alum mordants and cloth were natural, the processes and end products were very far from natural.

The distinction implied in earlier chapters between medieval alchemists and artists on the one hand, and the modern scientists on the other, is not so clear-cut either. Alchemy was simply a way of understanding the world and our place in it. The modern science that emerged from it – a material 'world-view' – was achieved by separating man from nature (hence, the 'world' and the 'view').[13]

Material and immaterial

Colour has always been understood as the interaction between light and matter. Traditionally, light was seen as quite distinct from matter, yet now we are told that light might be a wave propagating through space or it might be a stream of particles. Or it might be both. Modern physics' idea of 'wave-particle duality' suggests that 'red' could be thought of in two ways. It could either be weightless waves of a particular frequency, or a stream of photons that pack a particular punch. Equally, solid matter might be an aggregate of solid particles or localized waveforms.

Fundamental physics has eroded the neat distinction between material and immaterial realities. We might treat our mobile phones as solid objects, and assume that the light they emit is weightless, but the device itself exploits a blurred boundary between the material and immaterial in order to transform a blank screen into a multitude of colours at the push

44 A range of deep reds transmitted through petals and reflected off their inner and outer surfaces. This tulip (*Tulipa stapfi*, from western Iran and northern Iraq, Botanic Gardens, University of Cambridge) is one of the wild varieties from which garden varieties were derived from the 16th century onwards. An example of the nature that lies at the roots of all artifice.

of a button. Reds don't only come from natural or burned earths, vermilion, minium, madder or cochineal, or the coal-tar-based modern synthetics, all of which existed somewhere in the world. Red now flickers in and out of blank screens on local devices everywhere, fed by, and feeding, a cyberspace that exists nowhere. The gadgets in our pockets work because the sharp dividing line between the material and immaterial has been recognized as a fiction even in the so-called physical world.

Yet, oblivious of the way our phones work, most of us still live under the influence of René Descartes' insistence upon a sharp dividing line – or even a philosophical red line – between the apparently material world 'out there' and the apparently immaterial consciousness we have 'within' ourselves. Despite Descartes' assertion, there are hints in our everyday language that we do not actually see reality as inherently divided. For example, etymologically, 'matter' is the 'mother' of the material world, and matter (as in 'Does it matter?' 'Yes, it matters.') is also the mother of our worlds of meaning. Not only is there no uncrossable red line between the 'objective' world out there and the 'subjective' world in here; one persuasive interpretation of quantum physics even suggests that matter and meaning are in fact inextricably entangled.[14]

However, most of us find quantum physics difficult, if not just plain weird, and the profoundly split, practically schizophrenic, Cartesian way of thinking is so deeply ingrained in the West that the modern mind is generally more comfortable with the apparently objective world of seemingly solid materials. It is also relatively less comfortable with the apparently subjective world of sometimes shifting meanings. Acknowledging those dispositions, I started with a focus on red things in the material world. I'd like to now shift the focus towards meanings that have been associated with red.

EIGHT

Red Meanings

*F*OR KARL MARX, DIFFERENT SOURCES of red were simply more or less efficient ways of achieving the same thing. He said,

> The making of alizarin, a red dye-stuff extracted from coal tar, requires but a few weeks [whereas] it took a year for the madder to mature and it was customary to let the roots grow a few years before they were processed.[1]

Likewise, Friedrich Engels saw no essential difference between the two reds. He said,

> the 'thing-in-itself' became a thing-for-us, as, for instance, alizarin, the colouring matter of the madder, which we no longer trouble to grow . . . but produce more cheaply and simply from coal-tar.[2]

For Marx and Engels, the mystery of red was gone, and disparate parts of the visible spectrum and material world simply existed to serve their purposes. A red flag was a commodity in which more labour had been invested than a flag that had not yet been dyed red. It mattered little whether the red was madder or alizarin, both of which were also commodities. For them, a red was a red was a red. They were blinded to the nuances of red by their enthusiasm for a materialist ideology, much like modern scientists who stand ox-like in front of Wittgenstein's 'newly-painted stall door'. Yet in distancing themselves from the possible

45 'Rich blood or malignant magenta', or maybe just a line that must not be crossed? A mid-1970s municipal planting in the newly built Milton Keynes, United Kingdom.

inherent meanings of the things that provided their reds, they became hostages to fortune. Marx and Engels were victims of the Cartesian schism – willing to use red to wield power but with absolutely no means of knowing why red should actually be able to exercise any power over us at all.

In his 1937 *Struggle for Colour*, E. Barth von Wehrenalp claimed that 'Red is for all people the colour of life, of love and of passion. Red is the colour of both of the elements of life: the blazing heat of the sun and fire.' He found it 'delightful' to declare 'war against this natural colour' and was proud that 'chemists in a German laboratory managed to carry out the fatal blow against one of the most important natural dyes', gloating over the fact that French troops' trousers were coloured red with German dyes.[3] Von Wehrenalp seemed to take it for granted that the colour red exercised power. Yet his stated desire for a scientific 'independence from nature' went only so far as independence from agricultural sources of red. It did not question why human nature itself should desire or fear red.[4]

Loving and hating reds

There might be many different reasons for desiring or fearing a particular red. For the madder farmer, one red was definitely not the same as another. His or her family and community depended on the quality of their crop, while alizarin red threatened and then destroyed their way of life. For the person who dyed cloth, madder and alizarin were different in almost every respect. For the factory chemist, too, there was a difference, since one fed his family while the other was increasingly irrelevant. In the fine arts, however, a real distinction between alizarin and madder was maintained for well over a century. Winsor & Newton were making red artists' paints from dried madder roots from 1832 until the closure of their London factory in 2011. Yet they also manufactured red paints from alizarin. Artists could, and did, choose between the two. Winsor & Newton's customers

could see – or at least, feel – that natural madder was soft while synthetic alizarin was harder. Madder contains dozens of related molecules whereas alizarin is theoretically just one molecule. The eye has to be attuned to the difference between these reds but it can be likened to the difference between a green meadow with rich biodiversity and a green field that exhibits stark monoculture. Alizarin lends itself to the flat colour block of the screen print while madder lends itself to the organic flow of the paintbrush.

Differences in reds also had wide-ranging impacts on the colour's meaning for people not directly involved with their manufacture or use. Changes in colour making had unforeseen consequences. For example, the arsenic waste product from aniline red, magenta or fuchsine that poisoned the drinking water around dye factories quickly turned out to be marketable. It was a popular insecticide in America, sold as 'London purple', and was one of the arsenal of chemicals that transformed agriculture in the nineteenth century (until it poisoned too many agricultural workers, bees and consumers). It also helped to transform horticulture as flowers started to be grown in factory-like glasshouses that needed constant chemical intervention to maintain their fragile monocultures.

The application of mass-production techniques to flower growing had an impact on gardening styles and regimented bedding-out schemes started to invade gardens, estates and urban spaces. In 1899, the English garden designer Gertrude Jekyll warned against crimson plantings that could be either 'a rich blood colour or . . . a malignant magenta'.[5] Two years later, the American gardener Alice Morse Earle reinforced the idea that magenta flowers could be a 'symbol of vulgarity' thanks to 'the forceful brilliancy of our modern aniline dyes'.[6] The new reds gave red flowers new social and political meanings. For Shakespeare, a red flower could evoke love, but thanks to synthetic dyes and the political perspectives of John Ruskin and William Morris, red flowers could now evoke industrialization, pollution, rural depopulation, deskilling and the corrosive aesthetic effects of cheap fashion.

In addition to alizarin and aniline red, there were also other plant extracts, other organic and inorganic synthetic reds and, of course, now also the disembodied digital reds, not forgetting the natural animal, vegetable and mineral reds still in use today. Each of these reds had its own stories and its own sets of significance for those people who were, or are, involved in their production and consumption. Different sets of significance exist for those who knowingly or unknowingly consume those reds, whether in food, fashion, through military uniforms or flags, or in some bureaucrat's choice of flowers in the local park. There may be many disparate and shifting threads, but a red thread is somewhere among them.

Meanings and realities

Officially, modern understanding applies meanings to realities – hard (objective) physical realities come first and then (subjective) meanings are tacked on to them. According to this view, if the colour red has any meanings at all, then those meanings are the result of pre-existing facts. But the facts keep changing, so according to the modern understanding, the meanings must change too. For example, when the last Holocaust survivor dies, some meanings associated with IG Farben's synthetic reds will die with them, and when the chemicals that induce hyperactivity in children are no longer used as food colourants, then red drinks will mean something different for anxious mothers.

Yet some of red's meanings – like von Wehrenalp's 'life, love and passion' – endure and don't seem to depend on particular experiences. They are traces of the red thread. It is tempting to treat these historic and widespread meanings in the same way as we treat specific modern meanings. But there is a very good reason for not doing so – the traditional and modern relationships between meaning and reality are exact opposites.

In the traditional world-view, meanings come first and then physical reality takes shape around those meanings. In the Christian tradition, this relationship is implicit in the sequence

'God said let there be . . . and there was' (Genesis 1:3). In the
Buddhist tradition, exactly the same is implicit in the adage
that 'with our thoughts we make the world'.[7] This traditional
truth has been confirmed many times by science. (One example
would be Kekulé's dream of a snake biting its tail that spawned
a thousand synthetic dyes. In a lecture in Berlin some 30 years
after the event, he advised his learned audience, 'Let us learn to
dream, gentlemen, then perhaps we shall find [or even make?]
the truth.'[8]) However, since this traditional understanding runs
counter to modern science's mainly Cartesian ideology, it is
not widely advertised and has been sidelined by the majority of
practising scientists.[9] Yet if, as Wittgenstein claimed, modern
science stands 'ox-like' and bewildered when confronted by
colour, there are good reasons for acknowledging or even
adopting the idea that 'with our thoughts we make the world'.

First, when considering the historic meanings associated
with red, such an approach is consistent with the assumptions
of the cultures that held those meanings. Imposing our world-
view, which has only been in existence for a couple of centuries,
would do violence to the cultures in question and would only let
us see whatever aspects of those cultures could be filtered through
the lens of our own.

Second, sociologists have observed that we tend to understand
the products of human activity as if they were facts of nature, the
results of cosmic laws or manifestations of divine will. They also
consider that unspoken assumptions constitute nine-tenths of
the iceberg hidden beneath any visible statement.[10] Even today,
many of those unspoken assumptions will be the products of
pre-modern cultures that live on as unquestioned beliefs or
unrecognized superstitions.

Third, the idea that meanings actually generate reality is not
quite as alien as it might first seem. It is a commonplace that 'you
only see what you look for'. (For example, medical examinations
include X-rays and blood tests, but which technique you use
depends on whether you want to see broken bones or sugar levels.)
We apprehend things we think are meaningful and we ignore things
we think are meaningless. We are not passive receptors of a

predefined reality; we perceive only what we are disposed to believe meaningful and those meanings in turn determine our realities.

If a person is predisposed to see red as inherently meaningless, then the colour possesses plenty of contradictory associations to support and reinforce that belief. For example, in a single medieval manuscript, God and the Devil are both clad in the same red-trimmed robes. That same manuscript also has two dripping red horses that do not differentiate between the blood of innocent victims and the blood of sacred martyrs.[11] While red in both those contexts denoted death, in early Irish colour theory, red was the colour of conception.[12]

If, on the other hand, a person is predisposed to see red as inherently meaningful, then those apparent inconsistencies need not stand in their way. An overview can resolve the apparent opposition of conception and death, for example, as 'two sides of the same coin' – the transitions into and out of this life. And if red is capable of apparently conflicting meanings, then this is completely in accord with the cultural uses, and compositions, of red materials, since haematite was the source of iron (which caused bloodshed) and rust (which cured bloodshed). This book's review of red materials also showed that dragonsblood and vermilion both embodied the conjunction of opposites. Indeed, in his *Struggle for Colour*, von Wehrenalp said that 'red

46 Feathered cloak (*ahuula*) that belonged to King Kamehameha of Hawaii in 1810. Red is not only associated with royalty in the European tradition. Red was particularly prized across the Pacific and Captain Cook found that bundles of tiny red feathers from Tonga were 'the most valuable thing' to trade in Tahiti.

is the colour of the greatest contradictions. In it is embodied the dignity of kings and the blood of revolutions.'[13] However, I very much doubt that his opinion was directly influenced by Pliny's thoughts on haematite, the legendary origins of dragonsblood or the alchemical synthesis of vermilion.

Whatever meanings may be hidden in redness, clues to them can be sought in commonly used red words and phrases. They may have ingrained cultural significance and, of course, 'ingrained' itself is a 'red' word, due to the custom of dyeing cloth with grains of kermes or cochineal. However, since most red words have their origins in the distant past, some digging is required.

Red etymologies

The term 'red' embraces more colour sensations than most colour terms, an observation which is reinforced by the fact that the Spanish for 'red' is so closely related to the Spanish for 'colour', as in the words *tinto* and *colorado*. Apart from 'black' and 'white', the term 'red' also occurs more often than any other colour term in English colloquial phrases and folklore.[14]

In the late 1960s Brent Berlin and Paul Kay wrote about colour names in their book *Basic Color Terms: Their Universality and Evolution*. Berlin and Kay's work concluded that terms for red were found in all languages (as were those for black and white) but terms for the other colours only gradually appeared as different languages supposedly evolved to greater or lesser extents. Their book was widely influential but is deeply flawed.[15] It is very Anglocentric in outlook and it turns out that there are no terms for colours that are agreed across all cultures. More recent research shows that a number of Australian aboriginal languages, for example, do not have a word for 'colour', let alone a word for a colour category like 'red', even though their art can be very colourful and use lots of red.[16]

All languages constantly develop, with changes occurring as different cultures interact with one another. These changes can be tracked back in time to reveal connections between words and

things that initially seem quite unrelated. For example, according
to the *Oxford English Dictionary* the word 'colour' developed from
the word 'cover' in Latin.[17] Similar 'cover-colour' developments
are evident in ancient Greek, where 'chrome' was related to
'complexion' and 'skin', which is, of course, the 'covering' beneath
which we present ourselves to the world. And the same can also
be found in Sanskrit with *varna*, which means both colour and
caste.[18] The connection between colour and skin is reinforced
by traditional connections between cloth and skin since, for
example, Mary wove the flesh of Christ in her womb before she
wove the seamless garment he wore.[19]

What meanings can be 'uncovered' from beneath the 'colour'
red? The words for 'red' in all Indo-European languages share a
common origin in Sanskrit, and hints of red's ancient associations
are still found in many modern languages. For example, the Welsh
rhudd links with the phenomenon of a 'ruddy' complexion, the
colouring or covering that indicates an underlying 'rude' health.
The redness of rosy cheeks is, of course, due to blood and the
Sanskrit word for red, *rudhirás*, is obviously related to the Sanskrit
for blood, *rudhirám*.[20] The English 'blood red' has its roots in
Sanskrit *rudhirám rudhirás*. According to the *Oxford English
Dictionary*, the word 'blood' may share its origins with the word
'bloom'. Roses bloom, but the technical term for the iron that flows
from haematite (or 'blood stone') in the furnace is also 'bloom',
and colloquially, women can be said to 'bloom' when pregnant.
It follows that our everyday language carries in its very structure
a profound, if usually overlooked, implication that red is linked
to – or is the 'cover' for – a vital life force. The history of languages
suggests that the colour red might be the outward sign of a hidden
inner power – a power that gives wild beasts their rude health, a
power that makes women and plants bloom and the power that
drew the sword from the stone.

Ultimately, the life force that supports all plants, animals
and humankind is the generative power of the earth. We have
seen that 'earth' was one of the oldest pigments used by artists,
making the red colours found in Palaeolithic cave paintings.
And, just as 'colour' relates to 'cover', linguists have observed that

the Indo-European root of the word 'earth' 'frequently occurs in the context of hiding or covering'.[21] For example, Homer's Hector wished to 'hide' under the earth and Achilles wanted to 'cover' his body with earth.[22] Similarly, Hesiod's summary of life on earth said that the people of the Golden and Silver Ages were 'hidden' under the earth while the Bronze Age and the race of heroes were 'covered' by earth.[23] The earth is a 'cover' and colour is a 'cover'. These linguistic connections suggest that the prehistoric, classical and medieval artists' decision to use the 'covering earth' as a 'covering colour' could have more to it than meets the eye.

Even though the 'cover–colour' connection has now been lost, its effects are still with us and they help account for the relative neglect, or even fear, of colour – as something potentially deceitful – in the European tradition.[24] Yet despite a professed disdain, rulers have always recognized colour's power to sway the masses. The historian of colour John Gage noted, for example, that the Russian revolutionary attachment to red was 'heightened by the etymological link between [red] and beauty'. He also observed that the Chinese communist anthem 'The East is Red' appeals to concepts of dawn and, through the doctrine of Five Elements, also to fire, war, joy and enlightened government.[25] It is therefore worth pursuing etymology for clues about the colour red's often hidden red thread.

Modern 'forensic' etymology painstakingly traces the linguistic changes that occurred historically as ideas travelled between cultures, and the discipline of etymology itself grew out of a much older tradition in which, according to Plato, 'everything has a right name of its own'.[26] These old etymologies were 'poetic' and they rescued texts 'from prescriptive or reductive interpretations' such that 'what the name buries . . . the etymology animates or exhumes'.[27] Finding the animating hidden meaning of words has evident value in a biblical context, since 'the letter killeth but the spirit giveth' (II Corinthians 3:6) and, through spells and incantations, poetic etymology is also connected to the practice of magic.[28]

Numerous poetic etymologies are to be found in Isidore of Seville's enormously influential *Etymologies* in which he noted a

connection between the words 'colour' and 'calor', or energy.[29]
A modern academic etymologist would not recognize a linguistic
relationship here and we generally feel that we can luxuriate in
rich colours without worrying too much about putting on weight
– we assume that even the most gorgeous colour's calorific value
is zero. Yet Isidore's poetic 'colour–calor' etymology encapsulates
a concept still in circulation: colours have, or are, energies. These
energies are currently employed in forms of complementary
medicine that have their roots in the practice of nineteenth-
century chromotherapists like Edwin D. Babbitt, who argued
that, since red things – like cayenne pepper, bromine and iron
– were stimulating, the colour red itself was also stimulating.[30]
Babbitt himself was following a long tradition in which Avicenna
used colour to diagnose and treat patients around the turn of the
first millennium. The connection between calor and colour that
Isidore noted endures, and it is why we can still say we 'feel blue'
or low, we can be 'in the pink' or balanced, or, of course, why we
can 'see red' or be agitated.

Isidore's recognition of a deep linguistic connection between
colour and energy suggests that European 'folk' culture – if not
the refined, chromophobic, European 'high' culture – contains
buried within itself the possibility of attitudes towards colour that
are similar to those found in very different cultures. For example,
an anthropologist in central Africa reported a people who spoke
of red as one of three 'rivers of power flowing from . . . God . . .
permeating the whole world of sensory phenomena with their
specific qualities.'[31] (The other two rivers were black and white.)

Particular reds

What do modern European names for particular red things tell
us about the colour? At first sight, the names of modern reds –
'Naphthol', 'Pyrrole', 'Quinacridone', 'Rhodamine', 'Toluidine' and
so on – seem too technical to be insightful for any but a handful
of specialists. Perhaps acknowledging the limited interest in such
names, they are usually referred to by CI (Colour Index) code

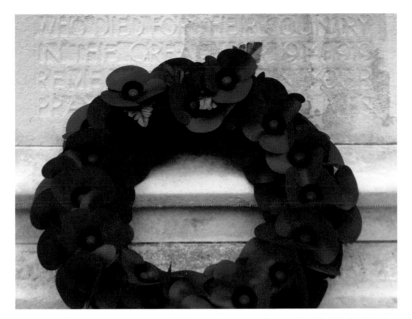

47 Remembrance Day poppy wreath, November 2014. Composite plastic, dyed red (possibly with the azo – or 'no life' – dye Ponceau). This particular wreath was laid at a church dedicated to St Giles, which gives it added cosmological significance, since he was the patron saint of blacksmiths. The fallen warrior represents the ultimate fruit of blacksmiths' martial labours. Red goes full circle.

numbers. However, collectively their names tell us something about the way red fits into the modern world.

'Aniline red', for example, tells us that it is derived from aniline, the chemical that also provided other colours and was the celebrated 'A' in the acronyms of chemical giants BASF and AGFA. The name 'aniline', coined in the mid-nineteenth century, acknowledges that this particular red belongs to a chemical family whose suffix, '-ine', is technical, but whose prefix, 'anil', comes from the Sanskrit for 'darkness'. Aniline red is therefore 'the red that comes from darkness', which succinctly summarizes its origins in coal tar. (IG Farben were fully aware of aniline's dark significance as they wrote that black 'coal deposits had locked inside of them a previous world of life, and all its colours'.[32])

Other synthetic reds belong to the range of azo dyes, thousands of which were developed over the twentieth century. They are now the biggest family of synthetic colours.[33] The name 'azo', also of

nineteenth-century origin, comes from the prefix 'a', meaning 'no', and *zoe*, Greek for 'life force'. The family of 'a-zo' or 'no-life' colours is aptly named, derived as it is from the fossilized remains of 'a previous world of life'. The name comes via *azote*, the French for nitrogen, a gas that will not support life. One of these azos, Congo red, was named in the wake of the 1884–5 Berlin West Africa Conference, piggybacking on a German bandwagon of exotica. A later member of this family, 'Ponceau red', was named in the twentieth century and its name tells us little apart from the fact that it mimics the colour of poppies, since the name comes from the French for 'corn poppy'. By choosing a colloquial French name, there is no trace of the classical associations that opium-bearing poppies had with sleep or death.[34] Nor is there any hint of the poppy's homoerotic associations that Oscar Wilde introduced in the 1890s.[35] Ponceau red is just poppy red, nothing more.

Since the 1920s, synthetic colours now also have more systematic names. For example, when Ponceau red is used as a food colouring it is rather unpoetically called 'E124'. And, thanks to committees like the International Union of Pure and Applied Chemistry, or IUPAC, Ponceau red can also be known as 'the tri-sodium salt of 1-(4-sulpho-1-napthylazo)-2-napthol-6,8-disulphonic acid', or alternatively, as 'trisodium (8Z)-7-oxo-8[(4-sulphonatonaphthalen-1-yl) hydrazinylidene] naphthalene-1,3-disulphonate'. Either way, quite a mouthful.

Over the course of a century, the inspiration for these names changed from the Sanskrit cosmic darkness and the Greek life force (or, more accurately, the lack of it) to a German trade show and a French weed, until they conformed to the strictures of international committee decisions. The chemicals' names reflect the worlds inhabited by the chemists who created them. As the economic importance of the aniline and azo dyes grew, from the nineteenth to the twentieth century, so science expanded in the curriculum. Something had to give. In school, the classics, languages and the humanities shrank to accommodate the proliferating sciences.

The cultural worlds of technocrats consequently became narrower and narrower until evidence of scientists' literary

knowledge, sense of humour, emotional sensibilities or prophetic hunches became rarer and rarer. This trend had already been noted in 1891 by the biologist William Bateson, who said, 'If there had been no poets there would have been no problems, for surely the unlettered scientist of today would never have found them. To him it is easier to solve a difficulty than to feel it.'[36] Three years earlier, in fiction, Dr Watson summarized Sherlock Holmes's knowledge of chemistry as 'profound', his grasp of anatomy as 'accurate' and his law 'good', whereas his knowledge of philosophy and literature was 'nil'. And in Conan Doyle's second novel, Watson described Holmes as 'an automaton – a calculating machine . . . something positively inhuman'.[37] Reinforcing this impression, one twenty-first-century incarnation of the master of the red thread plays him as a 'high-functioning sociopath'.[38]

Chemicals' technical names became less poetic and more functional and each chemical's key function was to sell. The enormous economic power of synthetic colours meant that they acquired trade names in addition to their technical names. Trade names had to appeal to the widest possible public. So, for example, the first aniline dye to have economic importance was called 'Tyrian purple' in 1856 – after the eastern Mediterranean port of Tyre, the ancient centre of trade in purple dyes extracted from Murex snails – but, in 1863, its name was changed to 'mauvine'. The Byzantine connection that would have been appreciated by an educated elite was dropped after seven years in favour of a more recent French connection that would have been recognized by all followers of fashion, 'mauve' being the favourite colour of Napoleon's consort, Josephine.

Today's catalogues of domestic house paint include names like 'Roasted Red', 'Raspberry Bellini' or 'Ruby Starlet', which try to evoke desirable moods for living spaces, conjuring up a warm, opulent or alluring ambience. These names tell us something about how focus-group-directed salespeople want us to feel about colours. But these particular names – attempts to evoke the glory and glamour of what has been lost through the industrialization of colour – are of little substance. Painting a bedroom in Ruby Starlet does not result in us being surrounded by rubies or starlets

48 Norwegian, *Wise and Foolish Virgins*, 17th century, tapestry (now faded). The wise girls (above) raise their flaming lamps; the foolish ones (below) appear to have none. The bridal gowns of both sets of girls contain reds. (See also illus. 3, 4 and 39.)

as we sleep, and Raspberry Bellini has very little or absolutely nothing to do with soft fruit and cocktails, a nineteenth-century Italian composer or a fifteenth-century Italian family of painters. Ruby Starlet and Raspberry Bellini are actually assorted ground-up stuff hauled from open-cast mines, tinted and glued together with other stuff made from crude oil or coal tar. And, in order to sell more house paint, next year's practically identical reds will have quite different names.

49 A red-jacketed
Moulin Rouge sex
game, late 19th
century, postcard.

The names of professional artists' paints are a bit less volatile
but they too can be quite evocative. For example, the 'madder'
in 'rose madder' comes from the plant from which the red dye
was extracted. But the 'rose' alludes to a flower which comes

in numerous shades, so the association is not with a particular colour so much as with the idea of roses as symbols of love. This was not missed by the Victorians. In a late nineteenth-century article about artists' female models it was said that models frequently enslaved the painters they sat for so that, over time, 'Miss Rose Madder blossoms into Mrs Vandyke Brown'.[39] 'Vandyke Brown' is a pigment of impeccable origin and is a dependable, if unexciting, colour which makes it an appropriate choice for a quip about respectable Victorian artists' wives. Other artists' pigments, like 'scarlet lake', would have been too racy since 'Mrs Scarlet Lake' would have brought to mind a 'scarlet woman', or follower of the Whore of Babylon (Revelation 17:3–4). Between them, the names 'Rose' and 'Scarlet' cover the spectrum from innocent love to depraved lust. One way or another, red has power over men.[40] And the colour is never far from sex. After all, sex is the main attraction around Montmartre's 'Moulin Rouge' (not 'Moulin Blanc' or 'Moulin Noir') and in the 'red light' districts of numerous cities across the globe.

The search for a red thread in the biographies of culturally valued red things is bound to throw up some red herrings, and details about the 'azo' reds, for example, are probably instances of this. After all, if the chemists responsible for its name chose to emphasize its lifelessness, then how could it possibly hope to contribute to red's widely recognized qualities, such as life and passion? Equally, technical details about the red neon signs outside sex shops and the potentially red electronic components that play a crucial part in virtual displays of on-screen sex would also be red herrings, except to the extent that the new reds reference and feed appetites associated with the old reds. Generally, material aspects of the modern world do little to add to red's traditional meanings. Nonetheless, red light districts are still red and they are visible proof that red's ancient associations with passion live on. To see why red's meanings endure in the face of today's apparent indifference to the physical stuff that actually makes the colour, we will turn to more timeless things associated with red – earth, blood and fire.

Red Earth

T HE EARLIEST EARTHS TO BE VALUED culturally were the red earths collected and created by people in prehistory. Before its use in cave painting, its role in burial customs is the most obvious evidence that red was held to be significant. The dressing of corpses with red earths has a long history and was common in the British tumuli and barrow burials of around 4,000 years ago.[1] A much earlier burial that also involved red earth took place about 34,000 years ago on the coast just west of Swansea in south Wales, one of the richest Palaeolithic sites in Europe.[2] There is unanimous agreement among archaeologists that this particular burial involved some sort of ritual. It was in a sparsely populated area, in a cave overlooking the sea, the body clad in red robes and aligned with cave walls, the head missing, and the bones stained with red ochre. Analysis of chemical trace elements in the red ochre suggests that the stone was probably taken from a red vein that outcropped at Mumbles Head, which is about a three-hour walk east along a coast of rolling hills and cliffs interspersed with sandy beaches.[3] The exact significance of the red earth is, however, much less clear-cut.

When first discovered in 1823, the bones were said to be those of a male customs officer who lived sometime after Noah's Flood. (The idea that the bones belonged to a customs officer is presumably because smuggling was a topical issue when they were dug up and the fact that the cave conveniently looked out to sea. However, the oldest recorded tax-imposing nautical traders in the region were the Celtic Veneti tribe whose activities were mentioned by Julius Caesar.[4] Moreover, when the bones were buried, the cave

didn't even overlook the sea. It overlooked tundra, snowbound
in the winter, strewn with flowers in the spring and grazed by
mammoths in the summer.) The next nineteenth-century theory
about the bones changed their sex and narrowed the date range
to identify the person as a female ancient Briton. She, by virtue
of the ritual aspects of the burial, was identified as having been
either a prostitute or a witch. The bones then became known as
those of the 'Red Lady' or the 'Witch of Paviland', names which
have stuck. In the twentieth century, the bones were reinterpreted
as belonging to a male hunter from one particular Palaeolithic
culture. The most recent interpretation is that the bones are those
of a male in his late twenties who was a shaman or a hero from
another Palaeolithic culture. This latest interpretation drew upon
improved forensics and a wider survey that showed the local
region to have been quite inhospitable at the time of burial. The
idea that he was a shaman owes something to finding the remains
of what could be a snapped ivory wand as well as, possibly, post-
1960s archaeologists' interest in altered states of consciousness. It
is suggested that the cave in which the body was found – Goat's
Hole – may have been a sacred place or a place of pilgrimage.[5]

The story of the 'Red Lady' or 'Witch of Paviland' tells us
something about attitudes to red, not only in Palaeolithic times,
but in the Victorian and modern worlds. Differences in opinion
arose from attempts to understand the significance of the bones'
colour and location. The change of sex and occupations suggested
in the early nineteenth century were intended to deflect attention
from contentious biblical and political issues.[6] Contemporary
ideas about mankind's origins were widely varied and included
theories that the first race was grunting and barbaric or,
alternatively, vegetarian and profoundly philosophical.[7] Then,
in some circles, being called a 'geologist' or an 'archaeologist'
could be a bit like being called a 'racist' today.

Identifying the bones as female and from a prostitute or
witch says something about what nineteenth-century (male)
archaeologists thought about red. It suggests that they associated
the colour with sex and with female power. On the other hand,
identifying the bones as male and from a hero or shaman says

something about what twenty-first-century (male and female) archaeologists think about red. All of them saw the red earth as a cosmetic but the nineteenth-century archaeologist saw cosmetics as superficial colouring-coverings intended to deceive and enthral, while the twenty-first-century archaeologists recognized the potentially cosmic dimension of cosmetics. Whether the bones were those of a prostitute, witch, hero or shaman, red was special and was associated with action or occult power. More clues about red's significance come from the choice of burial place – a cave.

Caves

Although the Paviland cave was chosen as a resting place for the dead, the caves of mythology are primarily places of birth. According to Hesiod, Zeus, king of the gods, was born in a cave on Mount Aegeum, while Apollodorus says the cave was on Mount Dicte. Hermes, Zeus' son, was born in a cave on Mount Cyllene.[8] Then, caves were places of education. For example, they were the homes of Silenus, who was Dionysius' tutor, Chiron the centaur, who was a font of medical lore, and Proteus, who was a reluctant source of much knowledge. Caves were also associated with knowledge of the future, for example Sibyl's oracle at Cumae and Apollo's oracle at Delphi (a place name that means 'womb').[9] Mythical education, healing and prophecy in caves was reflected in historic practice, with Pythagorean training and part of the druids' twenty-year syllabus being conducted in Italian and French caves, respectively.[10]

Mixed feelings about caves found expression in the comings and goings around them. Bees, for example, nested in mythical caves, going out to forage and coming back to give honey, the source of inspiration for the Delphic priestess, Melissa, the honeyed one. Bees were said to be born from the carcasses of cattle, and cattle also lived, or were hidden, in caves. For example, the infant Hermes stole those belonging to Apollo when they were out grazing. In Persian mythology, Mithras, who was born from a rock, stole the cosmic bull and kept it in a cave.[11]

Fear was also associated with caves, reflecting the fact that the earth delivers, but also devours; caves have mouths. As well as being a nurturing shelter, the cave was a monster's lair from which one must escape. For example, aided by Ariadne's thread (which may or may not have been red), Theseus escaped the Minotaur's labyrinthine cave at Knossos.[12] In Homer's *Odyssey*, Calypso the enchantress, Polyphemus the man-eating Cyclops (a conscientious shepherd who sheltered his sheep in a cave) and Scylla the many-limbed monster all lived in caves. Odysseus, aided by the goddess of wisdom, Athena, escaped them all. But of course, no one escapes completely and, as Milton noted on the subject of death, 'many are the ways that lead to his grim cave'.[13]

The double nature of caves – as places of both sanctuary and trial, both wombs and tombs – can be acknowledged in their architecture. For example, Homer's Cave of the Nymphs had two entrances, one for mortals and the other for immortals.

50 A particularly visceral slice of jasper that reinforces traditional connections between red earths, birth and death.

Plato's cave in the Myth of Er had two exits (one ascending, the other descending) for souls of the dead and two entrances (one ascending, the other descending) for those about to be born.[14] The idea of gods or heroes emerging from caves endured into the Renaissance with Christ's birthplace sometimes being depicted as a grotto or cave, the manger-like home for cattle (echoing Mithras' or Apollo's use of caves). The double nature of caves is also appropriate for their connection with red, which E. Barth von Wehrenalp recognized as the 'colour of the greatest contradictions'.

Whether or not the cave offers sanctuary or trial, it offers a place to hide and the previous chapter noted the etymological connection between hiding, covering, earth and colour. One way or another, earth supports all life – Hesiod wrote that 'the stuff of life' was 'hidden from us' by the gods – and the entrance to the hidden aspects of earth is through the mouth of a cave.[15]

Such constellations of ideas may have influenced the archaeologists who interpreted red-covered bones in a cave at Paviland as those of a crafty hero, like Odysseus, or a messianic shaman. On the other hand, the identification of the same red bones as those of a prostitute or a witch may have been influenced by Calypso's seductive nature or Scylla's destructive nature. Either way, the red signalled powers in the cycle of life.

Birth and death

The twentieth-century classical scholar Walter Burkert thought that shamanism and hunting magic linked all these Greek (and Persian) myths of cattle-raiding gods with prehistoric cave paintings, many of which depict red cattle.[16] The fourth-century Neoplatonic commentator Porphyry interpreted the caves around which all this activity circulated in cosmic terms. For him, the cave was like form enveloped by matter – it was the world under the dark arch of the sky and it was the soul shrouded within the body.[17]

Treating the cave as the theatre for the soul's activities within a body of earth is in accord with the body's role in supporting the soul, while also acknowledging that the soul must ultimately

escape the body, successfully by souls whose nature is like that of the crafty hero Odysseus but less so by those souls who are more like his unfortunate companions. It also accords with biblical references to humans who were 'made in secret and skilfully wrought in the lowest parts of the earth' (Psalm 139:15) from 'out of the clay' (Job 33:6), and it allows the individual's destiny to be considered in the same terms – 'as the clay is in the potter's hand so are ye in mine' (Jeremiah 18:6). Yet the human body and soul are not just clay-like; they can be gem-like treasures since 'our daughters may be as corner stones, polished after the similitude of a palace', or the 'stones of a crown' (Psalm 144:12).

Numerous creation myths make humans the direct offspring of earth, and the earth from which humans were made was red. The name of the first man, Adam, is derived from the Hebrew root ADM, with *adom* meaning 'red', 'fair' or 'handsome' and other words derived from the same root including *adamah*, or earth, *dam*, or blood. Greek mythology made similar connections, with man's companion, Pandora, being made from earth mixed with water by Hephaestus. Ovid told the story of Prometheus moulding humans out of the earth. He also recounted how the earth was repopulated after the flood by the Adam-and-Eve-like couple Deucalion and Pyrrha, who threw stones onto the earth.[18] Ovid provided few details apart from Pyrrha's flaming red hair, which may be significant since Lilith also had red hair. (She was Adam's first partner who, according to Jewish tradition, was created from the same red earth as him. A 'red hair' gene, MC1R, existed in Neanderthals, but it is not the same as that in present-day redheads.[19] It is therefore possible that the Lilith myth contains clues to our ancestors' prelapsarian relations.) The connection between red and humankind's origins in earth is also found in completely separate cultures. For example, the first Inca queen, Mama Huaco, emerged from the Cave of Origin in a red dress, ready to populate the whole world.[20]

In a cosmos where everything is in flux, birth into this world marks a death to the previous world and death's departure from this world marks a birth to, or an arrival in, the next. Our entrances into this world are smeared with blood – our mother's

– and some of our possible exits from the world can also involve being smeared with blood – our own. Since arrival into this world was associated with red, it is not surprising that departure should also be marked with red. Long after the Red Lady of Paviland was sprinkled with red earth, Osiris, god of the afterlife, underworld and death, was the 'lord of the red cloth', Roman-Egyptian mummies were clad in protective red shrouds, and embalming could include staining the soles of the feet red with madder or kermes. Also, just as the completely unconnected Inca culture associated red with mankind's origins, so entire subterranean funerary complexes in Mexico were also painted red and funeral garments were dyed red in the Andes.[21]

Red earth's association with life and death endures. T. S. Eliot's 'The Burial of the Dead' – where the 'son of man' knows only 'a heap of broken images' – seems to echo the Red Lady of Paviland:

There is shadow under this red rock,
(Come in under the shadow of this red rock) . . .
I will show you fear in a handful of dust.[22]

On the other hand, in 'The Argument', William Blake hints at resurrection with 'And on the bleached bones, Red clay brought forth'.[23]

Red earth?

The name 'Adam' may be related to the words for 'earth' and 'red', and our emergence from, and reinterring in, the earth may have been traditionally marked with red, but why should earth be red? Herodotus remarked that in the whole world known to the ancient Greeks, Libya's earth was particularly red, yet his statement implied that in most other places the earth was not particularly red.[24] Also, the people who buried the prostitute-witch-hero-shaman in south Wales took red earth from Mumbles Head precisely because the earth around Paviland cave was not so

red. We all know that the colour of the earth varies – some is red (usually due to iron minerals), some is yellow (again, usually due to iron) and some is lighter (the presence of calcium, aluminium or silicon) while some is darker (due to organic matter).

If I get up from the desk at which I am writing and walk north for an hour or two, I can be in the middle of flat fenland fields and be surrounded, horizon to horizon, by rich peat velvety-black soil. Yet if I decide instead to walk south for an hour or two, I can be in a gentle rolling landscape and stand at the top of a hill where the freshly ploughed earth is almost pure white. This chalky earth is like the foam on the crest of a breaking wave in a slowly swelling geological seascape. Just minutes from my desk, I can walk through meadows and follow tracks where cows have exposed an earth that is neither black nor white but pale greyish when dry, and dark liverish when wet. At a push, a sympathetic eye could almost interpret the earth as reddish. Yet if I were to dig up some and mix it with egg or oil I could paint

51 Red bullock. The Red Bull and The Red Cow were popular names for British pubs (a 'brown cow' is simply an elocution construct), while the red heifer was a favoured sacrificial offering. Yet some might say that none of them are particularly red, like the earth with which they were traditionally associated, since Taurus is an 'earth' sign.

it out on paper or canvas and see that it was actually a rather unimpressive indeterminate grey-brown.

Left in the cow-scarred meadow the earth might look slightly redder because grey-browns are such ill-defined colours that they are easily swayed by whatever accompanies them. Surrounded by rich green grass, Cambridge's bruised earth could take on a hint of green's complementary colour – red. Bare earth might therefore appear a bit redder in contrast with the green vegetation it supports. Yet these physiological subtleties of perception are probably relatively unimportant.

What is probably much more important is the symbolic nature of the earth and the colour red. Even in regions where earthquakes and landslides are rare, it is obvious that earth has enormous power. In this geologically slumbering part of the world, the pure white earth of chalk hills can support enormous beech trees and the dramatic black earth of the fens feeds millions. However, like true red earths, black earths and white earths are rare and most earths have a vague and variable colour. Following Isidore of Seville's colour- calor etymology, it may be that assorted shades of grey and brown simply do not have sufficient 'energy' to be associated with such a powerful entity as the ever-present, life-supporting earth. Perhaps it is simply the case that natural justice demands that earth should be a powerfully 'calorific' colour like red.

Earth's power

The earth's power comes from its ability to maintain balance. Today, an understanding of the way in which that balance is achieved draws on geochemistry, molecular biology and atmospheric chemistry. It is expressed in interconnected ecological terms and can be represented in the so-called 'Gaia' hypothesis, which nominally evokes an ancient earth goddess. (As an aside, it should be noted that the name 'Gaia' – coined in the 1970s – runs counter to the modern trend of scientific naming indicated by the sequence of 'anil', 'azo', 'Congo', 'Ponceau' and IUAPC-committee reds. However, the name was suggested by a

poetic neighbour of James Lovelock, the scientist who formulated
the hypothesis and who later came to regret the name's 'unscientific'
associations.[25])

Earth's balance is reflected in its nominal redness, since red
is exactly halfway between black and white in the Aristotelian
colour scale. Balance is a source of power and also a source of
safety which, along with red's calorific quality, may be one reason
why the colour had protective qualities. The red shrouds on
Egyptian mummies, for example, protected the deceased on their
journey in the afterlife. In that tradition, the concept of balance
was personified by the goddess Maat, who weighed the hearts of
the deceased against her feather of truth.[26]

Earth's balance can only be maintained because it is, as
Shakespeare noted, both a delivering womb and a devouring
tomb (*Romeo and Juliet*, ii, iii, 5–6). In death, humans are
converted into humus just as, according to Isidore of Seville,
they have their origins in, and even derive their name from,
humus.[27] Humans come from humus, and then return to – or
strictly speaking, after their souls have escaped their bodies
return to – humus or generic earth. (Today, in life, even our
heroes still have 'feet of clay'.) People can be called 'living stone'
or 'lively stones' because, in the classical tradition, all stones –
not just the flashing rubies extracted from serpent's heads – were
alive. In Ovid's *Metamorphoses*, rocks naturally 'grow from their
roots' and it is significant that he mentions the living nature
of rock in the context of powerful women like the princess
Anaxarete, the sorceress Medea and the goddess Diana.[28]

Earth's power has always been associated with women, from
the very earliest myths, right up to James Lovelock's insightful
neighbour, ecofeminism and its various offshoots.[29] Mother
Earth's power overflows, spilling out of the underworld and into
our world, but she is not a single deity and she is not the only
earth deity.[30] In the next chapter, we will meet another deity
associated with the earth who was male. Sometimes earth's power
is more evident than other times – during summer more than
winter, for example – and that variability was rationalized by
the goddess Persephone and her intermittent relationship with

Hades. The earth's power is also more evident in some places than in others, and fertile cereal-growing regions were rationalized by reference to the goddess Ceres. Although its effects vary through time and space, earth's power was continuous and ubiquitous. (Today, the earth's resources are exploited so rapaciously that the idea of Earth as a providing mother seems to have been completely forgotten. Yet most modern Western nations still have feminine names, like 'America', and they still choose female personifications, like the Statue of Liberty.)

Gaia was a relatively minor earth deity with a small cult following. However, philosophically and linguistically, she always punched above her weight. She was also known as Ge, and from that name we get words associated with the earth, like 'geology' and 'geography', but also less obvious words like 'generous' and 'genial', which hint at her nature. Following Isidore of Seville's humus–human etymology and a general correspondence between the macrocosm and microcosm, Mother Earth, Gaia or Ge's power is also reflected in our nature, from our 'genitals' to our 'ingenuity'.

We are members of Gaia's family and parts of the earth traditionally reflected parts of us – our flesh was obviously earthy, but so was our soul. For example, when climbing out of the Inferno up towards Mount Purgatory and Paradise, Dante came to three stone steps. The first of these steps was white, polished and reflective. It symbolized the recognition of sin. The second stone was rough and charred, and it symbolized contrition. The third step was red and symbolized the satisfaction gained through works of penance. The red step was the final stage on the path leading to forgiveness, and it is no coincidence that this sequence – white, black, red – is the same as the sequence guiding the alchemical quest and that which was observed in the synthesis of vermilion, the red pigment and the proto-Philosopher's Stone.

Dante described the last rock, red porphyry, in terms that expressed its geological life force – 'As blood which spurts out of a vein'.[31] And where a crack in rock has later been filled with another rock it is still called a 'vein' – like the exposed streak of red earth at Mumbles Head, which stained the bones at Paviland. Today, the rock through which a vein runs is called its 'matrix',

which etymologically maintains the identity of the enveloping
earth or rock as a mother.

One mythical expression of Mother Earth's empowering
nature was the story of the apparently invincible Antaios. He
could only be vanquished when Heracles lifted him into the
air and physically separated him from the vital, and constantly
revitalizing, earth.[32] Earth's mythic sustaining power lives on.
It is why, for example, at the end of the nineteenth century,
Bram Stoker had his bloodsucking creation, Dracula, transport
50 boxes of Transylvanian soil in his attempt to overrun
England with the living dead. The significance of Dracula's
transported native earth was reinforced by the name of the
ship in which it was conveyed – *Demeter*.[33] (Demeter is the
Greek name of Persephone's mother, and she was known to
the Romans as Ceres.)

Historically, even smaller amounts of earth than Dracula's 50
boxes – literally handfuls – have carried vast symbolic spiritual,
military and political power. For example, over 4,000 years ago,
the 30-m structure of Silbury Hill grew slowly as generation after

52 The earth's inner
redness – red-hot
magma. A glimpse,
in miniature, of the
subterranean fires
that are usually
covered, or hidden,
by a thin crust of
solid rock.

generation of people brought soil to mark a sacred site, the source of the River Kennet.[34] Millennia later, St Augustine recorded the miraculous properties possessed by earth taken from the site of the Holy Sepulchre of Jerusalem as spiritually charged relics.[35] A military example of earth's power is Xerxes' (the fifth-century BC king of Persia) demand for handfuls of earth from the Greeks. Some gave it in token submission of their territories, but the Athenians did not and had their city overrun.[36] Moot Hill in Scone, Scotland, is said to have been made by handfuls of local earth brought by generations of chieftains to demonstrate the allegiance of their home territories to the Scottish king. Shakespeare alluded to the power of 'mother' England's 'gentle earth' in Richard II's 'conjuration' on the beachhead. ('Gentle' is another 'Ge' word, literally meaning well-born.) Richard had landed in Wales on return from Ireland and found his forces overwhelmed. He released his weary human troops from his service, claiming that 'these stones will prove armed soldiers' (*Richard II*, III, ii, 4–26). Richard's prophecy – which drew on biblical sources and the myths of Prometheus, Deucalion and Pyrrha or Cadmus – proved fatally optimistic, yet today, power continues to be accorded to token amounts of earth. For example, in Hungary a 'Coronation Hill' was made from sacks of earth from every county in the empire. This was moved from Bratislava to Budapest in the nineteenth century and, in the twenty-first century, moved again with soil from every EU country added to it to create the new 'Integration Mound'.[37]

Even smaller quantities of red earth – first wrapped in bladders, then in collapsible metal tubes and now in conveniently squeezable plastic tubes – have a residual, if now largely unrecognized, symbolic resonance in art.

Burnt sienna

Artists' relationships with their reds today are very far removed from the relationships that cave painters had with their red pigments. Popping into a shop on the high street at the weekend, or clicking on a screen at any time, is not quite the same as

prising red earth from a vein in a cliff face on Mumbles Head while on the way to a sacred cliff-top cave. Yet faint echoes of past cultural values persist.

First, transparent red rocks, like rubies, are still valued more highly than translucent or opaque ones, like carnelian or jasper. When red earth is mixed with linseed oil (or with gums or acrylics) it makes an opaque red paint and when artists want a transparent red they use an organic colour (like cochineal, madder or their modern counterparts). When they want an intermediate, translucent red they use another, rather less common, red earth. Just as opaque earths occur as yellows and reds, so too do translucent earths. The yellow ones are now called 'raw sienna' and the reds are called 'burnt sienna'. As their names suggest, their relationship is exactly the same as the relationship between the natural yellow stone and the artificial red that protected the prehistoric dead and decorated their caves.

Burnt sienna's name also suggests that this particular heat-treated artificial red earth comes from the Italian city of Siena.[38] Indeed, until 1988, the British artists' colour manufacturer Winsor & Newton obtained their raw sienna – an earth which they sold as a yellow and also burned to make a red – from a mine just south of Siena. More recently the company started to source the pigment from Sicily and Sardinia, although the paint's name did not change to reflect its changed origins. Other manufacturers use a synthetic iron oxide in their tubes of so-called Burnt Sienna.[39] The chosen, and unchanged, trade name suggests that the earth of Siena was considered to be more marketable than the earths of Sicily or Sardinia.

Earlier chapters showed that sources of red earths change over time, so Winsor & Newton's shifting quarry locations for their burnt sienna is nothing new. Our culture usually celebrates such changes even when they are quite minimal, such as next year's red house paint, which will be almost the same colour as Raspberry Bellini but will have a very different name. So what is it about the idea of Siena's earth that is different from the idea of Sicily's or Sardinia's earths (or a synthetic iron oxide) and what makes the name worth keeping?

The *Oxford English Dictionary* gives the date of the first use of the name 'sienna' in connection with a colour as 1774. A late eighteenth-century English-speaking person with an interest in art would have known the city of Siena – by reputation, if not at first hand – through the Grand Tour, an institution in which British artists and aristocracy visited Italy to gain exposure to Culture. By the time the pigment's name was committed to print, the Tour had been established for over a century. Naming the pigment after the place enabled the colour to bask in the city's glory. As translucent earths, the raw and burnt siennas absorbed the clear light of Italy that once inspired generations of great medieval and Renaissance painters. And, for eighteenth-century Grand Tourists, the streets of Siena

53 Stream in the Forest of Dean, an ancient English iron-mining district. The discharge – one of countless thousands – is a trickle from a centuries-old iron ore mine and is an artists' potential source of yellow ochre or, if lucky, raw sienna.

were – if not exactly paved with gold – bathed in the golden glow of sun-soaked raw sienna.

The name of red burnt sienna will probably endure as long as Siena remains a popular destination for art lovers. Cennini, for example, called his red earth 'sinopia' at a time when Sinopia was still an important staging post on the Silk Road, source of sticklac and brazilwood as well as Eastern red earths. More recently, the popularity of 'sinopia' as a name for red colours has faded as Sinopia's fortunes as a port have faded. The name sinopia no longer evokes the riches of the East.

As long as burnt sienna's name remains fashionable, those who do not make the pilgrimage to the City of the Virgin can – nominally, at least – have a small part of the city come to them. The pigment's name acknowledges the fact that even a token amount of earth has the power to transmit something of the culture that sprang from that part of the earth. The colour burnt sienna has captured the sun that once shone on Duccio, Simone Martini and the Lorenzetti brothers. It was the earth which supported, and soiled, their feet. (Possibly acknowledging our origin in humus, our 'feet of clay' and the blurred red line between the animate and inanimate, the Italian for both 'soil' and 'sole of the foot' is *suolo*. Token quantities of powdered Sienese earth could even be a by-product of the ritual washing of pilgrims' feet.[40]) Burnt sienna was also the earth which once fed these great artists and was in turn fed by their bodies, burnt to make its fiery energy more visible. The appeal of burnt sienna's name is its implicit suggestion that some of the power of the Italian sun and the city's painters resides in its colour and might, in the right hands, flow again from a red-charged brush.

One way or another, over millennia red earth has been associated with the power to create, from the creation of the world's first peoples to the creation of great art.

TEN

Red Blood

NLIKE EARTH, WHICH HAS LOST much of its hold over our imaginations, blood still has us very much in its grip. For example, relatively few popular movies are driven by the earth's power but the appeal of blood has spawned entire genres of movies, from slashers to vampires. Although he was sustained by both, we remember Bram Stoker's Count Dracula not for the native earth upon which he slept, but for the blood he sucked.

Blood is said to be red; yet the previous chapter noted that earth was widely considered to be red even though its colour was usually rather drab and variable. This raises an important point. We might be tempted to assume that red derives some of its cultural importance from the fact that blood is an important bodily fluid. Yet all bodily fluids, like all vital bodily functions and organs, are equally important – if one fails then soon all will fail. The traditional world focused on the interplay and balance of four bodily fluids (blood, phlegm and two types of choler), each with a different colour. However, blood was, and still is, singled out for special attention. So, it may be that red is not a culturally important colour because blood is a physiologically important fluid. It may be quite the opposite – blood might command our attention more than other bodily fluids simply because of its powerful, 'calorific' colour. Blood's prominence in our imagination may be because, when vital, it is red. After all, spilled, coagulated blood that has lost its vitality is no longer red but, like most earths, a much duller colour.

In mythology, red blood merges with red earth. There is a force in red blood, just like the force in red earth that encouraged

our ancestors to discover iron, or, in their terms, by which iron chose to reveal itself to our ancestors. In creation myths, humans were moulded or sprouted from the earth, but sometimes blood was involved too. For example, Ovid records a race of humans created when Mother Earth breathed life into moulded earth soaked with giants' blood. And in the Mesopotamian tradition the blood of a god slain for rebellion was mixed with clay and moulded into people. The Persian cosmic bull that Mithras stole eventually escaped from his cave, was caught and sacrificed, and its blood fertilized the earth.[1] Blood is life-giving.

When blood is not mentioned in creation myths it may be because it is already there in the earth with red being the (sometimes only nominal) sign of its presence. Why else, given the obvious difficulty, would we continue trying to 'get blood from a stone'? After all, Dante described porphyry as being like 'blood which spurts out of a vein' and the word 'gore', describing coagulated blood, is linked etymologically to the word 'mud'.[2]

It was a commonplace that, to use Milton's words, 'gems and gold . . . grow deep under ground' in 'nature's womb', and geological processes were regularly conceived in terms of gestation within Ge or Mother Earth.[3] Red minerals were particularly associated with her blood. Another seventeenth-century text claimed that the ruby 'gradually takes birth in the ore-bearing earth [it] gradually acquires its redness in the process of ripening . . . Just as the infant is fed on blood in the belly of its mother so is the ruby formed and fed.'[4]

Pliny noted that the lead mines in Spain – the ones that provided the minium that ended up painted on Roman red-shroud mummies in Egypt – were allowed to rest for a while after active exploitation, whereupon they 'were reborn'. He also said that abandoned mines 'replenished themselves . . . just as a miscarriage seems to make some women more prolific'.[5] The language of genesis within the geological matrix was intimately linked to blood and, in the chapter on traditional synthetic reds, Albertus Magnus was quoted describing the creation of another red mineral, cinnabar, by the coagulation of Nature's 'menstrual fluid'.

Artists' blood

Parallels between subterranean fertility and women's fertility
were extraordinarily pervasive as a central part of the traditional
correspondence between the microcosm and the macrocosm.
Leonardo da Vinci, for example, compared flesh to soil, a 'pool
of blood' within the human body to the oceans and veins to
watercourses. Indeed, he considered that the 'increase and
decrease of the blood in the pulses is represented in the earth
by the flow and ebb of the sea'. Such parallels between anatomy
and geology subtly informed the relationship between the figure
and landscape in his *Mona Lisa*, giving the picture a dimension
which is completely lost to those of us who no longer feel a
visceral connection with Mother Earth.[6] These parallels are also
in Shakespeare's poetry where he speaks of 'rubies red as blood'
(*A Lover's Complaint*, 1, 198) and 'the ruby colour'd portal' (*Venus
and Adonis*, 1, 451). This is usually a reference to the mouth –
since lips can be 'rubies unparagon'd' (*Cymbeline*, ii, ii, 17) – but
it is also applicable to wounds, which 'like dumb mouths do ope
their ruby lips' (*Julius Caesar*, iii, i, 260).

Before the Enlightenment, the microcosm reflected the
macrocosm and people constantly criss-crossed the red line
with which Descartes attempted to separate the individual
from his or her environment, or divide our 'inner' from our
'outer' experiences. Everything that was said about earth in the
previous chapter also informed the traditional understanding
of blood. Whatever happened naturally underground and
in the visible landscape served to guide alchemists in their
laboratories and artists in their workshops. Artificial vermilion's
synthesis was a scaled-down rerun of cinnabar's subterranean
genesis, and the related red elixir hastened the natural ripen-
ing, or 'reddening', of base metals into gold. Exactly the same
cosmological principles guided what artists did after they had
made their materials. So, for example, red vermilion – conjoined
heaven and earth – was used to depict Christ's flesh and blood.[7]
However, now that we have forgotten vermilion's inner nature,

overleaf:
54, 55 Two of eight
pages of streaming
blood from a
*Psalter and Rosary
of the Virgin.* This
manuscript was
probably made
in the 1480s for a
Kentish woman's
private devotion.
The images –
approximately
the same size
as the original
– encourage
an immersive
meditation on
Christ's Passion.

the profound material connection between blood and red in paintings is no longer felt.

As the art historian Michael Cole has shown in his study of Cellini's *Perseus with the Head of Medusa*, even where blood is an explicit subject-matter in a work of art, its deep connection with the materials of art is easily overlooked. Benvenuto Cellini, the sixteenth-century goldsmith (and unrepentant murderer), celebrated the nature of blood in his monumental bronze of Perseus triumphantly displaying Medusa's severed head while astride her body. Her death throes are caught in the final gush of blood. The piece now has a slightly greenish cast, but the surprisingly high copper content means that it was originally much redder. The red statue was made for an architectural location upon which Michelangelo's *David* seemed to gaze. Cellini's subject-matter – the petrifying Medusa's head – seemed to have turned *David* to stone, and its power was derived from Cellini's cosmological and technical understanding of metal's connection with blood. Agricola said that the natural state of metal was 'liquidity' with 'some sentiment and passion', and Allegretti considered that metal had 'within it that living spirit which infuses all created things'. Cellini 'fused' shape-shifting molten red bronze in his cast just as blood 'infuses' animals with life.[8] Blood has its own potency and Cellini's bronze blood of Medusa was a meditation on that potency, from the subterranean force harnessed in metals to a life force in art that could turn *David* to stone.

Blood becomes solid when it leaves its container, just as red coral does when it comes out of the sea. According to Ovid, Medusa's petrifying gaze transformed the first coral, and Cellini purposefully alluded to coral in the branched shape of the now frozen, once red, bronze blood that spurted from her severed head and fallen torso. Whether artificial cast bronze, natural coral or blood, all these reds transform. But nothing transforms as much as holy blood.

Holy blood

Contemporary fascination with holy blood focuses on the living bloodline of Christ's alleged progeny, as witnessed, for example, by blockbuster films and bestseller books. However, earlier interest was in the drops of blood shed by Christ.

Around the year 1300 painters were interested in how blood flowed from wounds, but by around 1400, they also became interested in the way blood changed colour when it left the body and started to congeal.[9] They emphasized the way blood sustains life by differentiating between shades of red – one for fresh and flowing blood, another for dry and still blood. The painter Cennini recommended two different reds for blood – vermilion and lac.[10] The use of vibrant pure vermilion is, of course, fitting for Christ's living blood, as the combined sulphur and mercury, the form and matter or the fire and water that sustained His combined divine and human natures. The addition of a veil of lac darkens the red to make the blood look congealed. By changing the shade of red, artists drew attention to the metamorphosis, transformation or change of state – from living to dead – and so used reds as visual markers for the boundary between life and death.[11] These transitional reds in art are reminiscent of nature's reds – dawn and dusk as markers for the boundaries between day and night.

Painters recognized that there were two bloods, *sanguis* and *cruor* (from which we get 'gore'). These two bloods were seen as opposites – *sanguis* was 'sweet', referred to blood in the body and was associated with fertility, while *cruor* was 'corrupt', blood that had been shed and was associated with violence. They could be interpreted as 'good', female blood and 'bad', male blood.[12] The twofold nature of blood is reflected in the two types of location and two types of occasion at which the transition can take place. Bleeding can occur from a natural orifice and be governed by natural causes, the most obvious example of which is menstruation. Alternatively, it can take place from an unnatural orifice and be controlled by an intention, either medical or martial, life-saving or life-stealing.

Yet, of course, the blood of Christ offered a third option that
transcended the duality of mortal blood. The holy blood that
gushed from Christ's pierced side symbolized the remission of
sins and formed the basis for a frenzied cult that gripped Europe
for several centuries. The cult was such that other types of bloods
became venerated, in addition to Christ's. These included bloods
that were created by miracles associated with the Eucharist and
with works of art, some of which bled spontaneously while others
bled when maltreated. Such 'effluvia' had a long tradition and, from
the sixth century, there are records of blood which flowed from
icons, paintings and statues of Christ and the saints, especially
when they were abused, desecrated or humiliated. In other words,
a sacred work of art could respond just like the cold body of a
murder victim that bled anew when approached by the murderer.[13]

Christ's blood was extremely potent and much sought after
and Westminster Abbey acquired some holy blood in 1247
through the efforts of Henry III. Yet this particular drop failed
to generate a local cult, possibly due to the fact that it came from
the Holy Sepulchre of Jerusalem, which had not previously
claimed to possess such a precious relic. Its provenance was
therefore suspect. The credibility of Westminster's holy blood
may have been further undermined by the fact that before 1200,
at least twenty other churches in Western Europe claimed to
have Christ's blood.[14] Even though the quantities were modest
– amounting to a single drop, or at most a few drops that were
mainly dried and coagulated – the number of blood relics
proliferated through the thirteenth, fourteenth and fifteenth
centuries. Still, theoretically, there was enough to go round since
contemporary calculations suggested that between 28,000 and
over 500,000 drops of blood were shed during Christ's Passion.[15]

Christ's holy blood casts light on a dimension of the colour
red that is so ingrained it is hardly noticed, although it has shaped
the structure of society across the whole of Latin Christendom.
This is because the underlying order of modern Western society
rests on, among other things, a fundamental distinction between
the religious and the secular, the sacred and the profane, the holy
and the worldly – or Stendhal's *The Red and the Black*. The holy is

56 Christ's wound and the instruments of his Passion, manuscript illumination. The wound is presented in a form that could evoke a *vesica piscis*, *mandorla* or whole-body halo. It could also evoke a vagina. The ability to slip so easily between spiritual and sexual imagery is perhaps shocking, but it connects the blood of 'wounding' to the blood of 'birthing' and reinforces the Christian link between (re)birth and sacrifice.

'sanctified', a word that comes from the Latin, *san-ctus*, which is derived from *sanguine unctus*, or 'anointed with blood'.[16] Anointing involves daubing, smearing or partially covering – which Isidore, of course, related to 'colouring'. So red is the colour of the sanctified and blood marks the modern West's red line or even (to anticipate the subject of the next chapter) the 'firewall' between Church and State.

Yet since there are two types of blood, what is the red that sanctifies? Perhaps surprisingly, since it turns our gender stereotypes on their heads, Christ's saving blood was thought of by some devotional writers in the Middle Ages to be more like the 'flow of birthing than the flow of wounding'.[17]

Birthing and wounding

When Eve described the birth of her child, she used the
same verb that was used to describe God's creation of Adam
(Genesis 4:1). This placed the female power to give birth 'on
a par' with powers in the sacred sphere'.[18] (Over time, such
powers were eventually demonized, which is why nineteenth-
century archaeologists thought red Palaeolithic bones, if female,
must have been those of a prostitute or witch.) The apparent
competition between natural and divine birth may account
for why menstrual blood and the sacred were portrayed as
incompatible in biblical stories, in social arrangements and in
craft rituals, including the smelting of iron from red earths, for
example, which was widely considered to be a sacred act of
creation (Genesis 31:19). However, the compatibility or otherwise
depended upon context – in or outside the temple, in or outside
the body. We have already seen that Mother Earth's menstrual
blood was the matter from which stones and metals were made
and the whole earth's fertility – supporting animals and vegetables
as well as minerals – rested upon her subterranean blood.

According to Pliny, menstrual blood spoiled wine, dimmed
mirrors and killed bees, all of which was obviously bad. But it
also killed locusts, cured fevers and protected vineyards from
violent weather, which was good.[19] Presumably, the difference was
again due to context. Over 1,500 years later, a wide diversity of
attitudes was still evident in Elizabethan England, which shows
that the two sides of menstrual blood remained in circulation
until the issue became sanitized in the Enlightenment.[20]

The traditional, or pre-Enlightenment, double nature
of menstrual blood was shared by sacrificial blood. This is
evident because, while the blood of a bull or a goat might cleanse
and consecrate communities, when priests slaughtered a red
heifer in order to purify a tainted community, they themselves
became tainted (Leviticus 16:19 and Numbers 19:2). Sacrificial
blood could also turn into a supplement for Mother Earth's
menstrual blood, as when excess blood was wiped off the altar

and drained away through channels out of the temple to be used as a fertilizer.[21] Red blood was life – sometimes holy, sometimes worldly, sometimes giving, sometimes taking – but always life. It embodied the paradoxes of immutability and decay, giving and receiving, wholeness and dividedness.[22]

Women tend to shed their own blood, while men tend to shed the blood of others and after it has been spilled, it is difficult to tell whose blood is whose. Blood mingles, sticks and covers. It disguises identities, which is entirely appropriate for the loss of the particular identity that accompanies sanctification, or the anointing with blood. Blood's ubiquity and apparent anonymity reinforces the idea of red as a profound life force. Its impersonal redness transcends the individual, whether male or female, birthing or birthed, slayer or slain – even whether human or animal.

While the crimson-red that oozed from a cochineal beetle and the purple-red that oozed from a Murex snail were, strictly speaking, not blood, the red dyes were thought of as bloods. Their dyes seem to give an affirmative answer to the question 'If you prick us do we not bleed?' (*The Merchant of Venice*, III, i, 59). In fact, the insect and the snail did give their lives for our reds – *sanguis* from the insect, *cruor* from the snail – while the kermes cordial went on to stimulate the human heart, so prolonging life.[23]

Reds were generally associated with blood even when they were known not to be blood, such as the mythical spilled blood of dragons and elephants that was actually a tree resin. Other trees were also connected with blood – for example, alder wood turns from white to blood-red when the tree is wounded. (In Ireland, this tree was used for divination and its felling was forbidden.[24]) Alder was used for making shields and Bronze Age Irish anthropomorphic alder-wood figures have been interpreted by archaeologists as the 'red man of war'.[25] Gods of war, like Mars, were usually red, and the second horseman of the apocalypse who will wield a sword and 'take peace from the earth' (Revelation 6:4) will be mounted on a red horse, the colour of blood. Marvel Comics were faithful to this tradition when they

57 Static red paint on a polychrome stone sculpture of a flag that will never fly, imitating the usually animated madder or alizarin of St George's cross in the Union Jack. (Honouring the dead of the 15th County of London Battalion, the London Regiment, Prince of Wales Own Civil Service Rifles and the Civil Service Cadet Battalion.)

made a predominantly red costume for their (inevitably martial) superhero Iron Man.

In a chapter on red in his manual for artists, Giovanni Paolo Lomazzo cited Homer, Virgil and Plutarch, noting that the military has traditionally liked the colour – whether madder, alizarin or purple, which 'differed not much from red'.[26] In its preference for red, the military was true to the colour of its guiding spirit who Chaucer repeatedly called 'mighty Mars the Red'.[27] Indeed, the military has only relatively recently opted for camouflage in battle,

while red continues to feature in ceremonial military dress and is conspicuous in the flags around which armies rally.

Red flags

Through the twentieth century, the red flag was synonymous with communism, but most flags feature red. In the 1970s a survey was undertaken that studied the flags of 137 established nation states. The survey showed that national flags were unique, separate and distinct, yet the overwhelming majority conformed to quite tight standard designs. For example, 60 per cent consisted of vertical or horizontal stripes, nearly 60 per cent had the same proportions and over 50 per cent had just three colours. Over the past 40 years there has been a significant increase in the number of nation states, but the statistics remain roughly the same.

It appears that nations do not seek to maximize their distinctiveness with their flags – they want to be seen as 'one of the club' and identify with, rather than deviate from, other nations. This leads to local affiliations (like red, gold and green in African states or red, black, white and green in Arab states) and the use of colour in ways that correlate with cultural identities (predominantly Christian nations tend to favour blue while predominantly Islamic nations tend towards green, although there are, of course, exceptions). Red, on the other hand, is used equally by both Christian and Islamic nations and nearly 80 per cent of all flags contain the colour red, making it by far the most popular colour across all national flags.[28]

Flags have been defined as modern totems, complete with taboos, and their primary purpose is to bind nations together internally. The great historian of colour, John Gage, suggested that colour's meaning is accessible 'only through a study of symbolism' and the colours chosen for national flags are of interest because the flags themselves are symbolic.[29] The furling and unfurling of national flags is surrounded by a pomp intended to convey sacredness; indeed, statutory laws exist to deal with the 'desecration' of flags. Flags are presented as indestructible, with

frayed or faded flags being discreetly replaced and with rules governing their correct disposal. For example, the flags used to drape coffins are not buried with the dead, but are ceremoniously folded. As is appropriate for such culturally significant objects, flags even have their own mythologies. The Danish flag (a white cross on a red ground) was said to have descended from heaven, on 15 July 1219, in response to prayers during a battle in Tallinn, Estonia. The red and white flag changed the course of the battle and can claim to be the oldest national flag in use today.

In everyday use national flags fly high, requiring the viewer to look upward, inferring supremacy over individuals, groups and institutional buildings. They are all brightly coloured (worldwide, only about seven colours are used and none of them are dull) and they are kinetic, animated by the wind.[30] American patriots have described their flag – the red, white and blue Stars and Stripes – as 'a living creature' (1927) and as possessing a 'magic' in the way it 'catches and lets go of the breeze' (1991).[31] Such sentiments echo those of Romans who, in the fourth century, were awed by dragon-shaped military standards 'with mouths open to the breeze . . . hissing as if roused by anger . . . tails winding in the wind'.[32]

The 1970s survey of national flags also studied official government publications which explained their choice of colours. Reasons for the most commonly used colour, red, were remarkably consistent:

> The vast majority of nations use the colour red to symbolize such things as 'wars fought against aggressors', 'military valour', 'courage', 'blood shed in battle', 'readiness to sacrifice', 'revolt', 'struggle for independence', 'revolution', etc . . . [there is an] . . . extraordinary degree of consensus among all these vastly different cultures about the meaning of this colour.[33]

The dominance of red as blood on national flags is consistent with a criticism of the new flags that sprung up upon the Soviet Union's division into separate republics. In 1991, Vladimir Zhirinovsky dismissed these newly created flags as mere abstractions, saying, 'They don't understand that you have to

pay with blood for this process.'[34] His sentiment is exactly echoed in a sociological analysis of Americans' relationships with their Stars and Stripes, which defined the bond that holds America together as 'the shared memory of blood sacrifice, periodically renewed'.[35] Flags all over the world display the modern secular equivalent of red's traditional religious associations - red as the blood of martyrdom. Of those nations that did not have blood-related reasons for choosing red, one mentioned 'soil', which we have already seen was red. Another mentioned 'fire', to which we will turn next, and two mentioned the 'sun', with which this meditation on red will draw to a close.

For several national flags that did not have the colour red, the willingness to shed blood was implied with decorative motifs of 'martial elements'. The avoidance of both such motifs and the colour red in flags was associated with nations that actively sought neutrality or peace following recent periods of internal strife. This is in accord with the widespread belief that red

58 A 1970s model globe of Mars showing the northern ice cap, craters and other topological features. The Martial planet's red colour is due to the presence of haematite or bloodstone, the source, on earth, of the Martial metal iron.

stimulates aggression and that exposure to the colour should be minimized in order to help resolve conflict. For example, after the bloody Haymarket Riot in Chicago in 1886, the city authorities ordered that red be 'cut out of street advertisements and replaced with a less suggestive colour'.[36]

Whether or not red actually provokes particular behaviours – like the proverbial 'red rag to a bull' – it definitely encourages certain expectations. In the Arthurian legends, for example, knights were colour-coded. White knights were forces for good, black knights were an unknown force and green knights had an elemental force. Knights clad in red, on the other hand, had raw power and could be expected to be victorious in combat. In the seventeenth century, when England had turned piracy into policy (and its ships may have had red threads in its ropes), it was said that

> No nation is more warlike and high spirited than the English whose very clothes are fiery; wearing more scarlet than any nation in the world . . . [they] go in red and be like the sun . . . single-out such ships [as carry] the rich commodity of cochineal, whereof they make more use than Spain itself . . .[37]

The expectation of aggression from those who wear red lives on and, today, sports teams kitted out in red are statistically more likely to be victorious than teams dressed in any other colour.[38] This rather surprising phenomenon means that red appears to either motivate the wearers or intimidate their opponents. Quite how it works is a mystery, but may have some distant connection with the historic use of red as an invigorating tonic (as in *confectio alchermes*) or as health-giving regalia (as in Henry VII's wardrobe).

Red hearts

Red sports kits might hint at blood, and on national flags red explicitly alludes to blood, but according to the official government publications, the flag's red is not simply a reference to *cruor* – the gore that is the fruit of battle. Red also implies

59 A 21st-century 'I ♥ Tintin' mug. One of many apparently unstoppable copyright-infringing uses of the red heart as a graphic text emoticon. (Does Tintin have red hair?)

sanguis – the lifeblood that may, in theory, be willingly given in battle. In fact, this aspect of blood is arguably the most important as an agent for promoting social cohesion or national, as opposed to familial, 'consanguinity'.

The apparent red of actually invisible, hidden, living and unspilled blood not only represents affinity or relatedness within groups; it asserts firm intent within individuals and, as such, has a long history. For example, when Hamlet eventually overcame his doubts and resolved to avenge his father's murder, he declared that 'my thoughts be bloody' (IV, iv, 66). This was in marked contrast with his earlier, hesitant, 'pale cast [vomit] of thought' to seek revenge (III, i, 85). Since the earlier and the later thoughts both involved his uncle's murder, Hamlet's 'bloody thoughts' do not refer to the deed that would result from his thoughts. Rather, they refer to the galvanizing fervour of his no-longer indecisive thoughts.

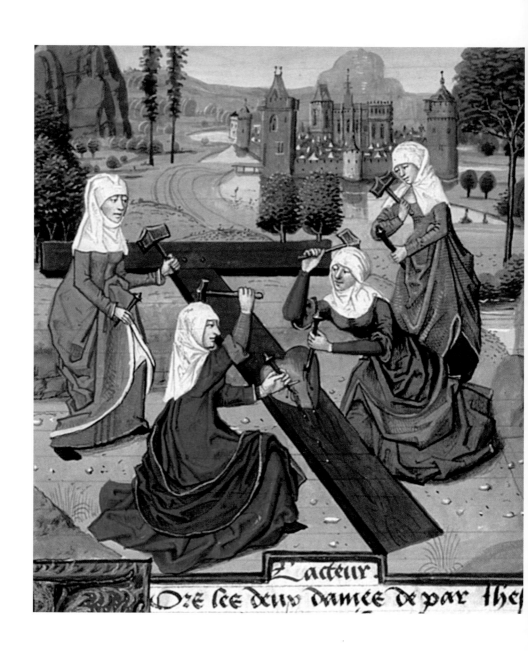

L'acteur

Ore see deup dan̄e de par the̅

60 Loyset Liédet,
*The Heart Nailed
to the Cross by
Fear of God, Faith,
Love and Grace,*
c. 1465, illuminated
manuscript. One of
many 15th-century
examples of graphic
hearts.

Reinforced by its relationship with blood, rich, bold 'calorific' red represents zeal, vehemence or determination, something that Shakespeare contrasted with the sickly green of indecision.

The connection between red and zeal comes from the traditional identification of the heart – the organ most closely associated with blood – as the seat of thought, intellect and will, as well as its now more commonly recognized association with emotion. The heart was also the source of blood and the most honourable part of the body.[39] Red represents deep resolve or 'heartfelt' convictions that may be manipulated by hot passions, but are less amenable to cold reason. The idea lives on in the relative certitude of things that you 'know in your heart' as opposed to the things that you merely 'know in your head'. Of course, high levels of commitment apply just as much – in fact, even more – to love as they do to hate. Red hearts and roses, for example, abound on Valentine's Day.

The extraordinary iconic power of the colour red, when associated with the shape of the heart, shows itself in a recent successful use of the combination and also by the much less successful attempts to limit the combination. As part of a brief, local marketing campaign to promote New York State in 1977, Milton Glaser designed a logo consisting of a typewritten capital 'I' followed by a red heart below which were the typewritten capitals 'N' and 'Y'. This image took on a life of its own and has since spawned thousands of variants – like J'♥ PARIS and PARIS JE T'♥ – the only constant being the red heart. Although the red heart logo is trademarked, is subject to copyright and is fiercely defended in the courts, it refuses to conform to the dictates of modern intellectual property law.

There is more than a hint of hubris about the attempt to impose legal restrictions on the 1977 red heart symbol, as it is simply a minor variant on a centuries-old motif.[40] The widespread failure of attempts to control the copyrighted red heart reflects what happens when narrow legalistic justice conflicts with natural or poetic justice.

ELEVEN

Red Fire

\mathcal{S}OME OF THE NATURAL REDS – like brazil and carbuncle – were named after a fire's glowing embers and it is no coincidence that all the traditional synthetic reds were made by fire. Red ochre came from the caveman's fire, minium from the silver refiner's fire and vermilion from the alchemist's fire. Yet, of course, before you could make any of these reds, first of all you had to make a fire, which was itself also said to be red, even though we all know it can be a range of colours. Fire is the very definition of calorific so, returning to Isidore of Seville's *Etymologies*, it seems that whether or not it really is red, fire simply should be a powerful calor–colour. The natural or poetic justice that made varicoloured earth red, as well as making red blood the pre-eminent bodily fluid, also makes fire red.

Just as earth and blood were connected in mythology, so blood and fire are connected in etymology. The Greek words for purple (one of red's traditional hues) were *porphyreos* or *pyravges*, names which capture red's changeable quality. *Porphyreos* relates to the changing colours of gushing blood while *pyravges* relates to the changing colours of fire.[1]

Like earth and blood, fire is relatively familiar, but if earth's and blood's mysteries were largely hidden then fire's mystery is open for all to see. Earth quietly nourishes life from the outside and blood quietly nourishes life from the inside. Fire, on the other hand, seems to have a life of its own. We might try to nurture it or starve it but, given the chance, fire can feed itself and its appetite can be voracious. The fascination and fear that fire can inspire have always made people want to explain it.

61 Hestia confronting Hades, both assisted by Hephaistos. United Kingdom, 1980s. Fire as the source of both order and disorder and the agency underlying all arts and sciences.

One explanation was given by Michael Faraday across a series of six Christmas lectures to children at the Royal Institution, London, in 1860. His subject was 'The Chemical History of a Candle'.[2] Since then, scientific explanations of fire have moved from chemistry through physics to mathematics, until the naked flame no longer excites science. Yet as the explanations of fire apparently became more lucid scientifically, they ironically became more and more obscure for all but a select few. In response, alternative explanations were developed. Through the nineteenth and twentieth centuries, those who could not find satisfaction in the increasing mathematical complexities of thermodynamics looked instead at our more personal relationships with fire. As every Boy Scout knew, the most basic way to make fire was to rub two sticks together. One sharpened stick could be rotated in a hole in the other stick, or it could be rubbed up and down a groove in the other stick. Some adult commentators saw a sexual side to these rhythmic activities (although I'm not sure whether clean-living Boy Scouts would have seen it this way).[3] In skilled hands, fire was the child of two sticks, and upon springing to life it immediately started to devour its parents.

Fire-as-maths and fire-as-sex are examples of the modern split between reason and imagination as modes of explanation. This split erupted in the eighteenth century, when fire was briefly explained in terms of phlogiston, a fiery principle that resided in flammable materials and was 'liberated in combustion'.[4] But for millennia, before it was phlogiston, fire was one of four Aristotelian elements. These elements – earth, water, air and fire – were the joint products of both the rational and the imaginative faculties. They described different ways of being in the world, with earth, water and air being quite familiar – they were the solid, liquid and gaseous properties of things, respectively.[5] Fire, on the other hand, was more enigmatic since it was the way of being that related to processes of consumption and production, which are usually hidden away or covered up and take place within things. Elemental fire, for example, was the metabolic source of heat that digested our food and kept our bodies

warm. The idea of an internal metabolic 'fire' reinforced the belief – hinted at by glimpses of blood – that the inside of our body is, or should be, red.

The Doctrine of Signatures and the traditional logic that gave meaning to colours up to and beyond Babbitt's chromotherapy rely on elemental characteristics, and fire has the qualities of hotness and dryness.[6] According to Paracelsus, 'flowers that are of a burning colour like the rose are apt to heal inflammations.'[7] The traditional elements also manifested themselves psychologically, so, for example, red stones like ruby and garnet made people feel good because the 'hot dry' fire in them counteracted the 'cold wet' of melancholia. The four elements, in turn, were abstractions that had their origins in four of the Greek gods. According to Empedocles, fire was primarily associated with Hades (air was Zeus, water was Persephone and earth, Hera).[8]

Hades

Hades, god of the dead and of the underworld, was the brother of Poseidon, god of the sea, and Zeus, ruler of all the gods. Together, they were the three sons of Kronos, although they may simply represent three 'different facets of a single divine power'.[9] Hades lived in his kingdom of 'darkness below', ventured out only once (to abduct his niece, Persephone) and had a cap that made the wearer invisible.[10] Not surprisingly, he features relatively little in myths and, appropriately, his name means 'hidden'. By the fifth century BC, his name changed to Plouton (Romanized to Pluto), which means 'giver of wealth'. This other name may refer to the underworld power that manifests itself in the soil's fertility and in veins of mineral ores.[11] Hades-Plouton, or 'hidden wealth', was commonly depicted in art as bearing a cornucopia, usually full and probably containing agricultural produce or metal implements.

The unseen but productive nature of the elemental god of fire, Hades-Plouton, reinforces the positive aspects of red earth. The creation of mankind from red earth and the cosmetic use of red earth in funerary practices allude to birth, death and the cycle of

fertility overseen by the god and his part-time wife, Persephone. Echoes of their powers can be seen in the use of earth to maintain power for the undead Dracula, or to transmit power for Scottish kings, and they resonate in the traditional synthetic reds through their connections with the earths, ores and metals that made Excalibur.

Hades' underworld kingdom, as the abode of a hidden fire god, was reinforced by ancient notions of a fire at the centre of the earth, where the 'life force' of the dead resides.[12] This, in turn, reinforced the (nominal) redness of earth and, following the red thread, Hesiod's claim that the gods 'hid' what sustained humankind.[13] Hints of the hidden fire were evident in 'fire stones' that spontaneously burst into flames when bought together, and which, according to medieval lapidaries, was evidence of sexual attraction between rocks. Other, more insistent hints were the existence of Etna and Vesuvius, which catastrophically demonstrated earth's awesome firepower. Such volcanoes were fed by an underground river of fire that Plato likened to the heat of anger in humans.[14]

With the traditional connection between the macrocosm and the microcosm, the productive side of Hades' hidden fire was said to show in highly motivated people who had (and still have) 'fire in their bellies', while its destructive and angry side was associated with the choleric humour that made people 'hot tempered' and quick to 'see red'. While the fire of Hades might manifest itself in two ways, a single god was not enough to accommodate the power of fire; a second divine manifestation of fire was Hestia.

Hestia

Hestia, goddess of the hearth, was the sister of Demeter, goddess of the earth, and Hera, goddess of the air. Together, they were the three daughters of Kronos. Hestia was the last of Kronos' children but she is also called his first born, because of the order in which Kronos regurgitated his children after having swallowed them. She was wooed by her brother Poseidon and her nephew, Apollo,

but rejected them both and swore an oath of eternal chastity. Her virginity was symbolized by her invisibility. Like Hades, she was rarely portrayed, but was sometimes represented by a flame that burned in an unadorned, empty house. She features the least of any of her divine siblings in the early myths, but she was highly honoured in the homes of mortals.[15]

Hestia's domestic role was institutionalized by the Romans in the form of the Vestal Virgins. These were high-born girls who entered the shrine of Vesta aged between six and ten and immediately became free of all state controls for 30 years, enjoying a status greater than that of all males, including their biological fathers and the emperor. They were very public figures and their virgin bodies, removed from the role of both unmarried daughter and married woman, represented the separation of Roman political, legal and religious affairs. The Vestal Virgins embodied the domestication of raw power by its division, and their very real power over the cult of the state rested in large part on the ambiguity of their hybrid position within the state.[16]

According to Vitruvius, Vesta's power was the origin of society and social order, and according to one legend, a retired Vestal Virgin became the mother of Romulus and Remus.[17] So Hestia's fire was the source of civil order. Yet at the same time, fire was also the most potent agent of disorder, as demonstrated by Hades' destruction of Pompeii with an eruption of Vesuvius and, less dramatically, by Hades' annual potential to withhold the earth's fertility. It follows that, just like earth (which is both tomb and womb) and blood (*sanguin* and *cruor*), fire would seem to be two-sided – disorderly and Hades-like, or orderly and Hestia-like. Yet fire has a third way, the way of Hephaistos the legendary smith, equivalent of the biblical Tubal-cain and known to the Romans as Vulcan, to the Norse as Volundr and to the English as Wayland.

Hephaistos

Hephaistos belonged to the next generation of gods. His mother was Hera and his father may have been Zeus, her brother, in or

out of wedlock, or he may have been fatherless, depending on which account you read.[18] Like many other smith-gods, he was lame and his handicap prompted his mother to throw him out of heaven.[19] He usually took a minor supporting role in myth, making jewellery and weapons for gods and mortals alike. His most important acts were as midwife for Athena (splitting open Zeus' head to deliver the fully formed goddess of war and wisdom), the creation of Pandora (moulding her from earth, on Zeus' instruction) and the binding of Prometheus (to a rock, again on Zeus' command). Prometheus was punished for stealing fire and giving it to humans, Pandora's fateful opening of the box punished humans for receiving stolen fire and Athena's influence on humans – making us warlike or wise – determines whether or not we punish ourselves with fire.

Hephaistos' name was often used as a synonym for fire. He was also called Amphigueeis, which could either mean 'hobbling in both legs' or 'skilled in both hands', a name that was used by Hesiod and Homer with deliberate ambiguity.[20] His skill was unquestionable and his lameness was not a sign of a metalworker's occupational hazard like chronic arsenic poisoning, as some modern commentators suggest.[21] His congenital, rather than acquired, lameness was a sign that fire can be creative only when hobbled; when given free rein fire is destructive. Just as Hestia domesticated raw fire by division, Hephaistos harnessed raw power when hobbled.

Collectively, Hades, Hestia and Hephaistos show the classical world's ambivalence towards fire. That ambivalence is also evident across Europe through the Middle Ages, especially by the direct inheritors of Hephaistos' skills.

Metalworkers

Cellini's *Perseus with the Head of Medusa* was originally conceived in marble but his patron, Duke Cosimo I, was interested in metals and wanted a sculpture in bronze.[22] The metal itself had a magical pedigree – when Empedocles leapt

into Mount Etna's crater, all he left behind was a single bronze
sandal, a sign of the magician's access to the underworld.[23] Bronze
was mainly soft copper, the metal of Venus or Aphrodite, but it
became tough enough to cast into guns or statues when mixed
with some tin, the metal of Jupiter or Zeus. In order to cast the
technically challenging *Perseus with the Head of Medusa*, Cellini
had to enlist the help of master founders from Cosimo's arsenal –
men more used to making weapons – but then, according to his
own account, he had to rescue the operation from them, since they
'lacked his genius'.[24] At a crucial point in the pouring process, the
metal started to coagulate. In a blind panic, the quick-thinking
Cellini threw all his household pewter (various mixtures of lead
and tin) into the mix which re-liquefied and so 'resuscitated the
dead'. The founder's fire made the alloy flow like life-giving blood.
Cellini knew that the excellence of bronze, like the excellence of
Venetian glass, was not 'solely in the materials from which it is
made, but also in the melting', and he said the success of the melt
freed him from 'fear of death'.[25]

 Perseus with the Head of Medusa was made using a technique
that had been known to the ancient Egyptians, Greeks and
Romans but had only relatively recently been rediscovered.[26]
First, Cellini sculpted a wax model; then he added thin rods of
wax (sprues, which would act as channels later in the process)
and assembled a mould around the model and sprues. Then he
heated the mould until the wax melted and ran out. Finally, he
poured liquid bronze into the empty mould and allowed it to
cool before dismantling it to reveal the bronze statue. This 'lost
wax' technique was a way of making something (a bronze) out of
nothing (literally, the gaps in the mould). It was the metalworker's
version of God's creation out of nothing – the divine *ex nihilo*.[27]

 Artists consciously imitated the divine artisan's creation.
Traditional animal, vegetable and mineral sources of red showed
how parts of God's creation were associated with the colour red
and each gave meaning to the other. Traditional synthetic reds
then showed how the colour was associated with the process
of creation. After all, red ochre, red lead and vermilion were
all products of fire. All this suggests that, in the pre- and early

modern world, there was a mutual reinforcement between the
meaning of materials and the meaning of colour. Consequently,
everyone could see that the golden red, bright and reflective
surface of freshly cast bronze was like solidified fire. Given that
bronze casting was a virtuoso technology, designed to impress,
the mere sight of glinting cast bronze was a reminder of the way
in which a skilled artisan could – Hephaistos-like – harness fire's
power to transform.

These transformative characteristics of the craft process
and the finished product were fully exploited in the position
and function of cast bronze doors, for example, which were
reserved for the most important entrances to the most important
buildings. One such set of doors by an unknown metalworker
was commissioned in the early twelfth century by Abbot Suger for
his Abbey of St Denis, Paris. Suger described the doors as 'nobly
bright', and hoped they would 'brighten the minds, so that they
travel, through the true lights, To the True Light where Christ is
the true door.'[28] As one moved through the doorway, reflections
would move across the doors. Light animated the surfaces
as an outward reflection of the flickering fire that originally
formed them. (These Western doors played with exactly the
same ideas that informed Eastern icons some 500 years earlier.
Byzantine polished metal and enamel icons have been described
as 'fossilized fire' and the 'contact relics' of divine fire.[29]) Bronze
doorways, or doors of nobly worked fire, were liminal and they
defined the boundary or threshold between secular and sacred
realms.[30] Abbot Suger's bronze doors marked the transition from
the streets of Paris to the realm of God or, at least, to the place on
earth dedicated to the remembrance of God.

Today, the power of bronze doors is easily overlooked for
two reasons. First, patina darkens bronze and may even turn
it green, so we no longer see it as shiny and red and therefore
related to fire. Second, we now habitually see objects as located
somewhere in space, and the modern concept of 'space' – a
featureless container of things – is very different from the
traditional concept of 'place'. Space might be neutral, but place
is not, and all things have their place.

62 Benvenuto
Cellini's *Perseus
with the Head of
Medusa*, 1545–53,
Loggia die Lanzi,
Florence, with the
gorgon's severed
head dripping
coral-like bronze
blood.

Fire had its place in the traditional world and it knew its
place. Cellini had to work hard to keep fire in his foundry – the
fire wanted to be elsewhere and, given free rein, it would go where
it wanted or it would pine away and die. In the traditional world,
the ideal places for the four elements were: earth, at the centre
of the universe; water, as a sphere surrounding the earth; air,
enveloping the water; and fire, as the outermost layer. Above fire

were the heavens, from the orbit of the moon all the way through the nested spheres of planets and stars to the all-encompassing mind of God. Fire's natural movement – whether it found itself under Mount Vesuvius or in Cellini's foundry – was upward. Fire, according to Meister Eckhart, 'has something lofty in its nature' and keeps rising 'until it licks the heavens'.[31] Fire's natural place is far from earth and close to heaven.

Just as coral is soft under water yet becomes hard in the air, so the places in which people find themselves can exercise transformative powers over them. We are, for example, different people when on the streets of Pigalle-Montmartre or, just a short walk away, when in the nave of the Abbey of St Denis, and the transition occurs between shining red bronze doors. In other words, in the traditional world, we got from the secular place to the sacred place by passing through solidified fire.[32]

Divine transformations

Artists' transformations of matter have always generated a mixture of admiration and suspicion. Their skills were seen as god-like, so that Hephaistos' Pandora was aped directly in the case of Pygmalion's Galatea, for example (and rather less directly in the case of Professor Higgins's Eliza Doolittle). Traditional artists primarily tried to imitate things by imitating their nature, rather than their appearance. Red vermilion, for example, was made artificially from mercury and sulphur in imitation of supposed subterranean geological processes. The perceived power of art was due in large part to the recognition that artists' methods were imitations of God's methods. Cellini's red bronze *Medusa* could therefore apparently petrify Michelangelo's white marble *David*, because a blood-like spirit was infused into the cast by molten metal. And Suger's red bronze Abbey doors could apparently impart the appropriate decorum into those who passed through them, because fire transforms us as well as transforming bronze.

The transformative power of fire is another glimpse of the red thread. Hestia's domestic powers and Hephaistos' creative powers

63 The
transformative
Pentecostal fire
is described (in
Acts 2:3) and is
usually depicted
as descending
'tongues' of fire.
In this Parisian
illumination
of 1400–1420,
however, the fire
is represented by
almost psychedelic
radiating chromatic
waves of divine
power.

lived on in the Christian tradition in the person of Joseph, who
was the Virgin's and Christ Child's guardian, but who was also
depicted as a smith (as opposed to a carpenter) in some traditions.
A late medieval cult arose around Joseph as a craftsman to
personify Christ's humble background, to celebrate labour as a
virtue and to recognize craftspeople as privy to awesome secrets,
powerful but potentially dangerous marginal outsiders who were
worthy of respect for their possession of wisdom.[33] The Joseph
cult assimilated aspects of Hephaistos, Vulcan, Volundr and
Wayland, and a poem accompanying Dürer's *The Holy Family in
Egypt* said that Joseph 'forges bronze'.[34] Ambrose described Joseph
as 'the artisan', 'the Father of Christ [who] works by the fire and
the spirit' and 'the good artisan of the soul [who] trims off our
vices . . . softening the rigidity of the soul in the fire of the spirit'.[35]

Fire transformed human matter spiritually.[36] An angel of
the Lord spoke from within a burning bush, and God spoke
'out of the midst of the fire' (Exodus 3:2 and Deuteronomy 4:12).
At Pentecost, the Holy Spirit appeared in the form of tongues
of fire, promoted understanding and temporarily reversed
the confusions caused at Babel (Acts 2:3–8 and Genesis 11:7).
Unquenchable fire burned the chaff, while not touching Daniel
and his companions in the furnace (Matthew 3:12 and Daniel
3:26). Fire consumed the dross and awoke the inner spirit (just
as the Romans awoke the god Saturn and goddess Diana from
their 'imprisonment' in brittle stones by roasting them to release

fluid metals). The cleansing power of fire in hell was a central part of the medieval Christian tradition so that, in Dante's *Divine Comedy*, the Inferno and Paradise were given equal space. But the modern church downplays hellfire and the inferno is now more at home in disaster movies. In other words, today, fire burns things, not sins.

Scientific transformations

Fire is now more the tool of science than religion. Yet fire's relationships with science and religion are both equally magical. The historian Carlo Ginzburg acknowledged that the methods of modern science have their roots in prehistoric hunters who tracked their quarry by examining 'droppings, snagged hairs or feathers, smells, puddles, threads of saliva'.[37] And even though those same hunters' survival did not depend on it, their equally close observation of nature discovered (or allowed the revelation of) fire and the artificial reds. The traditional mythical values associated with earth's fire and red rocks may not seem very scientific, but Ernst Cassirer said there is 'no sharp temporal dividing line . . . between the theoretical and mythical consciousness. Science long preserves a primordial mythical heritage, to which it merely gives another form.'[38] Others have gone further, suggesting that

> in retrospect the age of science will appear as the greatest power orgy in the history of mankind . . . at the bottom of this orgy historians will find a gigantic outburst of magic imagination [that occurred] after the breakdown of . . . medieval high-civilization.[39]

Modern science has done much to harness the power of fire while at the same time making it seem even more magical by hiding it further and further from view. The potentially threatening realities behind Hephaistos' tricks are placed out of sight, and hopefully out of mind, and fire's powers to transform

64 Tongues of fire.

are associated with Hestia, rather than with Hades, with the obvious exception of fire's many martial applications. Yet over time, Hestia's domestic fire migrated from the ritual and physical centre of dwellings to a hole in the wall. Then it disappeared entirely into the boiler of a central heating system. Raw fire has been banished and is now treated as a threat. (However, when it was first introduced, the invisible force that replaced fire in domestic contexts – electricity – was also felt to be a threat.[40]) As a result of fire's effective banishment, the domestic focus of attention has switched from flickering hearths to flickering screens, and the hypnotic fascination offered by dancing naked flames is now rarely enjoyed.

The disappearance of fire is a loss because, if we but let them, tongues of fire can speak to us. For example, the nineteenth-century theoretical chemist August Kekulé said that his dream of benzene as a snake biting its tail came to him as he dozed in front of his fire.[41] The place where his dream occurred suggests that, even when domesticated, fire still keeps its elemental power. Simply by resting our gaze on its licking flames and its rippling embers – or just by letting them play on our closed eyelids – we can be transported from our everyday worries to a more primal place. A living fire can inspire, and with its banishment, our everyday experience of the colour red is greatly diminished.

Once, log fires provided heat and candles provided light, so windows radiated a warm red into the night. For a few decades, gas lighting gave a similar glow, followed by the red-hot filaments of incandescent tungsten light bulbs; but now fluorescent lights and digital screens fill the night with cooler blues. Our cool blue digital screens betray little hint of fire, but many labyrinthine connections beyond the plug in the wall and the sprawling grid lies a network of power stations, including many that consume fossil fuels in industrial-sized fires. In the eighteenth and nineteenth centuries, industrial fires in 'Satanic mills' inspired painters like Joseph Wright of Derby and John Martin to hint at the potential power of God's wrath. Now, power stations do not generally glow with the red of fire. Even when they failed catastrophically, the sinister slow burns around Three Mile Island,

65 Glowing embers. A traditional domestic wood fire towards the end of an evening, revived by breath.

Chernobyl and Fukushima were invisible, with little or with no sign of red.

The things which produce our power are no longer red and nor are many of the things that consume that power. Yet electricity is the 'lifeblood' of technology, transferring fire's power, and the hypnotic effect of today's flickering digital screens and flashing metallic skins shows them to be the secular equivalents, or parodies, of Byzantine's icons and Suger's bronze doors.

Hades' fire raged in the underworld; Hephaistos' fire was harnessed in the furnace; Hestia's fire was domesticated in the hearth. Today's fire is enslaved in gadgets and in utility infrastructures. There, fire is confined in specially constructed chambers that extract its calorific potential under duress, in accord with the scientific programme of interrogation outlined 400 years ago by Francis Bacon. He recommended subjecting nature to 'vexations' and advised 'twisting the [caged] lion's tail', and he was fully aware of the lion's traditionally solar or 'fiery' nature.[42]

Alfred Hitchcock's Technicolor *Rear Window* (1954) was set in a city built by, and run on, fire.[43] Yet the only fire on view was a tiny red dot in a dark room that slowly pulsed as a suspected murderer drew on his cigarette. Today, unseen industrial fires rage on with ever-greater ferocity, but that tiny visible glow is increasingly marginalized in the Western world. Meanwhile, in the streets, billions of explosions take place at a rate of thousands per minute in every single car, and the fire behind those explosions is again hidden from view. It usually remains concealed even when cars crash. However, natural justice tells us that cars are powerful and should look calorific, so action movie chase scenes are often peppered with speeding cars that satisfyingly end up as spectacular fireballs of red.

In the Middle Ages, a shiny red surface was an outward sign of the power of fire. That fire transformed bronze into statues and into doors that had the power to transform the people who passed through them. Today, faint echoes of fire's transformative powers persist. For example, a car's shiny red paint might just be an outward sign of the engine's technologically channelled hidden fire. Certainly, opening the door and stepping into the car can transform a person's behaviour, and red cars in particular are supposed to appeal to thrill-seeking drivers. This suggests that red's effect on us persists and it accounts for the persistent urban myth (that may or may not be true) about insurance premiums being higher for red cars.

However, the ways in which we now respond to red and the nature of our myths reinforce the suggestion that ours is indeed a 'disenchanted' world compared to the worlds of Hades, Hestia and Hephaistos.

TWELVE

Red Passions

THE TRADITIONAL UNDERSTANDINGS of red things we have explored here have absolutely nothing to do with the Newtonian idea of colour-as-wavelength now taught in schools. However, these stories, with their ancient roots, are completely in accord with Newton's own understanding of nature as a book written by God which, before his day, was once widely read.[1] Red things' stories are many and varied, but the threads all seem to come together in the colour's association with passion.

The *Oxford English Dictionary* defines passion as love, devotion, dedication, enthusiasm, zeal, suffering, pain or torture. Passion spans a wide spectrum of emotions, just as red describes more than half the Newtonian spectrum, including orange, yellow, purple and a whole range of browns. Passion is a far from straightforward concept and, since it is linked with red, it is entirely appropriate that there is nothing straightforward about red either.

For example, red berries are rich in sweet anthocyanins which encourage birds to eat them, yet the red in berry-like scale insects is bitter and discourages attack by birds (we should sympathize with them, since we know Campari is an acquired taste). Red woods and lichens were worth scouring the world for, yet their colour quickly faded away. Red haematite made iron that wounds, yet iron made red rust that heals. Playing with red cinnabar-vermilion can be life-shortening, but it can give the red elixir that promises immortality. The possibility of bright aniline red lay in dark coal and while making it put food on the table for factory workers, it could also poison them (and their neighbours).

Red phosphors, LEDs and LCDs come hot from spotless high-tech laboratories, yet their fate is exactly the same as the old red woods and lichens. The names Rose and Scarlet evoke both sexual innocence and experience. Red earth is rarely red. Red blood can be natural, female, birthing and *sanguis*, yet it can also be unnatural, male, wounding and *cruor*. It is both inviting lips and gaping wounds. It is the colour of love, which lifts us up but which can also cast us down. Red fire is both order and disorder, creative and destructive. The list of apparent red contradictions could go on. (See, for example, illustrations 4, 5 and 39.)

There are evidently two sides to redness and there are equally two sides to passion. Over a millennium or so, the meaning of the word 'passion' has shifted away from primarily evoking the torment associated with Christ's (red) blood towards the lust that might be associated with a (biblically scarlet) woman. Yet these are both encompassed within passion's broad spectrum. The link between sensual passion and spiritual passion is evident in the fact that pleasure and pain can be ecstatic and excruciating. (Etymologically, excruciating pain is the pain 'of crucifixion' and to be ecstatic is to literally 'stand outside' oneself – in other words, to have an out-of-body experience.) If pleasure and pain, and the sensual and spiritual, are all related, then passion's other side is to be found in other words that share the same etymological root. These include 'patient' – a person who suffers – and 'patience' – the ability to endure suffering – and they evoke the peaceful accommodation of passions of any and all persuasions.

According to E. Barth von Wehrenalp, red 'embodied the dignity of kings and the blood of revolutions'.[2] Red may have been the colour of revolutionary 'zeal' (one meaning of passion), but it was also the colour of regal 'dedication' (another meaning of passion). It satisfied both the revolutionary and the king because, more profoundly, red is the colour of change. For the young agitator, focused on immediate results, red was the sign of change and evoked political overthrow. (This immediate and sometimes feared type of change is why red is also the colour of danger, as in the colour of traffic warning signs.) However, in the 1960s, while China's Red Guards enforced government policy, they

also nurtured the roots of the 1989 Chinese student movement that came to challenge government policy.[3] So for the dignified king, aware of the cyclic nature of all revolutions, ever-changing red evokes the traditional adage 'this too will pass', and reflects the goddess Fortuna's (or Lady Luck's) constant inconstancy.[4] Constitutionally, the royalist knows 'the king is dead, long live the king' and the red thread that provides regal continuity through change is, of course, a bloodline.

Red is both partisan passion and politic patience. The association of red with change was evident in the traditional cultural significance of earth, blood and fire, each of which has power over life and is associated with change. Fire is the definitive agent of change and it is also the definitive red phenomenon. It is therefore worth considering what one of the greatest nineteenth-century scientists had to say about fire, from the perspective of passion.

In his *Christmas Lectures* for children, Michael Faraday said that 'there is not . . . any part of this universe' that is not 'touched upon' by the modest candle's flame. The colour of that flame held a universal key, which was first suggested to him by the fact that when a lit candle is seen in sunshine, the darkest part of its shadow corresponds to the most radiant part of its flame.[5] He demonstrated that the light given off by the flame was caused by soot, with each microscopic particle glowing like a miniature red-hot poker. He reminded his audience of the age-old tradition of writing magical charms on the ceiling with a candle, which harnessed the paradoxical relationship between the luminous flame and its black, sooty source of light. The paradox was such that he found it almost inconceivable that Victorian London's ugly and deadly black smog was chemically one and the same as 'the very beauty and life of the flame'.[6] He compared the candle's flame to our own breath, saying that the link between visible combustion and invisible respiration was 'not merely true in a poetical sense' but an example of (a still entangled) 'Nature being tied together by the laws that make one part conduce to the good of another'.[7] For him, the red of fire and blood would have been universal signs of life – one chemical and the other biological.

Such a connection between chemistry and biology was hinted at by a German pioneer of chemistry, Friedlieb Ferdinand Runge. He was Faraday's contemporary and he understood the ingredients in chemical reactions to be 'chemical halves [that were] striving to appropriate the lacking half and so become a chemical whole'.[8] This understanding of relationships between chemicals drew upon the alchemical tradition of (male) sulphur uniting with (female) mercury in vermilion. It was also consciously linked to the everyday relationships that exist between people. Runge knew Goethe's work and would have seen chemical significance in Ottilie and Eduard's doomed love story, with which this book's search for a red thread began.

Goethe's story *Die Wahlverwandtschaften* is usually translated into English as *Elective Affinities* but it could equally be called *Relations by Choice*. It was a nineteenth-century chemical phrase, and its domestic implications were spelled out early in the story when Eduard, his wife and a friend had a conversation about chemical elements that 'seek each other out, attract, seize, destroy, devour, consume one another, and then emerge again from this most intimate union in renewed, novel and unexpected shape'.[9] In this conversation, where the subject of extra-marital sex was skirted around under the cover of natural sciences, Goethe even managed to slip in a pun on *Scheidekünstler* and *Scheidung*, old German words for 'analytic chemist' and 'divorce'.[10] Choosing a title like *Elective Affinities* was the nineteenth-century equivalent of publishing a love story today called $E = MC^2$.[11] By merging passion and knowledge, Goethe was following a long and rich tradition. Shakespeare, for example, likened the sparkle in women's eyes to 'Promethean fire' and said that 'women's eyes' are the truly inspiring books, arts and academies (*Love's Labour's Lost*, IV, iii, 347–9). As a nineteenth-century chemist, it would have been very hard indeed for Runge to miss the parallels between fire and sex.

In the wake of Goethe's highly influential book, Runge would have seen the red of the candle flame as the spontaneous radiance of two passionate 'halves' joyfully finding, and joining with, their 'other half'. In the flame, wax and oxygen swap their

66 [....... in] sunlight. The luminous flame casts the darkest shadow. Faraday interpreted this as evidence that the red-hot glowing soot in the flame absorbed the light of the sun. (Other shadow features are due to the refraction of light.)

197

existing partners to become carbon dioxide and water, with heat
and maybe some glowing soot to celebrate their 'intimate union'.
(Actually, to be strictly accurate, if the candle flame is red then not
all the partners exchange. In modern terms, complete combustion
is colourless and any redness in a flame is a sign of incomplete
combustion.[12]) The flame's paradoxically radiant darkness is
due to the fact that some carbon has not turned into carbon
dioxide. Carbon soot is the solitary witness of the others' ecstatic
exchanges. Each speck of soot may only be red hot for a fraction
of a second but, as we shall see, in the fullness of time each tiny
black particle has innumerable opportunities to contribute to
another dramatic red on an incomparably greater scale.

Goethe, Runge and Faraday's nineteenth-century science
forms a bridge between modern and traditional understandings
of the relationships between matter, light, colour and people.
A persistent echo of such ways of thinking is the 'chemistry' that
can be said to exist between two people, whether on screen or
in real life. Fainter echoes are the partner who might have been
called a 'flame', the ex- who was an 'old flame' and the rather sad
and distinctly old-fashioned phrase that one might 'hold a torch'
for someone. In terms of the Eastern red thread, the Western
'chemistry' of love acknowledges the existence of a connection
between two souls, while 'holding a torch' was the recognition
of a connection by only one of the souls.

Passionate partner swapping and transforming fire regularly
failed to be truly red; but so too did earth. This would of course
have been completely obvious to practically all the people who
called them red. We cannot assume that everybody in history was
colour-blind. (Our problems in assessing the historic evaluation
of colour are due to our comparatively recent emphasis on
hue – as opposed to tone and saturation – and our consequent
marginalization of colour's dynamic aspects. As the colour
associated with change and life, red was bound to have many
hues.) People may have historically accommodated any mismatch
of hue by remembering their traditional expectations about the
cosmos. This is because, as well as being a familiar material, 'earth'
was also the part of the cosmos that was contrasted with 'heaven'.

Earth was in a state of 'becoming', in a constant state of flux, where everything changed and nothing was predictable. So, in the earthly theatre of change, varicoloured earth (and varicoloured fire) may be striving towards red (as a particular hue) while nonetheless still manifesting red (as colour's inherent dynamism).

Heaven, on the other hand, was in a state of 'Being', fixed and predictable like the stars, so the heavenly colours we see have no need to strive. A heavenly red sky at night might promise shepherds delight, but when considered in traditional terms, it also holds the key to how red could possess such diverse, passionate, associations – from the love and hope embodied in St Valentine's Day roses to the love and loss embodied in Remembrance Day poppies.

67 Bucket of Valentine's Day red roses on display in an English supermarket, 2015.

Red skies

Modern science understands red skies in terms of scattered
light – dust in the air scatters red light less than it scatters blue
light. Dusty air therefore splits the white light of the sun into
red, which reaches our eyes directly, and blue that fills the sky
and comes to our eyes from every direction. This explanation
for the creation of red and blue in the dusty sky is based on
mathematics.[13] The theory manages to explain why the sun
looks so much redder when seen through the soot-laden dust
of industrial pollution or volcanic eruptions. (It turns out
that the brilliant red sunsets of Victorian paintings were
not necessarily poetic licence – they were Romantic artists'
responses to the local effects of England's 'dark satanic mills'
and the global effects of Tambora's and Krakatoa's catastrophic
explosions of 1815 and 1883.) Yet the modern theory of light-
scattering dust holds absolutely no meaning for shepherds in
particular or humankind in general.

On the other hand, the traditional understanding of why the
sky turns red has some similarities with the modern view but,
being poetic and qualitative, not mathematical and quantitative,
it can also offer meanings to the colour we experience. In his
thirteenth-century explanation of colour in red rocks, like
haematite and ruby, Albertus Magnus cited Aristotle's *The
Senses*, saying that red happens when 'luminous transparency is
covered by [or, remembering our etymology, is 'coloured by] a
thin burning smoke'.[14] A modern scientist might have difficulty
with this statement as far as most red rocks are concerned, but
Aristotle's explanation is completely accurate when applied to
red skies.[15] (It also extends the universal meanings that Faraday
saw in the red of his candle flame.) The sun turns red when its
light shines through many miles of air made dusty by volcanic
activity or industrial pollution. According to the Bible, a 'blood-
red moon' foreshadows imminent apocalypse (Acts 2:20 and
Revelation 6:12). So what significance might be attached to a
blood-red sun? Clues are provided by where and when – with

68 Dawn sunlight reflected in clouds with red following the elemental instincts of fire, rising up from its usual place as a thin red line along the horizon.

an appropriate mixture of heavenly predictability and earthly unpredictability – the sun goes red.

When the sun is high in the sky, it looks white. It goes red on the horizon, at the border between the sky and land. However, like the 'end of the rainbow', the horizon is a mythical and elusive place – we can be part of someone else's horizon, they can be part of ours, but as we move towards our horizon, it backs away from us. The horizon is the junction of heaven and earth; it is simultaneously everywhere and nowhere. It follows that the place where the sun turns red is liminal, and if the place where the sun goes red is a boundary or threshold, then so too is the time when it goes red. Dawn and dusk mark the transition between day and night, the 'witching hour', a traditionally spooky time that is outside the jurisdiction of both the laws of the day and the laws of the night. Thus, both in space and time, the sun's redness appears not in one state or another, but between states. Its redness is neither heavenly nor earthly and the strip along the horizon is an entirely porous and regularly crossed red line between night and

201

day. The sun and sky's redness is a twilight affair, occurring in the half-light, half-dark.

The horizon- and twilight-bound strip of red – between the opposite states of heaven and earth, day and night – is entirely consistent with traditional understandings of red. In Aristotle's scale of colours, red was exactly midway between the opposite states of black and white.[16] In those cultures with apparently less emphasis on hue, red was the only colour between black and white. Red's position reinforces its connection with life, which the ancient Greeks like Heraclitus saw as the beautiful but perilous balance of tensions between opposites.[17] Just as red lies between opposites, so also our lives lie between opposites, like 'for richer and poorer, in sickness and in health'. As the anthropologist Lévi-Strauss said, all human life lies 'betwixt and between' opposites, including ultimately, it must be admitted, birth and death.[18] Red's position is life's position, and our lives are not static, so, voluntarily or otherwise, they are played out between those opposite states, changing constantly, and transforming us through those changes. This dynamic aspect of life is also consistent with traditional understandings of the colour red's dynamism and passion. For example, when Sir Walter Raleigh asked himself 'what is life?', his answer was 'a play of passion'.[19]

The liminal fiery red sun and sky are also consistent with Suger's liminal fiery red bronze church doors that marked the boundary or threshold, and possible transition, between secular and sacred places – Pigalle-Montmartre's earthly streets and his heavenly Abbey in St Denis. The movement through Suger's red doors was two-way, from the earthly to the heavenly and vice versa, and so is the sun's apparent movement – from dark to light and vice versa. This two-way movement is reflected in the red sky's two opposite meanings – in the morning it can signal a warning and, at night, a delight. Red signals can have two sides, like passion, which is both pleasure and pain and can, in an instant, flip from one to the other.

The significance of 'where' and 'when' the sun goes red is reinforced by the 'how' of its redness. The sun and sky seem heavenly and immaterial, but their colours are due to earthly

materials. According to Aristotle and Albertus Magnus, the sun is red because its light comes through smoke, which is effectively the same as the modern explanation. Leonardo da Vinci gave a related explanation of the sky's accompanying blueness. He said the light-filled sky was blue because of the 'darkness' of space which is above it.[20] Now, if smoke is considered to be darkness, then the two explanations complement each other and, around the turn of the nineteenth century, Goethe – the man who introduced Ottilie's diary with the image of a red thread – knew Leonardo's explanation of the blue sky, and he developed a theory that explicitly connected it with Albertus Magnus' explanation of red.[21]

In brief, Goethe said that if blue was the effect of seeing dark through lightness, then red was the effect of seeing light through darkness.[22] In the case of red sunrises and sunsets, the source of light is obviously the sun itself and the darkness through which we see it is the dusty, smoky, scattering atmosphere. This has become known as the 'turbid medium effect'. (It is easy to see the phenomenon at a small scale. Before you fully rub in suncream, the covering thin film of white makes your dark tanned skin look faintly blue.) The 'turbid medium' that makes the sky blue and the sun red is a disorderly crowd of dust or smoke particles suspended in air.

As an aside, it should be noted that artists were aware of this phenomenon long before Goethe, Leonardo and Albertus committed it to writing. Artists used it in the layering of paint, and their 'turbid medium' was a disorderly crowd of pigment particles suspended in oil. If artists placed a light layer over a dark layer then they created a cool, bluish effect that harnessed the way blue is created in the sky (seeing darkness through light). Following a long tradition, Rubens was particularly skilled with these 'scumble' layers and used a thin layer of white over a dark red to create the characteristic cool, pearly translucence of his flesh paint. Artists also knew that a dark layer over a light layer would create a warm, reddish effect that harnessed the way the sun goes red (seeing lightness through dark). Jan van Eyck was so successful with these 'glaze' layers that the great biographer of

artists Giorgio Vasari mistakenly thought that he had invented an entirely new way of painting.[23]

If the briefly red-hot black soot in Faraday's candle managed to escape being deposited on a ceiling in some magical charm, then it was free to circulate as visible smog until it dissipated into thin air where it remained, invisible, as the cause of scattering, making the sky blue and the sun red. The other nominally red things – earth and blood – also scatter sunlight. Earth is picked up by the wind and remains airborne, as does blood in the form of *cruor* and cremated ashes. One way or another, the stuff of which we are made finds its way into the sky – as smoke, scattered ashes or as wind-blown (part ex-human or posthumous) humus. The earth, blood and fire may not have been reliably red when on the earth, but suspended in the heavens, they invariably make dawns and dusks red. Appropriately for the stuff that causes such liminal phenomena, airborne dust hovers on the border between being and non-being. It is solid yet shapeless, or at least constantly shape-shifting, and countless millions of tons of it float, unseen and apparently weightless, above our heads.

Meister Eckhart said fire rises 'until it licks the heavens' and, on the horizon at dawn and dusk, the disembodied colour red appears on earth's margin, licking the heavens.[24] The significance of this phenomenon becomes apparent when the light 'incendiary' aspect of fire is eclipsed by the dark shadowy behaviour of 'incense', which rises upward in religious rituals, symbolizing the ascent of prayers.[25] One prayer which is particularly relevant to the red sky is the Order for the Burial of the Dead, and it ends with the phrase 'earth to earth, ashes to ashes, dust to dust'. That 'earth, ash and dust' invisibly gives the sky colour. The western red dusk is a visible cosmic *memento mori* that says to the mourners who remain, 'I once was as you now are, you will be as I now am.'[26]

Upon death, the matter that makes up an individual is reshuffled around the world. As Shakespeare's Cleopatra put it, 'I am fire, and air; my other elements / I give to baser life' (*Anthony and Cleopatra*, v, ii, 288–9). Yet recent research – which took advantage of the radioactive contamination of our bodies caused by Cold War atom bomb tests – has shown that this

reshuffling is a continuous, ongoing process. Variations in carbon-14 levels suggest that, whatever your age, most of the cells in your body are only up to about ten years old. Most of us, from our skin to our bones, is being constantly recycled, so a new twist can now be put on our relationship with airborne earth, ashes and dust.[27] The eastern red dawn can now also say to us, 'You once were as I now am, I will be as you now are.'[28]

It turns out that the traditional myths about humans being made of red clay or humus were right all along. As the Bible put it, 'thy seed shall be as the dust of the earth, and you shall spread abroad to the west and to the east' and 'dust thou art and unto dust thou shalt return' (Genesis 28:14 and 3:19). (Using slightly different imagery some 500 years before Christ, Heraclitus said that you could not step into the same river twice.[29] As a child I used to swim in the River Cam, but if I return to what looks like the same place to swim again today, all the matter that makes the Cam is different and practically all the matter that makes me is different too.) If the poet T. S. Eliot could show us 'fear in a handful of dust' under the shadow of a red rock then, true to red's 'contradictions', that same handful of dust can show us hope when lifted up into the sky. 'Celestial rosy red' is, as Milton said, 'love's proper hue'.[30]

The red sky is one face of a veil of matter – part of the reservoir from which we are made and to which we will again contribute – and it lies between us and the light. The veil itself is invisible but can be perceived in the redness of dawn and dusk. Since red is the colour of blood, the veil on the horizon could be seen as 'sanctified' sky, literally anointed with blood, like the apocalyptic blood-red moon of Revelation. But, as Albertus Magnus said, the colour is in fact due to light being seen 'through smoke'. 'Smoke' in Latin is *fumare*, and the prefix for 'through' is *per*. It follows that red, the result of seeing light through smoke, is literally 'per-fumed' light.

Perfumed light

Red is to the eyes as perfume is to the nose. The eyes see dark smoky incense ascending to heaven, like prayers made visible, but the nose is aware of its perfume. Perfume's ritual purpose is to envelop the worshipper, surrounding them with an invisible and untouchable richness, a sensuous reminder of the all-encompassing spirit of God. Smell is the most mysterious of the senses. It is not like sight or hearing, the contents of which we actively decode. Nor is it like touch or taste, which require us to reach out to the world or put some of it in our mouths. Smells can just embrace and penetrate us, even though they seem to have no body with which to embrace or penetrate. Smell is the most powerfully evocative of all the senses and we can be instantly transported away from trivial concerns by the faintest smell of the sea, new-mown hay, or a lover, for example. Indeed, some of the things that we now value for their colour originally obtained their power over us with their smell. Roses, for example, became culturally important flowers due to the medicinal properties of their dried petals, rose water and rose oil. According to Avicenna, red roses 'comfort the heart' and a medieval text attributed roses' healing properties to their perfume's ability to penetrate the deepest parts of the body.[31] Red – perfumed light – is the colour of profound penetration.

Like perfume, the red sky seems disembodied. All the other reds we see are embodied in something animal, vegetable, mineral or artificial. Even the modern immaterial reds are only seen on solid screens. According to Albertus Magnus, Goethe and the works of numerous painters up to the seventeenth century, red is the presence of light perceived through the relative absence of light.[32] Red is the consequence of light having to jostle its way through smoky 'turbid' air, a disorderly crowd of earth, dust and ash particles that 'perturb' or 'disturb' the light. In the light's journey, blue was diverted, but the red carried on undiverted. Red is the colour of light that has endured suffering (the loss of blue) in its passage through the matter which we make and

69 Simon Marmion, detail showing 'Demons dragging Tondal into the Infernal Cistern', 1475, illuminated manuscript. The fiery red mouth of hell which marks access to the realms 'below' mortals. Expressing cosmic balance, Dante's *Divine Comedy* has nine circles of hell and Satan; the usually red angelic being furthest from God is at the centre of the ninth circle. The alchemical symmetry ('As above, so below') makes the very top and very bottom of the cosmos both red.

of which we are made.[33] Light's suffering and loss in that turbid air could be seen as its 'passion', and the light that penetrates – unperturbed and undisturbed by turbulence – could be said to have 'patience'. Red's beauty is the result of both light's passion and its patience.

Given red's genesis, it is not surprising that the colour was seen as two-sided and that whatever was said about it, its opposite could also be true. Red is a Janus-faced colour, and its 'calorific' effect is due to its dynamic relationship with both black and white.[34] Where traditions tried to explain the origin of

individual red materials, or even apparently immaterial candle flames, it was as if their stories all contained a thread spun equally from opposites like black and white, darkness and light, objectivity and subjectivity. For example, the turbulence that white light suffered in black smoke was expressed in dragonsblood's cosmic battle and red's power and beauty were expressed in the synthesis of vermilion, the proto-Philosopher's Stone.

A red thread runs through the colour of perfumed light – whether it is found in the animal, vegetable or mineral kingdoms, in artifice, or in the sky – and that thread is spun from darkness and light, or *yin* and *yang*. As such, of course, the colour shares the same red thread as all things, yet it expresses the intimate union of the material and the immaterial with particular clarity.[35]

Ancient understandings of the passions of red earth, red blood and red fire, as well as red in the patient dust-filled sky,

70 Seven fiery red seraphim, illuminated manuscript, *c.* 1335. Seraphim are the highest of the nine orders of angelic beings in Dionysius' *Celestial Hierarchy.* They are the closest to God. Seraphim are followed by cherubim, thrones, dominions, virtues, powers, principalities, archangels and angels. All reside 'above' the realm of mortals.

are in keeping with the late sixteenth-century Dominican who advised that we should carefully examine 'the stones and all the elements and be ashamed before their obedience'.[36] They are also in keeping with the thoughts of John Ruskin, who declared that our personal 'bonds of affection' made us 'better than dust'. Yet he also saw 'human clay' and the 'dust of generations' being cycled through nature's 'political economy of co-operation' to become worthy foundations for 'the city of God'.[37] Such nineteenth-century philosophizing might seem quaint and out of date. However, at the time of writing, these old ideas of direct connections between the earth, our bodies and the sky (and of a red thread spun from darkness and light) are fully in accord with the emerging 'new ecologies', which see realities as dynamic sets of entangled relations.[38]

Fire and earth show their true colours in the blood-anointed sky and there they display the nature of red or, if you prefer, the natures of red, since red is Janus-faced. In the Christian tradition, seraphim – the top of the angelic hierarchy, closest to God – have been depicted as red. At the same time, furthest from God, the Devil, demons and the mouth of hell were also usually shown as red. Red is light that has passed through darkness. It follows that there are several ways we can approach the colour. We can appreciate red for what it is, we can associate it with the distant light, or with the darkness closer to hand. The choice is ours.

REFERENCES

Introduction

1 Geoffrey of Monmouth, *The History of the Kings of Britain* [*c.* 1136] (v, vii, 3), trans. L. Thorpe (London, 1966), pp. 171–4. Red and white flowers are not mixed by some as, for them, the combination evokes the 'blood and bandages' of wartime.

2 J. W. von Goethe, *Elective Affinities* [1809], vol. II, chap. 2, trans. R. J. Hollingdale (Harmondsworth, 1978), p. 163.

3 Ibid., p. 164.

4 Ibid., vol. II, chap. 4, p. 180.

5 J. Blower, 'Monuments and Memento Mori in Goethe's Elective Affinities', *Future Anterior*, VII/2 (2011), pp. 37–48.

6 B. Faure, *The Red Thread: Buddhist Approaches to Sexuality* (Princeton, NJ, 1998).

7 L. C. Jones, 'The Evil Eye among European-Americans', *Western Folklore*, X/1 (1951), p. 12.

8 *Oxford English Dictionary*, online version, www.oed.co.uk (2014).

9 A. Conan Doyle, 'A Study in Scarlet', in *The Stories of Sherlock Holmes* (London, 1991), vol. I, p. 45.

10 C. Ginzburg, 'Morelli, Freud and Sherlock Holmes: Clues and the Scientific Method', *History Workshop*, IX (1980), p. 12. Sigmund Freud also knew of Goethe's red thread and referred to it in his book *Jokes and their Relation to the Unconscious* (Redditch, 2013). See C. Ginzburg, 'Family Resemblances and Family Trees: Two Cognitive Metaphors', *Critical Inquiry*, XXX/3 (2004), p. 539.

11 P. Bayard, *Sherlock Holmes Was Wrong*, trans. C. Mandell (New York, 2008), pp. 30–53.

12 Ludwig Wittgenstein, *Remarks on Colour*, ed. G.E.M. Anscombe, trans. L. L. McAlister and M. Schättle (Berkeley, CA, 1979), p. 16e.

13 Matthew 27:28, Luke 23:11, Mark 15:17 and John 19:2.

14 M. Bimson, 'Cosmetic Pigments from the "Royal Cemetery" at Ur', *Iraq*, XLII/1 (1980), pp. 75–7; A. Lucas, 'Cosmetics, Perfumes and Incense in Ancient Egypt', *Journal of Egyptian Archaeology*, XVI (1930), pp. 41–53.

15 Ovid, *Rem. Am.* 351, in K. Olson, 'Cosmetics in Roman Antiquity: Substance, Remedy, Poison', *The Classical World*, CII/3 (2009), p. 296.

16 Olson, 'Cosmetics', pp. 291–310.

17 Pliny the Elder, *Natural History*, Book XXVIII, chap. 28, trans. H. Rackham (London, 1968), vol. VIII, p. 77.

18 H. D. Betz, *The Greek Magical Papyri in Translation, Including the Demotic Spells* (Chicago, IL, 1996), pp. 167–9.

19 Herodotus, *The Histories*, trans. R. Waterfield (Oxford, 1998), vol. II, p. 99.

20 F. Gunn, *The Artificial Face: A History of Cosmetics* (Newton Abbot, 1973), pp. 53–69.

21 F. E. Dolan, 'Taking the Pencil out of God's Hand: Art, Nature and the Face-painting Debate in Early-modern England', *PMLA*, CVIII/2 (1993), pp. 224–39.

22 G. P. Lomazzo, *A Tracte Containing the Artes of Curious Paintinge, Caruinge and Buildinge* [1598], trans. R. Haydocke (Farnborough, 1970), p. 127.

23 L. S. Marcus, J. Mueller and M. B. Rose, eds, *Elizabeth I: Collected Works, 1533–1603* (Chicago, IL, 2000), letter of 15 May 1549, p. 35.

24 A similar problem afflicted some portraits by Sir Joshua Reynolds two centuries later.

25 N. Williams, *Powder and Paint* (London, 1957), p. 17.

26 Melissa Hyde, 'The "Makeup" of the Marquise: Boucher's Portrait of Pompadour at her Toilette', *Art Bulletin*, LXXXII/3 (2000), pp. 453–75.

27 C. Palmer, 'Brazen Cheek: Face-painters in Late Eighteenth-century England', *Oxford Art Journal*, XXXI/2 (2008), pp. 197–213.

28 In a similar reaction against French formal gardens, the English adopted Lancelot 'Capability' Brown and Humphry Repton's contrived, but apparently natural, style of landscaping.

29 Williams, *Powder and Paint*, p. 98.

30 In fact, London's air had been choking and sulphurous for some centuries and Elizabeth I refused to enter London in 1598 because of the stench of burning sea coal. See *Calendar of State Papers, Domestic Series, of the Reigns of Edward VI, Mary, Elizabeth, 1547–1580*, ed. R. Lemon (London, 1856), p. 612.

31 *London Journal Fashions*, no. 98, p. 11, cited in Williams, *Powder and Paint*, p. 106.

32 Williams, *Powder and Paint*, pp. 107–33.

33 Anon., 'Cosmetics Not to be Rationed, Regardless of War Emergency', *Science News Letters*, XXXIX/17 (1941), p. 271.

ONE *Animal Reds*

1 R. Fletcher, 'Myths of the Robin Redbreast in Early English Poetry', *American Anthropologist*, II/2 (1889), pp. 97–118.

2 P. de Bolla, *Art Matters* (Cambridge, MA, 2001), p. 2.

3 A. Chrisafis, 'Head Two', *The Guardian*, 4 July 2002, p. 1. (The head in question was from Marc Quinn's first cast and the newspaper's front-page headline referred to an adjacent article on the decapitation of Margaret Thatcher's statue, appropriately entitled 'Head One'.)

4 V. Mazel et al., 'Identification of Ritual Blood in African Artefacts', *Analytical Chemistry*, LXXIX/24 (2007), pp. 9253–60; D. Fraser et al., 'Characterisation of Blood in an Encrustation of an African Mask', *Analyst*, 138 (2013), pp. 4470–74.

5 R. Chenciner, *Madder Red: A History of Luxury and Trade* (Richmond, 2000), pp. 181, 193.

6 R. de Clari, *La Conquête de Constantinople*, ed. P. Lauer (Paris, 1924), p. 117, cited in S. Kinoshita, 'Animals and the Medieval Culture of Empire', in *Animal, Vegetable and Mineral: Ethics and Objects*, ed. J. J. Cohen (Washington, DC, 2102), p. 39.

7 Kautilya's *Arthashastra*, Book XIV, trans. R. Shamasastry, p. 606. Available via www.bharatadesam.com.

8 D. A. Scott et al., 'An Egyptian Cartonnage of the Graeco-Roman Period', *Studies in Conservation*, XLVIII/1 (2003), pp. 41–56; R. Hofmann-de Keijzer and M. R. van Bommel, 'Dyestuff Analysis of Two Textile Fragments', *Dyes in History and Archaeology*, 21 (2008), pp. 17–25.

9 M. Clarke, 'Anglo-Saxon Manuscript Pigments', *Studies in Conservation*, XLIX/4 (2004), pp. 231–44.

10 C. S. Smith and J. G. Hawthorne, 'Mappae Clavicula: A Little Key to the World of Medieval Technique', *Transactions of the American Philosophical Society*, LXIV/4 (1974), p. 52; see also J. Kirby, 'Some Aspects of Medieval and Renaissance Lake Pigment Technology', *Dyes in History and Archaeology*, 21 (2008), pp. 89–108.

11 J. R. McCulloch, *Dictionary of Commerce* (London, 1832), p. 695; W. Morris, 'Dyeing as an Art', *The Decorator and Furnisher*, XIX/6 (1892), pp. 217–18; and E. Howe, 'Wall Painting Technology at Westminster Abbey c. 1270–1300', in *Medieval Painting in Northern Europe*, ed. J. Nadolny, K. Kollandsrud, M. L. Sauerberg and T. Frøysaker (London, 2006), pp. 91–113.

12 R. A. Donkin, 'The Insect Dyes of Western and West-Central Asia', *Anthropos*, LXXII (1977), p. 851.
13 Ibid., p. 853.
14 H. Kurdian, 'Kirmiz', *Journal of the American Oriental Society*, LXI/2 (1941), pp. 106–7.
15 Donkin, 'Insect Dyes', p. 860.
16 Pausanius, *Description of Greece*, vol. IV (Phocis, Ozolian Locri), trans. W.H.S. Jones (London, 1969), p. 587.
17 Pliny the Elder, *Natural History*, Book XXVIII. chap. 28, trans. H. Rackham (London, 1968), vol. IV, p. 409.
18 Donkin, 'Insect Dyes', p. 859.
19 Pliny, *Natural History*, Book XXIV, chap. 4, vol. VII, p. 9.
20 Donkin, 'Insect Dyes', p. 862.
21 Edward Eggleston, 'Some Curious Colonial Remedies', *American Historical Review*, 5 (1899), p. 201.
22 L. C. Matthew, 'Vendecolori a Venezia: The Reconstruction of a Profession', *Burlington Magazine*, CXLIV/1196 (2002), pp. 680–86.
23 A. B. Greenfield, 'Alkermes "Liqueur of Prodigious Strength"', *Gastronomica*, VII/1 (2007), p. 29.
24 Donkin, 'Insect Dyes', p. 854.
25 Ibid., p. 855.
26 R. M. Massey, 'An Account of a Book', *Philosophical Transactions of the Royal Society*, XXXVII (1731–2), pp. 216–18.
27 E. Phipps, 'Cochineal Red: The Art History of a Color', *The Metropolitan Museum of Art Bulletin*, n.s., LXVII/3 (2010), pp. 12, 21.
28 R. A. Donkin, 'Spanish Red: An Ethnogeographical Study of Cochineal and the Opuntia Cactus', *Transactions of the American Philosophical Society*, n.s., LXVII/5 (1977), pp. 20–21.
29 *Letters of Cortes*, ed. F. A. MacNutt (New York, 1908), vol. I, p. 258, cited ibid., p. 20.
30 Donkin, 'Spanish Red', p. 12.
31 Ibid., pp. 11–15.
32 Phipps, 'Cochineal Red', p. 14.
33 Ibid., p. 27.
34 R. L. Lee, 'American Cochineal in European Commerce, 1526–1625', *Journal of Modern History*, XXIII/3 (1951), pp. 208–10.
35 John Donne, *Satires*, IV, 188–9, in *The Complete Poems of John Donne*, ed. R. Robins (Edinburgh, 2010), p. 411.
36 Lee, 'American Cochineal', p. 214.
37 *The Philosophical Works of the Honourable Robert Boyle Esq.*, ed. P. Shaw (London, 1738), vol. II, pp. 74, 92, cited in Lee, 'American Cochineal', p. 224. See also Donkin, 'Spanish Red', pp. 44–5.

38 K. H. Ochs, 'The Royal Society of London's History of Trades Programme', *Notes and Records of the Royal Society*, XXXIX/2 (1984), p. 149.

TWO *Eastern Trees*

1 H. M. Schaefer, K. McGraw and C. Catoni, 'Birds Use Fruit Colour as Honest Signal of Dietary Antioxidant Rewards', *Functional Ecology*, 22 (2008), pp. 303–10.

2 E. Cazetta, M. Galetti, E. L. Rezende and H. M. Schaefer, 'On the Reliability of Visual Communication in Vertebrate-dispersed Fruits', *Journal of Ecology*, C/1 (2012), pp. 277–86.

3 A. Gumbert, J. Kunze and L. Chittka, 'Floral Colour Diversity in Plant Communities, Bee Colour Space and a Null Model', *Proceedings of the Royal Society B: Biological Sciences*, CCLXVI/1429 (1999), pp. 1711–16.

4 G. A. Llano, 'Economic Uses of Lichens', *Economic Botany*, II/1 (1948), pp. 17–26. (The Japanese lichen *iwa-take* or 'rock-mushroom' is a delicacy.)

5 Cennino Cennini, *The Craftsman's Handbook*, XVIII, trans. D. V. Thompson (New York, 1960), p. 11. Robert Boyle noted that brazilwood and madder – to be considered in due course – also changed colour, along with lichens. See 'Some Observations Touching Colours', *Philosophical Transactions* (1665–78), vol. VI (1671), p. 2133; R. Boyle, *Experiments and Considerations Touching Colours* (London, 1664), p. 288; A. A. Baker, 'A History of Indicators', *Chymia*, 9 (1964), p. 148.

6 E. R. Caley, 'The Stockholm Papyrus: An English Translation with Brief Notes' (recipes 95, 96, 108–11, 117, 120, 123, 125, 127, 131, 142, 149 and 150), *Journal of Chemical Education*, IV/8 (1927), pp. 992–8.

7 E. Spanier, ed., *The Royal Purple and the Biblical Blue* (Jerusalem, 1987).

8 P. Walton, 'Dyes of the Viking Age', *Dyes in History and Archaeology*, 7 (1988), pp. 14–20.

9 A. Kok, 'A Short History of the Orchil Dyes', *The Lichenologist*, III/2 (1966), pp. 252–8.

10 Llano, 'Economic Uses of Lichens', p. 36.

11 *National Geographic Magazine*, February 1947, cited ibid., p. 37.

12 J. M. Synge, *The Aran Islands* (Oxford, 1979), p. 15.

13 Sigrid Holmwood, personal correspondence.

14 Cennini, *The Craftsman's Handbook*, XLIII, p. 26.

15 Caley, 'The Stockholm Papyrus', recipe 62, p. 988.

16 Albertus Magnus, *Book of Minerals* (II, ii, 19), trans. D. Wyckoff (Oxford, 1967), p. 124.

17 S. Bucklow, *The Alchemy of Paint: Art, Science and Secrets from the Middle Ages* (London, 2009), pp. 141–72.

18 Samuel Purchas, *The Pilgrim* (i, ii, 1i, 2), in *Hakluytus Posthumous* [1625], cited in J. Needham, *Science and Civilisation in China* (Cambridge, 1954), vol. iv/1, p. 245.

19 U. Baumer and P. Dietemann, 'Identification and Differentiation of Dragon's Blood', *Analytical and Bioanalytical Chemistry*, cccxcvii/3 (2010), pp. 1363–73.

20 E. M. Carus-Wilson, 'The English Cloth Industry in the Twelfth and Thirteenth Centuries', *Economic History Review*, xiv/1 (1944), p. 38.

21 J. McKillop, *A Dictionary of Celtic Mythology* (Oxford, 2004), p. 237; Apollodorus, *The Library of Greek Mythology* (ii, v, 10), trans. R. Hard (Oxford, 2008), pp. 80–81.

22 J. C. Sower, 'An Early Description of Pennsylvania' [1724], *The Pennsylvania Magazine of History and Biography*, xlv/3 (1921), p. 250. Trees were obviously a significant feature of the region, since the name means 'Penn's forest', after Admiral William Penn (1621–1670).

23 E. Hermens and A. Wallert, 'The Pekstok Papers, Lake Pigments, Prisons and Paint-mills', in *Looking Through Paintings*, ed. E. Hermens (London, 1998), pp. 276–80.

24 P. Walton, 'Textiles', in *English Medieval Industries*, ed. J. Blair and N. Ramsay (London, 1991), p. 334.

25 J. Kirby, D. Saunders and M. Spring, 'Proscribed Pigments in Northern European Renaissance Paintings and the Case of Paris Red' in *The Object in Context*, ed. D. Saunders, J. Townsend and S. Woodcock (London, 2006), pp. 236–43.

26 *Pedanius Dioscorides of Anazarbus*, trans. L. Y. Beck (Hildersheim, 2005), p. 245.

27 *Gerard's Herbal*, iii/172 [1597], ed. M. Woodward (London, 1994), pp. 256–7.

28 S. Grierson, *The Colour Cauldron: The History and Use of Natural Dyes in Scotland* (Perth, 1986), p. 32.

29 J. H. Munro, 'The Medieval Scarlet and the Economics of Sartorial Splendor', in *Cloth and Clothing in Medieval Europe*, ed. N. B. Harte and K. G. Ponting (London, 1983), p. 39.

30 Walton, 'Textiles', p. 334.

31 S. Fairlie, 'Dyestuffs in the Eighteenth Century', *Economic History Review*, xvii/3 (1965), pp. 498–9. See also Lee, 'American Cochineal', pp. 220–21.

32 Fairlie, 'Dyestuffs in the Eighteenth Century', pp. 489, 505.

33 Y. Dogan et al., 'Plants used as Natural Dye Sources in Turkey', *Economic Botany*, lvii/4 (2003), p. 442.

34 Munro, 'The Medieval Scarlet', pp. 28–9.
35 A. F. Sutton, 'Order and Fashion in Clothes: The King, his Household, and the City of London at the End of the Fifteenth Century', *Textile History*, XXII/2 (1991), p. 256.
36 Ibid., p. 259.
37 See A. Hunt, *Governance of the Consuming Passions: A History of Sumptuary Law* (New York, 1996); L. Taylor, *The Study of Dress History* (Manchester, 2002); D. Jacoby, 'Silk Economics and Cross-cultural Artistic Interaction: Byzantium, the Muslim World and the Christian West', *Dumbarton Oaks Papers*, 58 (2004), pp. 197–240; U. Rublack, *Dressing Up: Cultural Identity in Renaissance Europe* (Oxford, 2010).
38 Bucklow, *The Alchemy of Paint*, pp. 109–40.
39 Munro, 'The Medieval Scarlet', p. 39.
40 Carus-Wilson, 'The English Cloth Industry', p. 48.

THREE *Fruits of the Earth*

1 See, for example, A. Appadurai, ed., *The Social Life of Things: Commodities in Cultural Perspective* (Chicago, IL, 1986).
2 Except, perhaps, for a doctor with a very rich and very sick patient.
3 Pliny the Elder, *Natural History*, Book XXXVII, chap. 15, trans. H. Rackham (London, 1968), vol. XX, pp. 239–43.
4 Ruby (Al_2O_3:Cr) has a hardness of 9.0 while spinel ($MgAl_2O_4$) has a hardness of 8.0 and garnet has a hardness of 7.0. (Garnets have a variety of compositions – $X_3Y_2(SiO_4)_3$ where X is Ca_2+, Mg_2+ or Fe_2+ and Y is Al_3+, Fe_3+ or Cr_3+.)
5 Albertus Magnus, *Book of Minerals* (II, ii, 3), trans. D. Wyckoff (Oxford, 1967), p. 78.
6 J.C.M. van Winden, *Calcidius on Matter*, cited in I. Weinryb, 'Living Matter: Materiality Matter and Organism in the Middle Ages', *Gesta*, LII/2 (2013), p. 129.
7 O. Wilde, *The Picture of Dorian Gray* [1891], (Harpenden, 2013), p. 159.
8 Pliny, *Natural History*, Book XXXVII, chap. 57, vol. XX, p. 293; Peterborough MS 33 (cxxxi, xlvii and lxvii), in J. Evans and M. S. Sergeantson, *English Medieval Lapidaries* (London, 1933), p. 85; J. Evans, *Magical Jewels of the Middle Ages and Renaissance* (Oxford, 1922), p. 19; Albertus Magnus, *On Animals* (XXV, ii, 27), trans. K. F. Kitchell and I. M. Resnick (Baltimore, MD, 1999), vol. II, p. 1726.
9 Philostratus, *The Life of Apollonius of Tyana* (III, viii), trans. F. C. Conybeare (London, 1912), vol. I, p. 247.

10 Isidore of Seville, *Etymologies* (XII, iv, 12), trans. S. A. Barney, W. J. Lewis, J. A. Breach and O. Berghof (Cambridge, 2006), p. 256.

11 Kirani Kiranides, *Et ad Rhyakini Koronides* [1638], in Férand de Mély, *Revue de l'Art Chrétien*, III (1893), p. 136, cited in Evans, *Magical Jewels*, p. 19.

12 William Shakespeare, *As You Like It* (II, i, 12–13).

13 P. J. Heather, 'Precious Stones in the Middle-English Verse of the Fourteenth Century', *Folklore*, XLII/3 (1931), pp. 217–64.

14 Albertus Magnus, *Book of Minerals* (II, i, 2), p. 61.

15 Sloane Lapidary, cited in Evans and Serjeantson, *English Medieval Lapidaries*, p. 123.

16 G. F. Kunz, *The Curious Lore of Precious Stones* [1913] (New York, 1971), p. 351.

17 Albertus Magnus, *Book of Minerals* (II, iii, 4), pp. 138–9.

18 Thomas of Cantimpré, cited in J. Gage, *Colour and Culture: Practice and Meaning from Antiquity to Abstraction* (London, 1993), p. 74.

19 Albertus Magnus, *Book of Minerals* (II, ii, 17), p. 116.

20 PL 117, 1207A, PG 43, 293C and PL 93, 199D, cited in H. Šedinová, 'The Symbolism of the Precious Stones in St Wenceslas Chapel', *Artibus et Historiae*, XX/39 (1999), p. 84.

21 Šedinová, 'St Wenceslas Chapel', p. 84.

22 Isidore, *Etymologies* (XI, i, 15), p. 232.

23 T. Forbes, 'Chalcedony and Childbirth: Precious and Semi-precious Stones as Obstetrical Amulets', *Yale Journal of Biology and Medicine*, 35 (1963), p. 394.

24 Albertus Magnus, *Book of Minerals* (II, ii, 3), p. 82.

25 Pliny, *Natural History*, Book XXXVII, chap. 37, vol. XX, pp. 257–62.

26 Albertus, *Minerals* (II, ii, 7), p. 116.

27 Apollodorus, *Epitome*, III, 17–20, cited in J.D.P. Bolton, *Aristeas of Proconnesus* (Oxford, 1962), p. 164.

28 Marbode of Rennes, 'De Lapidibus', XXXII, trans. J. M. Riddle, *Sudhoffs Archiv, Zeitschrift für Wissenschaftsgeschichte*, Beiheft 20 (1977), pp. 70–71.

29 Albertus, *Minerals* (IV, i, 8), p. 234.

30 Richard Kieckhefer, *Magic in the Middle Ages* (Cambridge, 2000), p. 67.

31 Pliny, *Natural History*, Book XXIV, chap. 39, vol. IX, pp. 228–9.

32 Ibid., Book. XXXIV, chap. 40, vol. IX, p. 231.

33 Albertus, *Minerals* (II, ii, 5), p. 90.

34 Pliny, *Natural History*, Book XXXIV, chap. 45, vol. IX, p. 239, and Book XXXVII, chap. 60, vol. XX, p. 303.

35 E. E. Wreschner, 'Red Ochre and Human Evolution: A Case for Discussion', *Current Anthropology*, XXI/5 (1980), p. 632.

36 This ancient custom has been observed in the New World and, more recently, the Beothuk of Newfoundland were described as being painted with red ochre in 1497. See W. K. Moorehead, 'The Red Paint People of Maine', *American Anthropologist*, XV/1 (1913), pp. 33–47.

37 Wreschner, 'Red Ochre and Human Evolution', p. 638. Burial customs in Spain around 5,000 years ago also used cinnabar. This red mineral was transported over 100 km from its source. See J. Martin-Gil and F. J. Martin-Gil et al., 'The First Known Use of Vermilion', *Experientia*, LI/8 (1995), pp. 759–61.

38 Cennino Cennini, *The Craftsman's Handbook*, XLII, XXXVIII, XLV, trans. D. V. Thompson (New York, 1960), pp. 25–6, 23, 27.

39 Isidore of Seville, *Etymologies* (XIX, xvii, 2), p. 380. To add to the confusion surrounding colour names, sinople meant 'red' in Old French, but it also meant 'green' and the technical language of heraldry used it to describe both colours. See Gage, *Colour and Culture*, p. 82.

40 Strabo, *The Geography* (XII, iii, 11), trans. H. L. Jones (London, 1969), vol. V, pp. 387–391.

41 Ibid. (XII, ii, 10), vol. V, pp. 365–9.

42 W. Leaf, 'The Commerce of Sinope', *Journal of Hellenic Studies*, 36 (1916), pp. 1–15.

43 Theophrastus, *On Stones* (51–59), trans. E. R. Carley and J.F.C. Richards (Columbus, OH, 1956), pp. 56–8; Strabo, *The Geography* (XII, ii, 10), vol. V, pp. 365–9.

44 Pliny, *Natural History*, Book XXXIII, chap. 36, vol. IX, p. 85.

FOUR *Mysterious Reds*

1 D. Lowenthal, 'The Past is a Foreign Country', in *Key Debates in Anthropology*, ed. T. Ingold (London, 1996), p. 209.

2 E. Hovers et al., 'An Early Case of Color Symbolism: Ochre Use by Modern Humans in Qafzeh Cave', *Current Anthropology*, XLIV/4 (2003), pp. 491–522.

3 R. C. Thompson, *A Dictionary of Assyrian Chemistry and Geology* (Oxford, 1936), pp. 31–2.

4 L. James, *Light and Colour in Byzantine Art* (New York, 1996), p. 51.

5 J. Bersch, *The Manufacture of Earth Colours* (London, 1921); M. P. Pomiès, M. Menu and C. Vignaud, 'Red Palaeolithic Pigments: Natural Haematite or Heated Goethite?', *Archaeometry*, XLI/2 (1999), pp. 275–85.

6 P. Budd and T. Taylor, 'The Faerie Smith Meets the Bronze
 Industry: Magic versus Science in the Interpretation of Prehistoric
 Metal-making', *World Archaeology*, XXVII/1 (1995), pp. 133–43;
 D. Wyckoff, 'Albertus Magnus on Ore Deposits', *Isis*, XLIX/2 (1958),
 pp. 109–22.
7 G. Agricola, 'De Natura Fossilium', *The Geological Society of
 America, Special Paper*, LXII (1955), p. 5; see also A. Jones and
 G. MacGregor, *Colouring the Past: The Significance of Colour in
 Archaeological Research* (Oxford, 2002).
8 Bernard Stiegler called the process 'epiphylogenesis', in *Technics
 and Time*, trans. R. Beardsworth and G. Collins (Stanford, 1998),
 vol. I, p. 135; see, for example, papers and bibliographies in
 The Cognitive Life of Things: Recasting the Boundaries of the Mind,
 ed. L. Malafouris and C. Renfrew (Cambridge, 2010).
9 The Iron Age was preceded by the Bronze Age – the age that
 sprang from a red rock superseded the age of a red metal.
10 M. Eliade, *The Forge and the Crucible,* trans. S. Corrin (Chicago,
 IL, 1978).
11 G. Haaland, R. Haaland and S. Rijal, 'The Social Life of Iron',
 Anthropos, XCVII/1 (2002), pp. 35–54.
12 T. H. White, *The Once and Future King* [1958] (London, 1984).
13 Eliade, *The Forge and the Crucible*, pp. 21–4.
14 Sources of iron included haematites, goethites, limonites, siderites,
 magnetites, maghemite, lepidocrocite, ferrihydrite and low-grade
 sources like bog ores. All of these were also used as pigments for
 their red colours.
15 Albertus Magnus, *Book of Minerals* (III, i, 10), trans. D. Wyckoff
 (Oxford, 1967), p. 182.
16 M. W. Helms, *Craft and the Kingly Ideal: Art, Trade, and Power*
 (Austin, TX, 1993).
17 Vitruvius, *On Architecture* (VII, viii, 1–4), trans. F. Granger
 (London, 1962), vol. II, pp. 115–16; Theophrastus, *On Stones* (51–9),
 trans. E. R. Carley and J. F. C. Richards (Columbus, OH, 1956),
 pp. 56–8.
18 E. E. Wreschner, 'Red Ochre and Human Evolution: A Case for
 Discussion', *Current Anthropology*, XXI/5 (1980), p. 642.
19 Pliny the Elder, *Natural History*, Book XXVIII, chap. 28, trans.
 H. Rackham (London, 1968), vol. IX, p. 93, and Book XXXIII,
 chap. xxxvii–xli, vol. IX, pp. 89–95; Theophilus, *On Divers Arts*,
 III/37, trans. J. G. Hawthorne and C. S. Smith (New York, 1979),
 p. 112.
20 Albertus Magnus, *Book of Minerals* (IV, i, 2), pp. 207–8.
21 Pliny, *Natural History*, Book XXXIII, chap. 36, vol. IX, p. 85.

22 Albertus Magnus, *Book of Minerals* (IV, i, 1), p. 204; see M. Maier [1617], cited in S. K. de Rola, *The Golden Game: Alchemy Engravings of the Seventeenth Century* (London, 1988), pp. 111, 115.

23 Albertus Magnus, *Book of Minerals* (IV, i, 7), p. 231, and (IV, i, 2), pp. 207–8; Roger Bacon, *Speculum Alchimiea*, 206, cited in G. Roberts, *The Mirror of Alchemy: Alchemical Ideas and Images in Manuscripts and Books from Antiquity to the Seventeenth Century* (London, 1994), p. 62.

24 S. Bucklow, *The Alchemy of Paint: Art, Science and Secrets from the Middle Ages* (London, 2009), pp. 103–4.

25 Cennino Cennini, *The Craftsman's Handbook*, XL, trans. D. V. Thompson (New York, 1960), p. 24.

26 Theophilus, *On Divers Arts*, I/34, p. 40.

27 H. Nickel, 'The Judgment of Paris by Lucas Cranach the Elder', *Metropolitan Museum Journal*, 16 (1981), pp. 117–29.

28 M. Clarke, *The Art of All Colours: Mediaeval Recipe Books for Painters and Illuminators* (London, 2001), p. 54.

29 Marco Polo, *The Travels* [c. 1300] trans. R. Latham (Harmondsworth, 1987), p. 279.

30 Wu Chěng-ên, *Monkey*, trans. A. Waley (Harmondsworth, 1974); J. F. Pas and M. K. Leung, *Historical Dictionary of Taoism* (Langham, MD, 1998), p. 182; J. Needham, *Science and Civilisation in China* (Cambridge 1997), vol. V, part 3, p. 87.

31 Bucklow, *The Alchemy of Paint*, pp. 75–108, 224–46.

32 J. Gage, *Colour and Culture: Practice and Meaning from Antiquity to Abstraction* (London, 1993), p. 229.

33 Plutarch, *Moralia* (419F, 18), trans. F. C. Babbitt (London, 1969), vol. V, p. 405.

34 M. Walton, 'Appendix', in L. H. Corxoran and M. Svoboda, *Herakleides* (Los Angeles, CA, 2010), pp. 103–4.

35 S. Bucklow, *The Riddle of the Image: The Secret Science of Medieval Art* (London, 2014), pp. 11–41; Vitruvius, *On Architecture* (VII, xii, 1), trans. F. Granger (London, 1962), p. 125; Isidore of Seville, *Etymologies* (XIX, xvii, 11), trans. and ed. S. A. Barney, W. J. Lewis, J. A. Beach and O. Berghof (Cambridge, 2006), p. 380.

36 Wyckoff, 'Albertus Magnus on Ore Deposits', p. 155.

37 Theophilus, *On Divers Arts*, I/35, p. 41.

38 Ibid., II/4, p. 52; Bolognese MS, VII/268, in M. P. Merrifield, *Original Treatises on the Arts of Painting* (New York, 1967), vol. II, p. 524; Heraclius, *De Coloribus et Artibus Romanorum*, III/1, ibid., vol. I, p. 204; M. Cothren, *Picturing the Celestial City: The Medieval Stained Glass of Beauvais Cathedral* (Princeton, NJ, 2006).

39 Pliny, *Natural History*, Book XXXVII, chaps 16, 76, vol. XX,
 pp. 243, 327.
40 Theophilus, *On Divers Arts*, II/28, pp. 71–2.
41 Bucklow, *The Riddle of the Image,* pp. 141–99.
42 Gage, *Colour and Culture*, p. 75.
43 M. Faraday, 'The Bakerian Lecture: Experimental Relations
 of Gold (and other Metals) to Light', *Philosophical Transactions
 of the Royal Society of London*, CXLVII (1847), pp. 145–81.
44 Chaucer, 'The Squire's Tale', *The Canterbury Tales*, trans. N. Coghill
 (Harmondsworth, 1975), p. 414.
45 Migne, PL (165, 843), cited in H. L. Kessler, 'Vitreous Arts as
 Typology', *Gesta*, LI/1 (2012), p. 66.

FIVE *Reds for a Better Life*

1 J. Schot, 'Technology in Decline', *British Journal for the History
 of Science*, XXV/1 (1992), pp. 5–26.
2 S. Garfield, *Mauve: How One Man Invented a Colour That Changed
 the World* (London, 2002).
3 A. S. Travis, 'Science's Powerful Companion: A. W. Hofmann's
 Investigation of Aniline Red and its Derivatives', *British Journal for
 the History of Science*, XXV/1 (1992), pp. 27–44.
4 O. T. Benfey, 'August Kekulé and the Birth of the Structural Theory
 of Organic Chemistry in 1858', *Journal of Chemical Education*,
 XXXV/1 (1958), p. 22.
5 Travis, 'Science's Powerful Companion', p. 40.
6 See T. Ingold, *Perception of the Environment: Essays on Livelihood,
 Dwelling and Skill* (London, 2000), pp. 311–15.
7 A. E. Hofmann, cited in Travis, 'Science's Powerful Companion', p. 39.
8 W. J. Hornix, 'From Process to Plant: Innovation in the Early
 Artificial Dye Industry', *British Journal for the History of Science*,
 XXV/1 (1992), pp. 65–90.
9 A. S. Macrae, 'Competition Between the Aniline and Madder Dyes',
 Science, I/6 (1880), pp. 62–3; D. Cardon and G. du Chatenet, eds,
 Guide des Teintures Naturelles (Paris, 1990), p. 35; R. Chenciner,
 Madder Red: A History of Luxury and Trade (London, 2000), p. 339;
 A. Kok, 'A Short History of the Orchil Dyes', *The Lichenologist*, III/2
 (1966), p. 259.
10 Hornix, 'From Process to Plant', p. 78.
11 K. G. Ponting, *A Dictionary of Dyes and Dying* (London, 1980),
 p. 163.
12 E. Leslie, *Synthetic Worlds: Nature, Art and the Chemical Industry*
 (London, 2005), p. 77.

13 Ibid., pp. 118–19, 155, 167–87.

14 M. Weinreich, *Hitler's Professors: The Part of Scholarship in Germany's Crimes Against the Jewish People* (London, 1999).

15 See www.bayer.co.uk, accessed 9 November 2015.

16 Leslie, *Synthetic Worlds*, pp. 79–80.

17 B. Edwards, *Chemicals: Servant or Master?* (London, 1947), pp. 24–8.

18 T. Carreón, M. J. Hein, S. M. Viet, K. W. Hanley, A. M. Ruder and E. M. Ward, 'Increased Bladder Cancer Risk among Workers Exposed to O-toluidine and Aniline: A Reanalysis', *Occupational and Environmental Medicine*, LXVII/5 (2010), pp. 348–50.

19 W. Cummings, 'Remarks on the Medicinal Properties of Madar and the Effects of Potassium Dichromate on the Human Body', *Edinburgh Medical Journal*, XXVIII (1827), p. 295; J. Blair, 'Chrome Ulcers', *Journal of the American Medical Association*, XC (1828), pp. 1927–8.

20 A. S. Travis, 'Poisoned Groundwater and Contaminated Soil: The Tribulations and Trial of the First Major Manufacturer of Aniline Dyes in Basel', *Environmental History*, II/3 (1997), pp. 343–65; H. van den Belt, 'Why Monopoly Failed: The Rise and Fall of Société La Fuchsine', *British Journal for the History of Science*, XXV/1 (1992), p. 57.

21 Hornix, 'From Process to Plant', p. 75.

22 C. M. Mellor and D.S.L. Cardwell, 'Dyes and Dyeing, 1775–1860', *British Journal for the History of Science*, I/3 (1963), p. 278.

23 J. J. Hummel, 'Fast and Fugitive Dyestuffs', cited in J. C. Barnett, 'Synthetic Organic Dyes, 1856–1901: An Introductory Literature Review of their Use and Related Issues in Textile Conservation', *Reviews in Conservation*, VIII (2007), p. 70.

24 J. Mertens, 'The History of Artificial Ultramarine: Science, Industry and Secrecy', *Ambix*, LI/3 (2004), pp. 219–44.

25 W. Linton, 'A Summary of Modern Colours', *The Crayon*, III/10 (1856), pp. 300–303.

26 Letters in Roberson Archive, Hamilton Kerr Institute, University of Cambridge. FM MS 802–1993 and FM MS 802A–1993.

27 *Field's Chromatography*, ed. T. W. Salter (London, 1869), pp. 139–40; L. Carlyle, 'Authenticity and Adulteration: What Materials Were 19th Century Artists Really Using?', *The Conservator*, XVII (1993), p. 57.

28 J. H. Townsend, L. Carlyle, N. Khandekar and S. Woodcock, 'Later Nineteenth Century Pigments', *The Conservator*, XIX (1995), p. 67.

29 Vincent van Gogh, *The Oise at Auvers*, 1890, Tate Gallery, N04714.

30 J. T. Bethell, 'Damaged Goods', *Harvard Magazine*, xc (July–August 1988), pp. 24–31.
31 D. W. Gade, 'Past Glory and Present Status of Cochineal', *Geographical Review*, lxix/3 (1979), pp. 353–4.

six *Brave New Reds*

1 The range of hues was extended in the blues and greens and some saturation levels were increased in the nineteenth century, but artists have generally had sufficient colours throughout history. The everyday availability of colour was also much more widespread through historic European society than many modern commentators recognize.

2 Another way of making colour is by 'interference' in very thin colourless structures. Rainbow colours on the road are due to a thin layer of petrol on water, and the magnificent displays by peacocks, butterflies and fish also use this method of making colour. Some of these 'photonic structures' have been valued culturally – like blue feathers – but the way they make their colour has yet to be widely exploited so they will not be considered here.

3 W. Ling, 'On the Invention and Use of Gunpowder and Firearms in China', *Isis*, xxxvii/3–4 (1947), pp. 164–5.

4 P. B. Goodwin, 'The Cathode Ray Tube: A Development of the General Electric Research Laboratory', *Radiology*, viii/1 (1927), p. 77.

5 L. Mullen, 'Visions of the Uncanny', lecture given at the workshop 'Thinking with Things', 25 April 2014, crassh, Cambridge.

6 Eight digital bits gives 256 (2^8) possible levels for each colour. Three colours give 256^3 or $256 \times 256 \times 256$ or 16,777,216 different combinations of levels.

7 E. H. Land, 'Some Aspects of the Development of Sheet Polarizers', *Journal of the Optical Society of America*, xli/12 (1951), pp. 957–62.

8 C. Hilsum, 'Flat-panel Electronic Displays', *Philosophical Transactions of the Royal Society A: Mathematical, Physical and Engineering Sciences*, ccclxviii (2010), pp. 1038, 1044.

9 J. Bennett, *Vibrant Matter: A Political Ecology of Things* (London, 2010), pp. 24–8.

10 M. Lewis, *Flash Boys: Cracking the Money Code* (London, 2014).

11 As an aside, having acknowledged that these brave new reds disrupt the cultural order, it is ironic that they are produced by the disruption of natural order. Modern artificial phosphors and leds that emit colour are otherwise colourless crystals, the order of which has been purposefully disrupted or, to use the technical jargon, 'doped'.

12 H. Belting, 'Image, Medium, Body: A New Approach to Iconology', *Critical Inquiry*, XXXI/2 (2005), pp. 309.

13 Plato, *Phaedrus* (275a–b), trans. H. N. Fowler (London, 1966), vol. I, pp. 563–5.

14 Although of course their computer use reveals a set of information-gathering characteristics which hackers, advertisers and government agencies can target.

15 D. Haraway, *Simians, Cyborgs and Women: The Reinvention of Nature* (New York, 1991), pp. 100–9.

16 Approximately 380,000 copies of *The Guardian* featured a story about the decapitation of Margaret Thatcher's statue on 4 July 2002. At the time of writing, probably fewer than a dozen survive.

17 John Donne, *Satires*, IV, 192, in *The Complete Poems of John Donne*, ed. R. Robins (Edinburgh, 2010), p. 411.

18 For summaries of Max Weber, Hans Blumenberg and others on 'modern disenchantment', see J. Bennett, *The Enchantment of Modern Life: Attachments, Crossings, and Ethics* (Princeton, NJ, 2001), pp. 56–90. Such disenchantment is related to Bernard Stiegler's 'disorientation', a consequence of the (now magnified) tensions between humanity and technology. See B. Stiegler, *Technics and Time*, vol. II, trans. S. Barker (Stanford, CA, 2009). Some disenchantment was inevitable given that modernity emerged from a Cartesian world-view that Iredell Jenkins identified as 'The Postulate of an Impoverished Reality', *Journal of Philosophy*, XXXIX/20 (1942), pp. 533–47.

19 Bennett, *The Enchantment of Modern Life*, p. 171, drawing upon C. Chesher, 'Digitising the Beat: Police Databases and Incorporeal Transformations', *Convergence: The Journal of Research into New Media Technologies*, III/2 (1997), pp. 72–81.

SEVEN *Crossing the Red Lines*

1 Inadvertently continuing the purposeful sixteenth-century Spanish deception, a twenty-first-century book describes pregnant kermes insects as 'oak galls': J. Newton, *The Roots of Civilisation* (Sydney, 2009), p. 222.

2 Ovid, *Metamorphoses*, IV, trans. M. M. Innes (Harmondsworth, 1975), p. 114.

3 M. Endt-Jones, ed., *Coral: Something Rich and Strange* (Liverpool, 2013).

4 H. K. Cooper, 'The Life (Lives) and Times of Native Copper in Northwest North America', *World Archaeology*, XLIII/2 (2011), pp. 252–70.

5 Of course, for us, red is a relatively small and fixed range of hues, but our emphasis on hue is quite recent. Historic understandings of colour placed more emphasis on tone, saturation and textural effects, which tended to make colour a more dynamic phenomenon. Red as a fusion of hues is a unitive, as opposed to a separative, approach to the phenomenon.

6 Aristotle, *History of Animals*, VII, 588b–589a, trans. D. M. Balme (London, 1991), pp. 61–7; and Albertus Magnus, *Book of Minerals* (III, i, 6), trans. D. Wyckoff (Oxford, 1967), p. 171.

7 Matthew Blakely, personal correspondence.

8 K. Helwig, 'A Note on Burnt Yellow Earth Pigments: Documentary Sources and Scientific Analysis', *Studies in Conservation*, XLII/3 (1997), pp. 181–8.

9 Theophrastus, *On Stones*, trans. E. R. Caley and J. C. Richards (Columbus, OH, 1956), p. 56.

10 The other elements were water and air. All four were combinations of properties which also included 'wetness', 'coldness' and 'heat'. See S. Bucklow, *The Alchemy of Paint: Art, Science and Secrets from the Middle Ages* (London, 2009), pp. 52–4.

11 *Summa Perfectionis of Pseudo-Geber*, XI–XII, in W. R. Newman, 'Alchemical and Baconian Views on the Art/Nature Division', in *Reading the Book of Nature: The Other Side of the Scientific Revolution*, ed. A. G. Debus and M. T. Walton (St Louis, MO–IL, 1998), p. 86.

12 Albertus Magnus, *Book of Minerals* (II, iii, 3), pp. 134–5.

13 It then developed by ignoring the spiritual aspects of man and nature, acknowledgement of which would have significantly complicated its methodology. An alternative European science more or less died with Giordano Bruno. See F. Yates, *Giordano Bruno and the Hermetic Tradition* (London, 1964).

14 K. M. Barad, *Meeting the Universe Halfway: Quantum Physics and the Entanglement of Matter and Meaning* (London, 2007).

EIGHT Red Meanings

1 Karl Marx, *Capital* (Moscow, 1971), vol. III, p. 71, cited in E. Leslie, *Synthetic Worlds: Nature, Art and the Chemical Industry* (London, 2005), p. 78.

2 Friedrich Engels, *Ludwig Feuerbach and the Outcome of the Classical German Philosophy* [1888] (London, 1943), p. 33, cited in Leslie, *Synthetic Worlds*, pp. 79–80.

3 E. Barth von Wehrenalp, *Farbe aus Kohle* (Stuttgart, 1937), pp. 32–4, cited in Leslie, *Synthetic Worlds*, p. 172.

4 Marx, Engels and von Wehrenalp were like the armies of modern chemists who saw aniline and alizarin in terms of separate, external, objective, six-membered rings of carbon atoms. They were quite unlike the choreographer of Mercury and Sulphur's dance whose millennia-old tail-biting snake image of nature's unity had to (by definition) include human nature. Since their thoroughly entangled world pre-dated Descartes' divided world, traditional alchemists and artists did at least have a theoretical possibility of understanding red's hold over our psyches.

5 G. Jekyll, *Wood and Garden* (London, 1899), p. 224, cited in S. W. Lanman, 'Colour in the Garden: "Malignant Magenta"', *Garden History*, XXVIII/2 (2000), p. 214.

6 A. M. Earle, *Old Time Gardens* (New York, 1901), p. 244, cited ibid., p. 214.

7 *Monkey*, BBC One (1978–80), dubbed version of *Saiyuki*, Nippon Television series.

8 O. T. Benfey, 'August Kekulé and the Birth of the Structural Theory of Organic Chemistry in 1858', *Journal of Chemical Education*, XXXV/1 (1958), p. 22.

9 But see, for example, K. M. Barad, *Meeting the Universe Halfway: Quantum Physics and the Entanglement of Matter and Meaning* (London, 2007), pp. 385–6.

10 P. Berger and T. Luckmann, *The Social Construction of Reality: A Treatise in the Sociology of Knowledge* (Harmondsworth, 1967).

11 E. S. Bolman, 'De Coloribus: The Meanings of Color in Beatus Manuscripts', *Gesta*, XXXVIII/1 (1999), p. 27.

12 J. Carey, 'The Three Sails, the Twelve Winds, and the Question of Early Irish Colour Theory', *Journal of the Warburg and Courtauld Institutes*, LXXII (2009), pp. 221–32.

13 Wehrenalp, *Farbe aus Kohle*, p. 33, cited in Leslie, *Synthetic Worlds*, p. 172.

14 J. B. Hutchings, 'A Survey of the Use of Colour in Folklore – a Status Report', in *Colour and Appearance in Folklore*, ed. J. B. Hutchings and J. Woods (London, 1991), pp. 56–60.

15 J. Van Brakel, 'The Plasticity of Categories: The Case of Colour', *British Journal for the Philosophy of Science*, XLIV/1 (1993), pp. 103–35.

16 A. Wierzbicka, 'There Are No "Colour Universals" But There Are Universals of Visual Semantics', *Anthropological Linguistics*, XLVII/2 (2005), pp. 217–44.

17 This seems appropriate given that those who study the sociology of knowledge have used the iceberg as an analogy to suggest the hidden meanings of everyday words.

18 The root 'vr' means 'screen, veil, covering, external appearance'. *Oxford English Dictionary*, online version, www.oed.co.uk (2014).

19 K. Rudy and B. Baert, *Weaving, Veiling and Dressing: Textiles and their Metaphors in the late Middle Ages* (Turnhout, 2007).

20 *The Oxford Dictionary of English Etymology*, ed. C. T. Onions (Oxford, 1966), p. 748.

21 A. Willi, 'Demeter, Ge, and the Indo-European Words for "Earth"', *Historische Sprachforschung / Historical Linguistics*, Bd. 120 (2007), p. 190.

22 Homer, *Iliad* (6, 464, 18, 332), trans. E. V. Rieu (Harmondsworth, 2003), pp. 112, 328.

23 Hesiod, *Theogony* (105–75), in *Hesiod and Theognis*, trans. D. Wender (Harmondsworth, 1973), pp. 62–4.

24 D. Batchelor, *Chromophobia* (London, 2000).

25 J. Gage, 'Black and White and Red All Over', RES: *Anthropology and Aesthetics*, XVI (1988), p. 53.

26 Plato, *Cratylus* (1a), trans. H. N. Fowler (London, 1970), vol. IV, p. 7.

27 H. Marks, 'Biblical Naming and Poetic Etymology', *Journal of Biblical Literature*, CXIV/1 (1995), pp. 28, 34.

28 J. Bronkhorst, 'Etymology and Magic: Yasha's *Nirukta*, Plato's *Cratylus*, and the Riddle of Semantic Etymologies', *Numen*, XLVIII/2 (2001), pp. 147–203.

29 Isidore of Seville, *Etymologies* (XIX, xvii, 1), trans. and ed. S. A. Barney, W. J. Lewis, J. A. Beach and O. Berghof (Cambridge, 2006), p. 380.

30 E. Babbitt, *The Principles of Light and Colour* (London, 1878), pp. 18–19.

31 V. Turner, *The Forest of Symbols: Aspects of Ndembu Ritual* (Ithaca, NY, 1967), p. 68, quoted in M. Taussig, *What Colour Is the Sacred?* (Chicago, IL, 2009), p. 7.

32 Anon., *Erzeugnisse unserer Arbeit* (Frankfurt am Main, 1938), p. 25, cited in Leslie, *Synthetic Worlds,* p. 47. IG Farben themselves coined names for synthetic chemicals that had ideological origins and signalled a bright future. The name of the 1937 fibre Vistra was derived from two Latin phrases – *si vis pacem para bellum* (if you want peace then prepare for war) and *per aspera ad astra* (through adversity to the stars). See ibid., p. 176.

33 B. H. Berrie and S. Q. Lomax, 'Azo Pigments: Their History, Synthesis, Properties, and Use in Artists' Materials', *Studies in the History of Art*, LVII, MS II (1997), pp. 8–33.

34 Ovid, *Metamorphoses*, XI, 590–610, trans. M. M. Innes (Harmondsworth, 1975), p. 262.

35 O. Wilde, *The Picture of Dorian Gray* [1891] (Harpenden, 2013), p. 120.

36 D. Lipset, 'Gregory Bateson: Early Biography', in *About Bateson: Essays on Gregory Bateson*, ed. J. Brockman (New York, 1977), p. 38.

37 A. Conan-Doyle, 'A Study in Scarlet', in *The Stories of Sherlock Holmes* (London, 1904), vol. I, pp. 16–17; A. Conan-Doyle, 'The Sign of the Four', in *Sherlock Holmes: Selected Stories* (London, 1960), p. 81. Conan-Doyle rather diluted the effect by having Holmes drop a number of literary references, including the one to Goethe's red thread quoted in the Introduction of this book.

38 'A Study in Pink', *Sherlock* (series 1, episode 1), BBC One, 2010.

39 M. H. Spielmann, 'The Artist's Model', *Magazine of Art* (1887), p. 140.

40 A. J. Elliot and D. Niesta, 'Romantic Red: Red Enhances Men's Attraction to Women', *Journal of Personality and Social Psychology*, XCV/5 (2008), pp. 1150–64.

NINE Red Earth

1 P. van de Velde et al., 'The Social Anthropology of a Neolithic Cemetery in the Netherlands', *Current Anthropology*, XX/1 (1979), p. 39; L. V. Grinsell, 'Early Funerary Superstitions in Britain', *Folklore*, LXIV/1 (1953), p. 272.

2 R. M. Jacobi et al., 'Radiocarbon Chronology for the Early Gravettian of Northern Europe', *Antiquity*, LXXXIV (2010), p. 37.

3 S. Aldhouse-Green, *Paviland Cave and the 'Red Lady': A Definitive Report* (Bristol, 2000), p. 213.

4 Julius Caesar, *The Gallic War: Seven Commentaries on The Gallic War*, III/8, trans. C. Hammond (Oxford, 1996), p. 57.

5 Aldhouse-Green, *Paviland Cave and the 'Red Lady'*, p. 233.

6 M. Sommer, *Bones and Ochre: The Curious Afterlife of the Red Lady of Paviland* (Cambridge, MA, 2007), p. 1.

7 G. Higgins, *Anacalypsis, or an Attempt to Draw Aside the Veil of the Saitic Isis, or, an Inquiry into the Origin of Languages, Nations and Religions* (London, 1836), vol. I, p. 553.

8 Hesiod, *Theogony* (484), in D. Wender, *Hesiod and Theognis* (Harmondsworth, 1973), p. 39; Apollodorus, *The Library of Greek Mythology* (I, 1, vi), trans. R. Hard (Oxford, 1997), p. 28; ibid. (III, 10, ii), p. 117.

9 F. M. Weinberg, *The Cave* (New York, 1986), p. 124; Apollodorus, *The Library of Greek Mythology* (I, 4, i), p. 31.

10 P. Kingsley, 'From Pythagoras to the Turba Philosophorum: Egypt and Pythagorean Tradition', *Journal of the Warburg and Courtauld Institutes*, LVII (1994), pp. 1–13; *Pomponius Mela's Description of the World* (III, 19), ed. F. E. Romer (Ann Arbor, MI, 1998), p. 107.

11 Porphyry, 'The Cave of the Nymphs in the Odyssey', *Arethusa Monographs*, I (Buffalo, NY, 1969), pp. 3–35; Apollodorus, *The Library of Greek Mythology* (III, 10, ii), p. 118; Weinberg, *The Cave*, p. 148.

12 Apollodorus, *The Library of Greek Mythology* (III, epit. i, 9–10), p. 140; Ovid, *Metamorphoses* (VIII, 170), p. 183. Neither gives the colour of the thread.

13 J. Milton, *Paradise Lost* (XI, 468–9), ed. J. Leonard (London, 2000), p. 259.

14 Homer, *Odyssey*, XIII, trans. E. V. and D.C.H. Rieu (London, 2003), pp. 171–8; Plato, *Republic* (X, 614c–615c), trans. C. Emlyn-Jones and W. Preedy (Cambridge, MA, 2013), vol. VI, pp. 465–7.

15 Hesiod, *Works and Days* (46), in Wender, *Hesiod and Theognis*, p. 60.

16 W. Burkert, *Structure and History in Greek Mythology and Ritual* (Berkeley, CA, 1979), pp. 88–95.

17 Porphyry, 'The Cave of the Nymphs in the Odyssey', pp. 3–35.

18 Hesiod, *Theogony* (571), trans. M. L. West (Oxford, 1966), p. 133; Ovid, *Metamorphoses* (1.380–420), pp. 39–40.

19 C. Lalueza-Fox, 'Agreements and Misunderstandings among Three Scientific Fields: Palaeogenomics, Archaeology and Human Palaeontology', *Current Anthropology*, LIV, S8 (2013), pp. S218–9.

20 E. Phipps, 'Cochineal Red: The Art History of a Color', *Metropolitan Museum of Art Bulletin*, n.s., LXVII/3 (2010), p. 22.

21 *The Ancient Egyptian Book of the Dead* (spell 99, part III), trans. R. O. Faulkner, ed. C. Andrews, (London, 1985), p. 95; B. B. Baumann, 'The Botanical Aspects of Ancient Egyptian Embalming and Burial', *Economic Botany*, XIV/1 (1960), p. 86; D. M. Kerpel, 'The Hidden Aesthetic of Red in the Painted Tombs of Oaxaca', RES: *Anthropology and Archaeology*, 57–8 (2010), pp. 55–74; and Phipps, 'Cochineal Red', p. 18.

22 T. S. Eliot, 'The Waste Land' [1922] (I, 25–6, 30), in *Selected Poems* (London, 1976), pp. 51–2.

23 William Blake, *Marriage of Heaven and Hell* [1793] (II, 12–13), (New York, 1994), pp. 2, 28.

24 Herodotus, *The Histories* (II, 12), trans. R. Waterfield (Oxford, 1998), p. 99.

25 M. Bjornerud, 'Gaia: Gender and Scientific Representations of the Earth', NWSA *Journal*, IX/3 (1997), pp. 89–106.

26 *Book of the Dead* (spell 125), pp. 29–34; see also M. Lurker, *The Gods and Symbols of Ancient Egypt* (London, 1991), p. 78.

27 Isidore of Seville, *Etymologies* (XI, i, 4), trans. and ed. S. A. Barney, W. J. Lewis, J. A. Beach and O. Berghof (Cambridge, 2006), p. 231.

28 Ovid, *Metamorphoses* (III/150–70), p. 78; (VII/200–220), p. 160; (XIV/700–720), p. 330.

29 G. Gaard and L. Gruen, 'Ecofeminism: Towards Global Justice and Planetary Health', *Society and Nature*, II/1 (1993), pp. 1–35; and G. Gaard, 'Ecofeminism Revisited', *Feminist Formations*, XXIII/2 (2011), pp. 26–53.

30 R. Hutton, *The Triumph of the Moon: A History of Modern Pagan Witchcraft* (Oxford, 1999), pp. 32–43, 278–82.

31 Dante, *Purgatorio* (IX, 102), in *The Divine Comedy*, trans. C. H. Sisson (Oxford, 1993), p. 237.

32 Apollodorus, *The Library of Greek Mythology* (II, v, 11), p. 82.

33 Bram Stoker, *Dracula* [1897] (New York, 1981), pp. 85–91.

34 J. Leary and D. Field, *The Story of Silbury Hill* (Swindon, 2010).

35 St Augustine, *The City of God*, trans. W. M. Green (London, 1972), vol. VII, p. 227.

36 Herodotus, *The Histories* (VII, 131–8), pp. 448–50.

37 R. B. Salisbury, 'Engaging with Soil, Past and Present', *Journal of Material Culture*, XVII (2012), p. 31.

38 *The Oxford Dictionary of English Etymology*, ed. C. T. Onions (Oxford, 1966), p. 826.

39 P. Robinson, 'Endangered Species', *Turps Banana*, X (2011), p. 42.

40 C. McCormack, 'Filthy Feet in Seicento Rome: Dirt as Relic and Text', *Dandelion*, IV/1 (2013), pp. 1–11.

TEN *Red Blood*

1 Ovid, *Metamorphoses* (1.120–150), trans. M. M. Innes (Harmondsworth, 1975), pp. 32–3; D. J. McCarthy, 'The Symbolism of Blood and Sacrifice', *Journal of Biblical Literature*, LXXXVIII/2 (1969), p. 166; F. M. Weinberg, *The Cave* (New York, 1986), p. 148.

2 Dante, *Purgatorio* (IX, 102).

3 J. Milton, *Paradise Lost* (VI, 475–8, V, 181), ed. J. Leonard (London, 2003), pp. 137, 106.

4 De Rosnel, *Le Mercue Indien* [1672, p. 12] in M. Eliade, *The Forge and the Crucible* (Chicago, IL, 1978), p. 44.

5 Pliny the Elder, *Natural History*, Book XXXIV, chap. 37, trans. H. Rackham (London, 1968), vol. IX, pp. 245–7.

6 J. P. Richter, *The Literary Works of Leonardo da Vinci* (London, 1970), vol. I, p. 100, cited in W. Smith, 'Observations on the Mona Lisa Landscape', *Art Bulletin*, LXVII/2 (1985), pp. 183–99.

7 S. Bucklow, *The Riddle of the Image: The Secret Science of Medieval Art* (London, 2014), pp. 183–4.

8 M. Cole, 'Cellini's Blood', *Art Bulletin*, LXXXI/2 (1999), pp. 215–35, 227, 222. For the correspondence between blood and metals, see P. H. Smith, 'Vermilion, Mercury, Blood and Lizards', in *Materials and Expertise in Early Modern Europe,* ed. U. Klein and E. Spary (Chicago, IL, 2010), pp. 29–49.

9 B. Fricke, 'Matter and Meaning of Mother-of-pearl: The Origins of Allegory in the Spheres of Things', *Gesta*, LI/1 (2012), pp. 42–3.

10 Cennino Cennini, *The Craftsman's Handbook*, CXLIX, trans. D. V. Thompson (New York, 1960), p. 95.

11 Cennini defined the painted boundary of a dead body with a mixture of dark sinopia and the aptly named 'sanguino'. See ibid., CXLVIII, p. 95.

12 C. W. Bynum, *Wonderful Blood: Theology and Practice in Late Medieval Northern Germany and Beyond* (Philadelphia, PA, 2007), pp. 17–18.

13 N. Vincent, *The Holy Blood* (Cambridge, 2001), pp. 43–9; and ibid., pp. 181, 187.

14 Vincent, *The Holy Blood*, pp. 63–71.

15 Ibid., p. 178.

16 Bynum, *Wonderful Blood*, p. 191.

17 Ibid., p. 256.

18 J. R. Branham, 'Blood in Flux, Sanctity at Issue', RES: *Anthropology and Archaeology*, XXXI (1999), p. 62.

19 Pliny, *Natural History*, Book VII, chap. 15 and Book XVII, chap. 47, vol. II, p. 549 and vol. V, p. 185.

20 B. Hindson, 'Attitudes towards Menstruation and Menstrual Blood in Elizabethan England', *Journal of Social History*, XLIII/1 (2009), pp. 89–114.

21 D. Wright, *The Disposal of Impurity* (Atlanta, GA, 1987), pp. 155–6, cited in Branham, 'Blood in Flux', p. 61.

22 Bynum, *Wonderful Blood*, pp. 188–9.

23 An earlier chapter noted that madder roots and 'blood red web cap' mushrooms were not red. In fact, both the roots and the mushrooms were *cruor*, while the colours extracted from them were *sanguis*. This is the exact opposite of animal blood-colour relationships, where *sanguis* is living and *cruor* is dead. However, in the traditional world, that difference would have been ` entirely appropriate, given the cosmological Law of Inversion. Vegetables,

like madder or mushrooms, and animals, like snails and insects, are on different links in the great chain of being. Animals and vegetables occupy different rungs on the ladder of nature or steps on the stairway to heaven and, like mirrors, each step reflects but also inverts reality.

24 J. McKillop, *Dictionary of Celtic Mythology* (Oxford, 1998), p. 11.

25 M. Stanley, 'The "Red Man" of War and Death', *Archaeology Ireland*, XXVI/2 (2012), pp. 34–7.

26 G. P. Lomazzo, *A Tracte Containing the Artes of Curious Paintinge, Caruinge and Buildinge*, III, xiiii, trans. R. Haydocke [Oxford, 1598] (Farnborough, 1970), p. 117.

27 Chaucer, 'The Knight's Tale', *The Canterbury Tales*, trans. N. Coghill (Harmondsworth, 1975), pp. 66, 72.

28 S. R. Weitman, 'National Flags: A Sociological Overview', *Semiotica*, VIII/4 (1973), pp. 338–49.

29 C. Marvin and D. Ingle, *Blood Sacrifice and the Nation: Totem Rituals and the American Flag* (Cambridge, 1999); J. Gage, 'Black and White and Red All Over', RES: *Anthropology and Aesthetics*, XVI (1988), p. 53.

30 Weitman, 'National Flags', pp. 336–7.

31 Cited in Marvin and Ingle, *Blood Sacrifice*, p. 43.

32 Ammianus Marcellinus, *The History* (XVI, x, 7), trans. J. C. Rolfe (Cambridge, MA, 1963), vol. I, p. 245.

33 Weitman, 'National Flags', pp. 349–50.

34 Marvin and Ingle, *Blood Sacrifice*, p. 63.

35 Ibid., p. 4.

36 R. Sennett, 'Genteel Backlash: Chicago 1886', in *Sociological Realities*, ed. I. L. Horowitz and M. Strong (New York, 1971), pp. 287–99, cited in Weitman, 'National Flags', p. 351.

37 T. Gage, *A New Survey of the West Indies* (London, 1699), p. 222, cited in R. L. Lee, 'American Cochineal in European Commerce, 1526–1625', *Journal of Modern History*, XXIII/3 (1951), pp. 212–13.

38 R. A. Hill and R. A. Barton, 'Red Enhances Human Performance in Contests', *Nature*, CDXXXV/7040 (2005), p. 293, based on analysis of results in 2004 football, Olympic boxing, taekwondo and wrestling, with opponents dressed in blue.

39 Aristotle, *On the Parts of the Animal* (III, iv, 665b–667b), trans. A. L. Peck (London, 1961), pp. 233–47.

40 H. Webb, *The Medieval Heart* (New Haven, CT, 2010).

ELEVEN *Red Fire*

1 *Oxford Dictionary of Byzantium*, ed. A. Kazhdan (Oxford, 1991), vol. III, pp. 1759–60.

2 M. Faraday, *A Course of Six Lectures on the Chemical History of a Candle*, ed. W. Crookes (London, 1960).

3 For example, see Max Muller in G. Bachelard, *The Psychoanalysis of Fire*, trans. A.C.M. Ross (London, 1964), p. 24.

4 James St John (1788) cited in V. D. Boantza and O. Gal, 'The "Absolute Existence" of Phlogiston: The Losing Party's Point of View', *British Journal for the History of Science*, XLIV (2011), p. 317.

5 S. Bucklow, *The Alchemy of Paint: Art, Science and Secrets from the Middle Ages* (London, 2009), pp. 49–58.

6 In conventional medicine, we still take 'anti-inflammatory' medicines – in other words, drugs that counter fire – to treat burning sensations in hidden parts of the body and red rashes on the body's surface.

7 No source, cited in M. Touw, 'Roses in the Middle Ages', *Economic Botany*, XXXVI/1 (1982), p. 82.

8 Empedocles (fragment 6), in P. Kingsley, *Ancient Philosophy, Mystery and Magic* (Oxford, 1995), p. 13.

9 T. Gantz, *Early Greek Myth: A Guide to Literary and Artistic Sources* (Baltimore, MD, 1993), vol. I, p. 72.

10 Homer, *Iliad* (XV, 187–91), trans. E. V. Rieu (London, 2003), p. 258.

11 Plato, *Cratylus* (403a), trans. H. N. Fowler (London, 1970), vol. IV, p. 71.

12 Kingsley, *Ancient Philosophy*, pp. 47, 40.

13 Hesiod, *Works and Days* (46), in D. Wender, *Hesiod and Theognis* (Harmondsworth, 1973), p. 60.

14 For fire stones, see T. H. White, *The Book of Beasts: Being a Translation from a Latin Bestiary of the 12th Century* (Stroud, 1992), pp. 226–7; for volcanoes, Kingsley, *Ancient Philosophy*, p. 102.

15 Hesiod, *Theogony* (150–497), trans. M. L. West (Oxford, 1988), pp. 7–18; Gantz, *Early Greek Myth*, vol. I, p. 73.

16 I. Kroppenberg, 'Law, Religion and Constitution of the Vestal Virgins', *Law and Literature*, XXII/3 (2010), pp. 418–39; A. B. Gallia, 'The Vestal Habit', *Classical Philology*, CIX/3 (2014), pp. 222–40.

17 Kroppenberg, 'Law, Religion and Constitution of the Vestal Virgins', p. 419.

18 Gantz, *Early Greek Myth*, vol. I, p. 74.

19 Homer, *Iliad* (XVIII, 395–405), p. 330.

20 Gantz, *Early Greek Myth*, vol. I, p. 78.

21 H. W. F. Saggs, *Civilization before Greece and Rome* (London, 1989), pp. 200–201.

22 Although, appropriately enough, Perseus' sword was made of martial iron.

23 Kingsley, *Ancient Philosophy*, p. 238.

24 M. Cole, 'Cellini's Blood', *Art Bulletin*, LXXXI/2 (1999), pp. 219–20.

25 Georg Agricola, *De re metallica*, XII, trans. H. C. Hoover (New York, 1912), p 592; Cole, 'Cellini's Blood', p. 221.

26 J. Ogden, 'Metals', in *Ancient Egyptian Materials and Technology*, ed. P. T. Nicholson and I. Shaw (Cambridge, 2000), pp. 157–8.

27 I. Weinryb, 'The Bronze Object in the Middle Ages', in *Bronze*, ed. D. Ekserdjian (London, 2012), pp. 69–77.

28 Abbot Suger, *De Administratione*, XXVII, in *Abbot Suger on the Abbey Church of St Denis and its Art Treasures*, ed. E. Panofsky (Princeton, NJ, 1979), pp. 47–9.

29 B. V. Pentcheva, 'The Performative Icon', *Art Bulletin*, LXXXVIII/4 (2006), pp. 631–55.

30 U. Mende, *Dei Bronzetüren des Mittelalters* (Munich, 1983), pp. 21–4, 131–3; and H. Fillitz, 'Die Bronzetüren des Aachensers Münsters', in *Le porte di bronzo dall'antichita* (Rome, 1990), pp. 139–44, both cited in Weinryb, 'The Bronze Object in the Middle Ages', p. 69.

31 F. Pfeiffer, *Meister Eckhart*, trans. C. de B. Evans (London, 1924), vol. I, p. 192.

32 Actually, although the structure of the cosmos meant that you had to pass through fire to get to heaven spatially, spiritually, it was said that you had to go through fire and water. If the church's bronze doors were fire, then their marble walls were water, so entering the great west doors and progressing east down the nave together symbolized the passage through both fire and water. See S. Bucklow, *The Riddle of the Image: The Secret Science of Medieval Art* (London, 2014), pp. 200–239.

33 L. White, 'The Iconography of *Temperantia* and the Virtuousness of Technology', in *Action and Conviction in Early Modern Europe*, ed. T K. Rabb and J. E. Seigel (Princeton, NJ, 1969), pp. 199–201.

34 M. W. Helms, 'Joseph the Smith and the Salvational Transformation of Matter in Early Medieval Europe', *Anthropos*, CI/2 (2006), pp. 516–17.

35 C. Hahn, 'Joseph as Ambrose's "Artisan of the Soul"', *Zeitschrift fur Kunstgeschichte*, XLVII/4 (1984), p. 516.

36 Ibid., pp. 451–71.

37 C. Ginzburg, 'Morelli, Freud and Sherlock Holmes: Clues and Scientific Method', trans. A. Davin, *History Workshop*, IX (1980), p. 12.

38 Cited in E. Kris and O. Kurz, *Legend, Myth and Magic in the Image of the Artist* (New Haven, CT, 1981), p. 21.

39 E. Voegelin, 'The Origins of Scientism', *Social Research,* XV/4 (1948), p. 488.

40 L. Simon, *Dark Light: Electricity and Anxiety from the Telegraph to the X-ray* (Orlando, FL, 2005).

41 O. T. Benfey, 'August Kekulé and the Birth of the Structural Theory of Organic Chemistry in 1858', *Journal of Chemical Education,* XXXV/1 (1958), p. 22.

42 F. Bacon, *Novum Organum* [1620], 1.98, in *The Works of Francis Bacon,* ed. J. Spedding, R. L. Ellis and D. D. Heath (New York, 1968), vol. IV, p. 95.

43 As was evident in the 'valley of ashes' between the city and its exclusive suburbs a generation earlier in F. Scott Fitzgerald's 1925 novel *The Great Gatsby* (London, 1991), p. 20.

TWELVE *Red Passions*

1 J. E. McGuire and P. M. Rattansi, 'Newton and the Pipes of Pan', *Notes and Records of the Royal Society of London,* XXI/2 (1966), pp. 108–43.

2 E. Barth von Wehrenalp, *Farbe aus Kohle* (Stuttgart, 1937), p. 33, cited in E. Leslie, *Synthetic Worlds: Nature, Art and the Chemical Industry* (London, 2005), p. 172.

3 G. Yang, 'The Liminal Effects of Social Movements: Red Guards and the Transformation of Identity', *Sociological Forum,* XV/3 (2000), pp. 379–406.

4 Boethius, *The Consolation of Philosophy* (II, i–iv), trans. V. E. Watts (Harmondsworth, 1969), pp. 54–65.

5 M. Faraday, *A Course of Six Lectures on the Chemical History of a Candle,* ed. W. Crookes (London, 1960), pp. 1, 13–14.

6 Ibid., p. 25.

7 Ibid., pp. 93, 101.

8 F. F. Runge, *Hauswirthschaftliche Briefe* [1866] (Leipzig, 1988), p. 66, cited in Leslie, *Synthetic Worlds,* p. 55.

9 J. W. von Goethe, *Elective Affinities* [1809], vol. I, chap. 4 (Harmondsworth, 1978), p. 56.

10 Ibid., p. 53.

11 R. J. Hollingdale, 'Introduction' to Goethe's *Elective Affinities,* p. 13.

12 Combustion is a very complex and variable process. In its simplest form, the complete combustion of wax (with a clear flame) could be represented by the following equation: $2.C_nH_{2n+2} + (3n+1).O_2 \rightarrow 2n.CO_2 + (2n+2).H_2O$. Incomplete combustion occurs when less

oxygen is available and can produce carbon monoxide. A red glow occurs when there is free carbon in the flame, as follows: $2.C_nH_{2n+2} + (3n).O_2 \rightarrow (2n-1).CO_2 + (2n+2).H_2o + C$.

13 Rayleigh's Law states that scattering is inversely proportional to the fourth power of the wavelength.

14 Albertus Magnus, *Book of Minerals* (I, ii, 2), trans. D. Wyckoff (Oxford, 1967), p. 40.

15 Modern science would say that the red of ruby, for example, is the effect of a tiny number of chromium atoms disrupting the order of a corundum lattice that, if pure, would be colourless. So, poetically, the ruby could be considered to be a 'thin veil' of chromium atoms scattered through a 'luminous transparency' of corundum. However, modern scientists would more likely see ruby as the natural analogue of the synthetically 'doped' materials that are used to create some of the disruptive virtual reds that were the subject of Chapter Seven.

16 J. Gage, *Colour and Culture: Practice and Meaning from Antiquity to Abstraction* (London, 1993), p. 229.

17 Fragments 8, 10 and 51 in D. Sweet, *Heraclitus, Translation and Analysis* (Langham, MD, 1995), pp. 5, 7, 23, 59–60.

18 C. Lévi-Strauss, *The View from Afar*, trans. J. Neugroschel and P. Hoss (New York, 1984), p. 118. The phrase was used in the context of a Cartesian divide between the 'etic' and 'emic'.

19 Sir Walter Raleigh, 'What Is Our Life?', in *The Poems of Sir Walter Raleigh*, ed. A.M.C. Latham (London, 1951), p. 48.

20 MS H fol. 77 [29] v, in E. McCurdy, *The Notebooks of Leonardo da Vinci* (London, 1938), vol. I, p. 411.

21 J. W. von Goethe, *Weimarer Ausgabe* (V(1), 393–4), in G. A. Wells, 'Goethe's Qualitative Optics', *Journal of the History of Ideas*, XXXII/4 (1971), p. 618.

22 See G. Hoeppe, *Why the Sky Is Blue*, trans. J. Stewart (Princeton, NJ, 2007), pp. 120–28.

23 Giorgio Vasari, *The Lives of the Most Eminent Painters, Sculptors and Architects* [1550], trans. G. du C. de Vere (London, 1996), vol. I, pp. 425–7.

24 F. Pfeiffer, *Meister Eckhart*, trans. C. de Evans (London, 1924), vol. I, p. 192.

25 S. A. Harvey, *Scenting Salvation: Ancient Christianity and the Olfactory Imagination* (Berkeley, CA, 2006).

26 This adage is commonly found uttered by the emaciated cadavers that decorate carved medieval tombs.

27 K. Spalding, R. Bhardwaj, B. Buchholz, H. Druid and J. Frisén, 'Retrospective Birth Dating of Cells in Humans', *Cell*, CXXII/1 (2005),

pp. 133–43. 'Contradictions' embodied in dust-laden red skies proliferate. The dust that scatters light in the sky also reflects heat back into space. As a result, the Cold War bombs that inadvertently illuminated the constant recycling of our bodies also created the prospect of an artificial 'nuclear winter', similar to the natural global cooling that may have caused the dinosaurs' demise. But all things change, and now that fear of nuclear destruction has been replaced by fear of global warming, some scientists have suggested countering the new threat by purposefully emulating a nuclear winter, filling the skies with even more soot. If they have their way, the future may have spectacular sunsets and sunrises (albeit at the price of dull days and starless nights). See Michael McKimm, 'Abstract from a Conference: Plenary', *Fossil Sunshine* (Tonbridge, 2013), p. 24, a poem in response to *The Anthropocene: A New Epoch in Geological Time?*, Geological Society of London, Burlington House, 11 May 2011.

28 Just as the horizon's twilight red line is an entirely porous barrier between the temporal states of day and night, so the two-way traffic between bodies and dust reinforces the essential porosity of the boundary between the spiritual states of heaven and earth. See S. Bucklow, *The Riddle of the Image: The Secret Science of Medieval Art* (London, 2014), p. 226. Since much of the carbon above our heads now comes from fossil fuels that once lay beneath our feet, we have literally 'raised the dead' and added novel complexities to these traditional cycles.

29 Fragments 91 and 12, in Sweet, *Heraclitus, Translation and Analysis*, pp. 39, 7, 59.

30 J. Milton, *Paradise Lost* (VIII, 619), ed. J. Leonard (London, 2000), p. 183.

31 M. Touw, 'Roses in the Middle Ages', *Economic Botany*, XXXVI/1 (1982), p. 81.

32 By the same token, blue is the relative absence of light perceived through the presence of light.

33 'Scattering' is the opposite of the biblical 'gathering'. It is making many from one, as opposed to making one from many. As such, scattering light in the turbid medium is a process of what Empedocles called 'strife', as opposed to 'love', and of the 'analysis' that Goethe punned with divorce, as opposed to the 'synthesis' that is marriage. The traditional world saw our death as a 'scattering' of elements, yet modern science has shown that we are also a continuous 'gathering' of those elements. Red arises when we perturb light in our 'scattered' phase.

34 Of course, green is also midway between black and white in Aristotle's scale of colour, but it is passive and its balance shows

in its grounding and calming effect. (Phenomena are traditionally multivalent or polysemic and traditional accounts accommodate multiple dimensions – red and green are the same in their relationships with black and white, but they are opposite in terms of activity and passivity. See Bucklow, *The Riddle of the Image*, pp. 200–239.)

35 The fact that the same thread runs through all things is the reason why some of what was said in the biographies of red things could be equally applicable to things that have nothing to do with red. Most cultures see all things as connected and related. The mainstream modern Western world-view is alone in treating things as essentially separate and different.

36 Nicholas Ridolfi, *A Short Method of Mental Prayer* (x), trans. R. Devas (London, 1921), p. 50.

37 J. Ruskin, *The Ethics of the Dust*, 2nd edn (New York, 1886), pp. 32–3, 236–8.

38 Those working in the new ecologies cited here include Karen Barad, Jane Bennett and Tim Ingold.

BIBLIOGRAPHY

Albertus Magnus, *Book of Minerals*, trans. D. Wyckoff
 (Oxford, 1967)
Aldhouse-Green, S.H.R., *Paviland Cave and the 'Red Lady':*
 A Definitive Report (Bristol, 2000)
Barad, K. M., *Meeting the Universe Halfway: Quantum Physics and the*
 Entanglement of Matter and Meaning (London, 2007)
Bennett, J., *The Enchantment of Modern Life: Attachments, Crossings,*
 and Ethics (Princeton, NJ, 2001)
—, *Vibrant Matter: A Political Ecology of Things* (London, 2010)
Bucklow, S., *The Alchemy of Paint: Art, Science, and Secrets from the*
 Middle Ages (London, 2009)
—, *The Riddle of the Image: The Secret Science of Medieval Art*
 (London, 2014)
Bynum, C. W., *Wonderful Blood: Theology and Practice in Late*
 Medieval Northern Germany and Beyond (Philadelphia,
 PA, 2007)
Caley, E. R., 'The Stockholm Papyrus: An English Translation with
 Brief Notes', *Journal of Chemical Education*, IV/8 (1927), pp. 979–1002
Cennini, Cennino, *The Craftsman's Handbook*, trans. D. V. Thompson
 (New York, 1960)
Donkin, R. A., 'The Insect Dyes of Western and West-central Asia',
 Anthropos, LXXII (1977), pp. 847–80
—, 'Spanish Red', *Transactions of the American Philosophical Society*,
 n.s., LXVII/5 (1977), pp. 1–84
Eliade, M., *The Forge and the Crucible*, trans. S. Corrin (Chicago, IL, 1978)
Evans, J., *Magical Jewels of the Middle Ages and Renaissance* (Oxford,
 1922)
Fairlie, S., 'Dyestuffs in the Eighteenth Century', *Economic History*
 Review, XVII/3 (1965), pp. 488–510
Faraday, M., *A Course of Six Lectures on the Chemical History of a*
 Candle, ed. W. Crookes (London, 1960)

Field, G., *Chromatography*, ed. T. W. Salter (London, 1869)

Gage, J., *Colour and Culture: Practice and Meaning from Antiquity to Abstraction* (London, 1993)

—, *Colour and Meaning: Art, Science and Symbolism* (London, 1999)

Goethe, J. W. von, *Theory of Colours* [1840], trans. C. L. Eastlake (Cambridge, MA, 1970)

Haraway, D., *Simians, Cyborgs and Women: The Reinvention of Nature* (New York, 1991)

Harley, R. D., *Artists' Pigments, c. 1600–1835: A Study in English Documentary Sources* (London, 1982)

Hilsum, C., 'Flat-panel Electronic Displays', *Philosophical Transactions of the Royal Society A: Mathematical, Physical and Engineering Sciences*, 368 (2010), pp. 1027–82

Hutchings, J. B., and J. Woods, eds, *Colour and Appearance in Folklore* (London, 1991)

Ingold, T., *The Perception of the Environment: Essays on Livelihood, Dwelling and Skill* (London, 2000)

Jones, A., and G. MacGregor, eds, *Colouring the Past: The Significance of Colour in Archaeological Research* (Oxford, 2002)

Kieckhefer, R., *Magic in the Middle Ages* (Cambridge, 2000)

Kingsley, P., *Ancient Philosophy, Mystery, and Magic: Empedocles and Pythagorean Tradition* (Oxford, 1995)

Kok, A., 'A Short History of the Orchil Dyes', *The Lichenologist*, III/2 (1966), pp. 252–8

Leslie, E., *Synthetic Worlds: Nature, Art and the Chemical Industry* (London, 2005)

Lomazzo, G. P., *A Tracte Containing the Artes of Curious Paintinge, Caruinge and Buildinge* [1598] trans. R. Haydocke (Farnborough, 1970)

McCurdy, E., *The Notebooks of Leonardo da Vinci* (London, 1938)

McGuire, J. E. and P. M. Rattansi, 'Newton and the "Pipes of Pan"', *Notes and Records of the Royal Society of London*, XXI/2 (1966), pp. 108–43

Marvin, C., and D. W. Ingle, eds, *Blood Sacrifice and the Nation: Totem Rituals and the American Flag* (Cambridge, 1999)

Merrifield, M. P., *Original Treatises on the Arts of Painting* (New York, 1967)

Olson, K., 'Cosmetics in Roman Antiquity: Substance, Remedy, Poison', *The Classical World*, CII/3 (2009), pp. 291–310

Ovid, *Metamorphoses*, trans. M. M. Innes (Harmondsworth, 1975)

Ponting, K. G., *A Dictionary of Dyes and Dyeing* (London, 1980)

Rublack, U., *Dressing Up: Cultural Identity in Renaissance Europe* (Oxford, 2010)

Smith, C. S., and J. G. Hawthorne, 'Mappae Clavicula: A Little Key to the World of Medieval Techniques', *Transactions of the American Philosophical Society*, LXIV/4 (1974)

Theophilus, *On Divers Arts*, trans. J. G. Hawthorne and C. S. Smith (New York, NY, 1979)

Theophrastus, *On Stones*, trans. E. R. Carley and J.F.C. Richards (Columbus, OH, 1956)

Travis, A. S., 'Science's Powerful Companion: A. W. Hofmann's Investigation of Aniline Red and its Derivatives', *British Journal for the History of Science*, XXV/1 (1992), pp. 27–44

Vincent, N., *The Holy Blood: King Henry III and the Westminster Blood Relic* (Cambridge, 2001)

Webb, H., *The Medieval Heart* (New Haven, CT, 2010)

Weinreich, M., *Hitler's Professors: The Part of Scholarship in Germany's Crimes Against the Jewish People* (London, 1999)

Weitman, S. R., 'National Flags: A Sociological Overview', *Semiotica*, VIII/4 (1973), pp. 338–49

Williams, N., *Powder and Paint* (London, 1957)

Wittgenstein, L., *Remarks on Colour*, ed. G.E.M. Anscombe, trans. L. L. McAlister and M. Schättle (Berkeley, CA, 1979)

ACKNOWLEDGEMENTS

I would like to offer my sincere thanks to Michael Leaman of Reaktion for suggesting that I write *Red* and for giving me free rein. I would also like to thank Reaktion's Martha Jay for her judicious editing.

The book draws upon work undertaken at the Hamilton Kerr Institute, University of Cambridge, and my thanks are to all the staff and, especially, to all the interns and students. Its illustrations draw upon, among others, the collections of the Fitzwilliam Museum and other University of Cambridge Museums and I would like to thank all museum staff for their advice and assistance.

Others to whom thanks are due include: Oscar Moro Abadia, Fabio Barry, Tao-Tao Chang, Sven Dupré, Orion Edgar, Sarah Finney, Ian Garrett, Abby Granville, Ella Hendriks, Anita Herle, Sigrid Holmwood, Deirdre Jackson, Christine Slottved Kimbriel, Andrea Kirkham, Kaja Kollandsrud, Andria Laws, Nick Marsden, Onya McCausland, Rose Miller, Douglas Palmer, Dan Pemberton, Sally Petitt, Penny Price, Simon Ravenscroft, Paola Ricciardi, Simon Schaffer, Sydney Sims, Helen Strudwick, Chris Titmus, Philippe Walter, Ittai Weinryb, James Wood, Sally Woodcock and Lucy Wrapson. Last but not least, I am deeply grateful to my family for their support and for their patience during my passion for all things red.

I would also like to thank the Monument Trust and the Marlay Group of the Fitzwilliam Museum for their generous support, without which the book would not have been written.

PHOTO ACKNOWLEDGEMENTS

The author and publishers wish to express their thanks to the below sources of illustrative material and/or permission to reproduce it. (Some information not placed in the captions for reasons of brevity is also given below.)

Photos courtesy the author: 9, 10, 12, 19, 20, 22, 23, 35, 36, 39, 44, 45, 47, 51, 57, 59, 61, 65, 66, 67, 68; Bibliothèque Nationale de France, Paris: 1; British Library, London (photos © The British Library Board): 54, 55, 70; photo Cambridge University Library/Grant Young: 41; Fitzwilliam Museum, University of Cambridge: 21, 28, 30, 31, 48, 60, 63 (photos Mike Jones); photo The Foraged Book Project/James Wood: 11; Hamilton Kerr Institute (Fitzwilliam Museum, University of Cambridge): 8, 13, 14, 26, 27 (photos Chris Titmus), 40 (photo Michaela Straub and Amiel Clarke); Harvard Art Museums, Fogg Museum (bequest of Charles E. Dunlap, © President and Fellows of Harvard College): 2; J. Paul Getty Museum, Los Angeles, California/ Open Content: 69, 70; photo Jebulon: 62 (this file is made available under the Creative Commons CC0 1.0 Universal Public Domain Dedication); photo Onya McCausland: 53; photo Metropolitan Museum of Art/Scala: 56; photo www.morguefile.com/alexfrance: 64; photo www.morguefile.com/Tahoe1231: 52; Museum of Archaeology and Anthropology, University of Cambridge: 46; photo Museum of Zoology, Cambridge/Chris Green and Tom Mayle: 5; The National Archives, London: 4; photos Rochester Institute of Technology: 33, 34; Royal Collection: 15, 16; Sedgwick Museum, Department of Earth Sciences, University of Cambridge: 17, 24, 25 (photos Eva-Louise Fowler), 18, 42, 43, 50 (photos author); photos Sue Shepherd/author: 37, 38; Van Gogh Museum, Amsterdam: 33; Vincent van Gogh Foundation, Amsterdam: 33, 34; Wellcome Library Images: 3, 6, 7, 49; Whipple Museum of the History of Science, Cambridge: 29, 58 (photos Steven Kruse); Winsor & Newton archive, Hamilton Kerr Institute (photo author): 32.

INDEX

Illustration numbers are in *italics*